EARLY
ANGLO-SAXON ART
AND
ARCHAEOLOGY

EARLY
ANGLO-SAXON ART
AND
ARCHAEOLOGY

BEING
THE RHIND LECTURES
DELIVERED IN EDINBURGH
1935

BY

E. T. LEEDS, M.A., F.S.A.

KEEPER OF THE
ASHMOLEAN MUSEUM, OXFORD

GREENWOOD PRESS, PUBLISHERS
WESTPORT, CONNECTICUT

Originally published in 1936
by The Clarendon Press, Oxford

Reprinted from an original copy in the collections
of the Brooklyn Public Library

First Greenwood Reprinting 1970

Library of Congress Catalogue Card Number 77-109764

SBN 8371-4254-7

Printed in the United States of America

PREFACE

THE Council of the Society of Antiquaries of Scotland, in honouring me with an invitation to deliver the Rhind Lectures in Edinburgh in 1935, added a suggestion that I should choose the Anglo-Saxon period for my subject. I was the more ready to fall in with this suggestion, since it afforded me an opportunity to gather together the additions to my knowledge and the modifications of my earlier opinions about the period which have inevitably resulted since the publication of *The Archaeology of the Anglo-Saxon Settlements* over twenty years ago. The following chapters contain the substance of my lectures, for the most part as they were delivered, but in preparing them for publication I have made alterations and additions. The lectures were illustrated by numerous lantern-slides, from the material of which only a very small selection is possible within the compass of their book-form. For that reason I have tried to include extensive references to the literature of the subject, and especially to illustrations, giving preference to those which I have thought likely to be most accessible to readers and, where possible, reserving my own illustrations for less familiar objects.

I wish to make due acknowledgement for permission to reproduce illustrations to:

The Trustees of the British Museum for Plate XXX *a*, and Figs. 1, 6, 13 *a*, and 15 *a*; the Council of the Society of Antiquaries of London for Plates VI *c*, IX *b*, XX *c–d*, and Figs. 8–10; the Lord Gage and the Council of the Sussex Archaeological Society for Plates II *b* and III *d*; the Council of the Cambridge Antiquarian Society for Plate XXIII; the Council of the Wiltshire Archaeological Society for Fig. 23 *b*; the Editorial Committee of the Victoria County Histories for Plate VI *b* and Fig. 15 *b*; the Liverpool Free Museums for Plates XIII, XIX, and XXIX; the Staatliches Museum für Vor- und Frühgeschichte, Berlin, for Plate XVI *b*. Many other museums, particularly the British Museum (Department of British and Medieval Antiquities), have greatly facilitated my work by kindly supplying me with photographs for illustration or study, and I am indebted for similar help to Dr. A. E. Relph, the

Lord Northbourne, Mr. Hugh Lawson, and Mr. T. D. Kendrick. To the Very Rev. Dom Ethelbert Horne I am especially grateful, not only for photographs, but also for first-hand information about the Camerton cemetery. Finally I am under a deep obligation to the Delegates of the University Press for their acceptance of the lectures for publication, and to the Staff of the Press for their constant interest and assistance in the preparation of this volume.

E. T. L.

ASHMOLEAN MUSEUM,
April 1936.

CONTENTS

LIST OF TEXT FIGURES viii

LIST OF PLATES ix

INTRODUCTION xi

I. NATIVE ART IN EARLY ANGLO-SAXON TIMES . . 1

II. THE INVADERS; LIFE AND DEATH 20

III. THE KENTISH PROBLEM 41

IV. THE KENTISH PROBLEM (CONT.) 59

V. THE CULTURAL RELATIONS OF EAST ANGLIA WITH THE
 MIDLANDS AND NORTHERN ENGLAND . . . 79

VI. THE FINAL PHASE 96

APPENDIX. KENTISH CIRCULAR JEWELLED BROOCHES . 115

GENERAL INDEX 125

INDEX OF PLACES 128

LIST OF TEXT-FIGURES

1. Escutcheon of bronze bowl, Faversham, Kent . . . 8
2. Swastika elements in designs on escutcheons of bowls . . 13
3. Bronze casket, Strood, Kent 15
4. Late classical ornament on helmets, buckets, &c. . . . 16
5. Bronze mounted bucket, Buire-sur-l'Ancre, detail . . . 17
6. Bronze buckle, Stanwick, N. Riding, Yorks. . . . 19
7. Salling, Jutland: interior construction of building . . . 22
8. Sutton Courtenay, Berks.: plan of House VI . . . 22
9. ,, ,, ,, plan of House XIII . . . 23
10. ,, ,, ,, plan of House XII . . . 25
11. ,, ,, ,, plan and section of House XXI . 27
12. Map of distribution of Anglo-Saxon cemeteries with cremation-burials 29
13. Bronze square-headed brooches from (a) Milton-next-Sittingbourne, Kent, and (b) Engers, Hessen Nassau, Germany . 48
14. Brooches from Hungary and Württemberg with skein ornament (after Salin) 63
15. Wooden goblets with embossed metal mounts. (a) Taplow, Bucks., and (b) Farthingdown, Surrey 65
16. Map showing distribution of florid cruciform brooches, on Pl. XXII 83
17. Map showing distribution of early cruciform brooches (Ant. Journ. xiii. 239–40) 87
18. Map showing distribution of East Anglian large square-headed brooches, on Pl. XXV 87
19. Map showing distribution of saucer and applied brooches with zoomorphic ornament (Ant. Journ. xiii. 243, Classes I–V, with additions) 87
20. Map showing distribution of large, square-headed brooches, from the same mould or model, exclusive of those on Pl. XXV . 87
21. Bronze buckles decorated à jour from Kent 103
22. Bronze buckle, Amt Stockach, Baden (after Salin) . . . 104
23. (a) Jewelled pins and necklace, Cowlow, Derbyshire. (b) Jewelled pins and necklace, Roundway Down, Wiltshire . . . 109
24. Map showing distribution of Kentish jewelled brooches, Class I a 122
25. ,, ,, ,, Class I b 122
26. ,, ,, ,, Class I c 122

LIST OF PLATES

I. Penannular and annular brooches from Anglo-Saxon graves (Ashmolean Museum).

II. Decorated silver annular and penannular brooches from Kent and Sussex.

III. Objects from Anglo-Saxon graves decorated in late Gallo-Roman style.

IV. Objects from 'the Warrior's Grave' at Vermand, Dept. Aisne (after Pilloy).

V. Buckles, belt-mounts, &c., from late Gallo-Roman graves at Vermand, Dept. Aisne (after Pilloy).

VI. (a) Enamelled escutcheon, Lincoln; (b) Bronze weight, Mildenhall, Suffolk; (c) Enamelled escutcheons, Baginton, Warwicks.

VII. (a) Sarcophagus from Charenton-sur-Cher (after le Blant); (b) Silver-plated iron buckle, Bifrons, Kent.

VIII. Sutton Courtenay, Berks.; House XXI: (a) puddling-pit; (b) cooking-pot.

IX. (a) Clay loom-weights, Cassington, Oxon; (b) Plan of House XX, Sutton Courtenay, Berks.

X. Miniature toilet-implements from cremation-urns, Abingdon, Berks.

XI. (a), (c), and (d) Bronze brooch and urn, Westerwanna, Hannover (after *Anglia*); (b) Bronze brooch, Caister, Norfolk.

XII. Objects from cemetery, Bifrons, Kent.

XIII. Pottery from Kent in Liverpool Museum; (a) Saxon; (b) Frankish or Kentish.

XIV. Jewellery from grave D3, Finglesham, Kent.

XV. Small square-headed brooches (Kentish type) from Kent and Upper Thames Valley (Ashmolean Museum).

XVI. Square-headed brooches (Kentish type), (a) Finglesham, Kent; (b) Herpes, Dept. Charente; (c) Bronze Coptic bowl, Chilton Hall, Sudbury, Suffolk (Ashmolean Museum).

XVII. (a) Square-headed brooch, Wurmlingen, Württemberg (after Salin); (b) Bronze brooch, Malton Farm (Barrington A), Cambs.; (c) Bronze pendent disk with griffins, Andernach, Germany.

XVIII. Late ornament with interlacing and spotted bands, from Kent and Suffolk.

XIX. Jewellery, with interlaced zoomorphic ornament, (a) Gilton, Kent ; (b) Market Overton, Rutland; (c) Asthall, Oxon.

XX. Zoomorphic ornament, Kent, East Anglia, and Midlands.

XXI. Finials and mounts of drinking-horns, Taplow, Bucks.

XXII. Florid cruciform brooches from East Anglia and Mid-Anglia.

XXIII. Cruciform brooch with rampant beast, Soham, Cambs.

XXIV. Large square-headed brooches in Kentish style, East Anglia, &c.

XXV. East Anglian square-headed brooches.

XXVI. Large square-headed brooches, Ragley Park, Warwicks., and Quy, Cambs.

XXVII. Grave-groups, Uncleby, E. Riding, Yorks.

XXVIII. Objects from grave, Garton Slack, E. Riding, Yorks., (after Mortimer).

XXIX. (a) Jewellery from a grave in barrow A; (b) buckles from various graves, Chartham Downs, Kent (after Faussett).

XXX. Late (seventh-century) jewellery from various sites.

XXXI. Jewellery and beads from graves, Camerton, Somerset.

XXXII. Kentish circular jewelled brooches, Class I.

XXXIII. „ „ „ „ Classes II and III.

INTRODUCTION

THE task of the archaeologist who concerns himself with the beginning of what has been termed the Dark Ages in the British Isles is a peculiar one. Students of the long Roman period immediately preceding it can bring archaeology to their aid in reconstructing a puzzle within an ascertained framework of history, but those who study the succeeding period find that the framework does not hang together in the same way. All that is available is a number of pieces that obviously belong to such a framework, but here and there strips are wanting, and the difficulty of filling in the remainder of the picture is correspondingly increased by their absence. In short, the conditions approximate closely to those under which research into the Iron Age, more particularly the la Tène period, has to be carried out. Again, apart from the historical side, the Roman archaeologist has at his hand a wealth of literature and epigraphical material, while that by which Anglo-Saxon archaeology can be tested is as scrappy as are the historical records, and, worse than that, is marred by the element of boastfulness that forms so marked a trait of the northern sagas. Attempts to correlate the two, as can be gathered from a perusal of Knut Stjerna's *Essays on Beowulf*, attractive as they are, necessarily leave the reader with a certain sense of unfulfilment; they do little more than dot the i's and cross the t's of the deductions of archaeological research. That in the nature of things is inevitable, given the character of the material with which the student has had, and still has, to deal. For though as time goes on the material slowly and steadily increases in bulk, yet its character changes extraordinarily little: so little that it would seem impossible to hope that any new light is to be obtained by further research. But such is not the case. The very obscurity that enshrouds the period renders it certain that some of its truths must still have escaped detection, and that only examination on yet more intensive lines will bring them to the light. Much has been

done within the last thirty years. No one deserves higher commendation for his contribution, particularly on the technical side, than that assiduous and careful scholar, the late Professor Baldwin Brown, whose monumental work, *The Arts in Early England*, will long remain an invaluable guide and an indispensable work of reference. The results obtainable, as he has clearly shown, are, however, at best relative in their value. Conclusions that seem established often dissolve again on closer study, but it is this very elusiveness, inherent in the subject, that provides the stimulus to further essays at interpretation.

In these chapters I have endeavoured to leave history almost entirely on one side, and, treating the material purely from an archaeological standpoint, to fit it within certain more or less determined historical limits, the time at which the invasions are stated to have begun and that at which Christianity became firmly established in Anglo-Saxon England. In a sense that has already been accomplished in the past, but nevertheless I dare to believe that I may be able to add some contribution to the labours of others, notably Professor Baldwin Brown, Mr. Reginald Smith, Dr. Nils Åberg, and Mr. T. D. Kendrick, all of whose writings have opened up for me new lines of thought.

As I have already said, the material has changed but little, and, indeed, is not likely to change. It is only because I am convinced that the last word has not been spoken that I am encouraged to persist in attempts to set the matter in what I consider to be its true perspective. I feel that certain aspects of Anglo-Saxon archaeology have been insufficiently explored. A fuller examination of these may not be devoid of interest or value, if thereby a truer estimate can be formed of the relationship between the English material and its continental analogues. This seems to afford the surest hopes of constructing a relative chronology for the remains of pagan Saxondom, as the first step towards establishing their absolute chronology.

I

NATIVE ART IN EARLY ANGLO-SAXON TIMES

IF all the statements of Gildas were to be accepted at their
face value, we should be compelled to believe that within the
region affected by the invasions of the late fifth century the
native population was for all practical purposes exterminated,
no more than a miserable remnant (possibly Gildas himself
among them) having succeeded in finding a qualified safety in
the west of Britain, or one more assured in Ireland or Brittany.
At first sight there would appear to be a large element of truth
in the statement, but when it is examined in the light of archaeo-
logy, doubts begin to assail the student, at first hesitatingly, but
later with ever-increasing force. Throughout history the victims
of invasion have exaggerated their own sufferings. They have
presented so lurid a picture of destruction, bloodshed, and
atrocities that the other side of the picture, the survival of a
large proportion of the native population, amid unquestionable
hardship and terrorism, is either ignored or forgotten. So, too,
in Anglo-Saxon times. The valiant and, for a time, effective
opposition offered by the natives under Ambrosius (or Arthur),
no matter where the site of the battles be located, proves the
existence of a far from contemptible native force, and the story
of Hengist and Vortigern shows that even in Kent the original
position was rather in favour of the latter and his subjects. The
unprovoked massacre was Hengist's solution of the problem of
overlordship, and cannot be read as more. It has no bearing
on the fate of the population at large, even if some of them did
flee to London. There is no means of telling how far the rest
remained in servitude to their new masters or gradually slipped
away to join their compatriots in the west. But the fact that
they remained in Kent and Sussex for some time after the arrival
of the invaders is proved not only by history but by the distribu-
tion of the remains of their eventual conquerors.

We may then ask, Is there anything that archaeology can

B

show for such a survival within the half-century or more that had elapsed between the withdrawal of the legions and the final assertion of Jutish supremacy in Kent?[1]

It is a remarkable fact that British archaeology seems almost to cease, at any rate in southern England, from A.D. 410. Nowhere can one point to discoveries of occupation-sites productive of remains that can be confidently assigned to post-Roman times. Here and there a group of graves may be suspected to belong to the period in question, like those of the cemetery at Frilford, where Anglo-Saxon graves have been found among them or close to them; or again more recently at Cassington, Oxfordshire, where two varieties have been found in proximity to one another.

Apart from such, possibly hypothetical, evidence of post-Roman Britain, it is a matter of controversy whether the minute coinage, found in large hoards at Lydney, Verulamium, and elsewhere, does not reflect economic conditions such as may well have ensued upon the reduction of the British to reliance on their own resources, unsupported by administrative and economic relations with other parts of the Empire.[2] Nevertheless, archaeology can furnish some evidence, scant though it be, not only that a cultural life went on, but also that, no longer dominated by a foreign rule the Britons were free to wed together classical and native (Celtic) ideas, and from this union a new native art was born, one which, as I have indicated elsewhere, represents a renaissance of the native spirit after more than three centuries of subservience to foreign masters.[3]

The material available is, as I have said, meagre, and is in many

[1] Professor Collingwood has informed me that he deals with this very point in the forthcoming *Oxford History of England*, vol. i.

[2] It is by no means universally admitted that the *minimissimi* from Verulamium can be as early as the third century. That *minimi* can occur in the third century is proved, as Mr. C. H. V. Sutherland has pointed out to me, by a hoard from Segontium (*Arch. Cambr.*, 1922, pp. 291 and 312) and others like it, but in these *minimi* and coins of orthodox size are found together, suggesting a relation between two sizes of currency. The hoards mentioned above consist purely of *minimi* or *minimissimi*.

[3] E. T. Leeds, *Celtic Ornament in the British Isles down to A.D. 700*, Ch. VI.

cases difficult to date, but light is slowly beginning to dawn, and it cannot be long before its inner meaning is wholly revealed. Already special studies have yielded important results. Mr. Kendrick in his[1] investigation of the typology of the bronze hanging bowls with enamelled escutcheons has traced their history back to Roman times, and has placed beyond all doubt their origin in native work. Their place in the general scheme of British art will be examined in due course. For the moment all that needs to be remarked is that these bowls are, with perhaps one exception, spun, not hammered, and no bronze vessel produced by that process can be ascribed to early Anglo-Saxon workmanship.

Meanwhile, when a survey is made of the corpus of archaeological material gathered from Anglo-Saxon graves and other sources, it must strike the observer at once that certain objects seem, as it were, to be out of place. They do not fit into the framework of Germanic types. One of these is the penannular brooch. It is a type that, as is well known, goes back to pre-Roman Celtic times in Britain and persists throughout the Roman period. Its appearance in English graves bears witness to the survival of a native substratum in Anglo-Saxon culture (Pl. I). It does more; it is productive of specialized Anglo-Saxon forms, like the broad, flat, annular class peculiar to English soil during the period under review. They, like the simple disk-brooches, almost defy attempts to date them. They seem to crop up at every stage and in every area, but they are associated beyond doubt with other evidence of an early period of the occupation. I would cite the Bifrons cemetery[2] in this connexion; for in Kent both the disk and the flat annular type are rare, and seem to have gone out of use, whereas in other parts of England both types remain. In some districts outside Kent the disk-brooch is almost the commonest variety, for example, in such cemeteries as Abingdon and Long Wittenham. The penannular and annular form are found everywhere from Wiltshire to Yorkshire, and the persistence of the latter from its Bifrons days is vouched for by the charming late examples

[1] *Antiquity*, vi.161 ff.
[2] G. Baldwin Brown, *The Arts in Early England*, iii. pl. xxxvi. 6 and 8.

from Castle Bytham, Lincolnshire,[1] and from Welford, Nor-
thamptonshire.[2]

But Kent and Sussex have produced a remarkable and highly
significant group of a special type, combining the penannular
and the flat annular forms. Examples are known to archaeo-
logists from Sarre (Pl. II c),[3] and Howletts, Kent (Pl. II a),[4]
and High Down,[5] and Alfriston, Sussex (Pl. II b),[6] and with them
goes a disk-brooch from Faversham, Kent,[7] whose decoration
connects it with the same group. To this list I can, through the
kindness of Dr. A. E. Relph, F.S.A., add a fifth example of the
quoit form, which in spite of its fragmentary condition is of
particular value for determining the history of the type (Pl. III a,
illustrated, two diameters).

Here we have in the outer zone running wolf-like animals
portrayed in an extremely lively manner, and in the inner
zone pairs of animal heads affronted and linked by elongated
bodies, while riveted to the plate is a dove exactly like those
on the specimen from Sarre. The animals in the outer zone
have nothing to do with Anglo-Saxon art proper, except in so
far as, like the cowering beast on certain of the Kentish square-
headed brooches, they go back to a provincial Roman proto-
type. When, however, the former are examined more closely, a
feature absent from the latter is at once detected, namely, the
method of decorating the bodies with small incisions intended
to represent fur. It is perfectly obvious whence this technique
was derived. It is a common feature in Gallo-Roman art of the
late fourth and early fifth centuries, just at the time when the
Salian Franks were beginning to move forward into Belgium
as far as the Namur region.[8] The style is admirably illustrated
in the rich warrior's grave at Vermand[9] and by a large number

[1] J. Y. Akerman, *Remains of Pagan Saxondom*, pl. XXXIII. 2.
[2] Ibid., pl. XII. 2.
[3] British Museum, *Guide to Anglo-Saxon Antiquities*, fig. 59. [4] Ibid., fig. 58.
[5] *Archaeologia*, liv. 372, fig. 2; *V.C.H. Sussex*, i. 344, fig. 7.
[6] *Sussex Arch. Collections*, lvii, pl. XXIV. 1. [7] B. M. *Guide*, fig. 38.
[8] Fr. Kauffman, *Deutsche Altertumskunde*, ii. 614–17.
[9] J. Pilloy, *Études sur d'anciens lieux de sépultures dans l'Aisne*, ii, coloured
plate opp. p. 52.

of objects from other graves in the same cemetery (Pls. IV–V). One may note a marked change in the portrayal of the animals on buckle-plates and the like. On examples like those from Sedan,[1] a lion is unmistakably intended in every case, as on others from Vermand.[2] These, however, represent a stage of the style when as yet some of the animals are depicted in recognizable shape. But already we find along with them other indeterminable, monstrous forms, frequently used as *protomi* on each side of the tongues of buckles. They sometimes have shapeless bodies with a griffin-like head[3] or are in the form of a fabulous hippocamp with ears, with or without forelegs, and with the body prolonged into a tail.[4] Other features of these buckles are the use of chip-carving technique, either in angular patterns or in running or geometrically ordered scrolls; engraved designs, vine and tendrilled scrolls, borders of half-circles with an annulet over the points of intersection; and frilled or ribbon mouldings, the former with each lobe either engraved with a bull's-eye circlet or perforated, the latter treatment being well exemplified in the tubular-sided belt-fittings of a class represented in the early Teutonic grave at Dorchester, Oxfordshire. The exposed ends of the hoops of the buckles terminate in a pair of open-mouthed animal heads, which, when compared with the engraved figures on the plates, are seen to be meant for lions' heads, and between these heads stretched the axle for the tongue of the buckle.

It is to this style that the Kentish brooches and their analogues from Sussex manifestly belong. The method of suggesting the fur is identical, and so are some of the animals, particularly the hippocamp, as seen on the Howletts and Faversham brooches. Those on the Sarre brooch seem to have advanced somewhat, for though the confronted animals in the outer zone are obviously intended for lions, they are the work of some one who had but a vague knowledge of that beast; the treatment of the feet is more reminiscent of an initial stage of the Germanic Style I.

[1] Ibid. iii. 262. [2] Ibid. ii. pls. 14–15. [3] Ibid. iii. 262, from Sedan.
[4] Ibid. iii. 258 in Budapest Museum, or from Vermand, ibid. ii. plate after p. 52; pls. 14. 3*a*, 15, 18–21. 2.

In the inner zone, as on an Alfriston buckle (Pl. III *d*), are confronted animals with heads turned backwards, that with their scut-like, abbreviated tails convey the impression of a hare, as indeed they may well be, retaining with the animals in the outer zone a reminiscence of the common motif of a dog chasing a hare that so frequently occurs on Roman bronze knife-handles, examples of which have more than once been found in Anglo-Saxon graves.

Again, the confronted monsters in the inner zone of the Howletts brooch in the British Museum, with a pellet held between their contiguous jaws, simply carry on the tradition of the hippocamp heads arranged in a similar manner on Gallo-Roman buckles,[1] but with a tendency to assume a shape more akin to the leonine heads on a somewhat later class that embraces examples with lions engraved on their plates. The two Howletts brooches are further ornamented with full-moon faces, with which may again be compared a representation on one of the Vermand buckles.[2] A more schematic version appears on the Alfriston brooch in conjunction with a running, tendrilled scroll; while an open-work border can be resolved into a formalized succession of the confronted heads with gaping jaws. The lion-heads at the terminals of the hoop are, however, turned inwards and have lost most of their reality.[3]

The tendrilled scroll appears on a tin platter from Vermand,[4] with cross-veined leaves in which can be seen the origin of the feathery tails of the hounds of the first Howletts brooch and of the Royston buckle[5] with its lion-headed terminals. There are other pieces that fall into the same category: the little plate from High Down,[6] Sussex, reproduces the style of the Babenhausen mount figured by Salin,[7] a piece that in its construction curiously repeats the flat, decorated surface with the almost detached moulded ring with its knobbed terminals, such as appears on

[1] Pilloy, ii. pl. 14, figs. 15 and 17; pl. 15, figs. 1*a* and 11.
[2] Ibid. ii. pl. 14, fig. 3 *a*.
[3] For the border in simple form see Pilloy, ii. pl. 21, fig. 2.
[4] Ibid., fig. on p. 206. [5] Baldwin Brown, iii. pl. v, fig. 2.
[6] Ibid. iv. pl. CLV, fig. 2. [7] *Altgermanische Thierornamentik*, fig. 335.

the penannular brooches. The central decoration of the High Down plate is paralleled in that of a plate from Bishopstone,[1] Buckinghamshire (Pl. III c), where once more we encounter the animals of the brooches.

The two embossed plates (Pl. III b) from Bidford-on-Avon[2] repeat the animal of the Alfriston buckle. The incised fur is, however, here replaced by a debased vine-pattern, which nevertheless clearly gives the pieces their place in time. The usual animal at its last gasp is to be seen on the Bifrons pendant.[3] The curled tail of the hippocamp remains, but the animal has received a wolf-like head.

All the pieces here noticed clearly belong to a cultural phase presenting indeed many affinities to the Germanic style of the settlement period; but in reality they represent a continental style antecedent to that development in southern England. In Kent they come chiefly from cemeteries that have a long history in Anglo-Saxon times. There is every reason to believe that they are objects antedating the invasion, and, if it is desired to know what the native women were wearing before or at the time of Hengist's landing, this group supplies the information.

We can go farther. We shall find that by placing objects decorated in this style in their proper setting, we shall obtain the key to the ornamentation of some of the hanging bowls. Let us turn back for a moment to the buckles with confronted lion-heads. Mr. Reginald Smith aptly drew attention to the affinity of one[4] found at Mitcham to an example from Vermand, a more formalized parallel to which from Burwell, Cambridgeshire, is illustrated by Baldwin Brown.[5] The heads in both cases have taken on the leonine in place of the hippocampic form, but the idea of the intervening ball is preserved.

So we come to the hanging bowls. Mr. Kendrick, who has done archaeology a great service in examining the typology of their form, has succeeded in singling out certain examples as

[1] Baldwin Brown, iv. pl. CLV. 1.
[2] Ibid. iii. pl. IX, fig. 8. [3] Ibid. iv. pl. CII, fig. 1.
[4] Ibid. iv. pl. CLIV, fig. 3; *Proc. Soc. Ant.* xxi. 8, fig. 8.
[5] Pl. CLIV, fig. 2.

early, like that from Wilton, Wiltshire,[1] with its open-work *pelta*-patterned escutcheon, or others with heater-shaped escutcheons, from Finningley, Yorkshire, and Chessel Down, Isle of Wight. All of these he places in the fifth century. But, having gone so far and, with his typological scheme before him, having rightly drawn attention to the parallelism existing between the escutcheons on the Faversham bowl with a Latin cross between

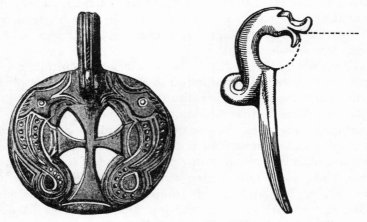

FIG. 1. Escutcheon of bronze bowl, Faversham, Kent ($\frac{1}{1}$)

fish-like animals (Fig. 1),[2] and the style of the Gallo-Roman art of Vermand, I do not understand why he should hesitate between a 'fifth or possibly sixth century date'.[3] There is ample Christianizing material in these Gallo-Roman cemeteries,[4] so why should there be any hesitancy? It is certainly no later than the fifth. It cannot be anything else. The hook of the escutcheon is, as also that of the Finningley[5] bowl, our friend the hippocamp once more; the fishes are another version of the same, decorated with little spots. The fish-tailed birds of other escutcheons

[1] *Archaeologia*, lvi. 40, fig. 1; Burlington Fine Arts Club, *Art in the Dark Ages in Europe, c. 400–1000 A.D.*, pl. IV, B. 17.

[2] B. M. *Guide*, fig. 51. [3] Loc. cit. 168.

[4] See Pilloy, ii. pl. 13, fig. 2, or iii. pl. B, fig. 1 opp. p. 187.

[5] *Antiquity*, vi. 163, fig. 3.

(Pl. VI a) tell the same story, but why call them fish-tailed? They are the dove-like forms, familiar on Roman brooches, that in due course appear on the Sarre and Howletts brooches, and for that reason, though the decoration is puzzling, the Basingstoke[1] escutcheons bring their simple-rimmed bowl to its proper position in the scheme of things.[2]

It is not difficult, with so many examples of late Gallo-Roman art in mind, to realize whence the British native was drawing a great part of the inspiration that resulted in the decorative patterns employed on the enamelled bowls. In the Romanizing class we have on the one hand the *pelta*, a legacy from the time of the Roman occupation itself, when the fourfold arrangement of the device is common enough, and on the other hand the running spiral, as on one of the Dover pieces,[3] on the Mildenhall bowl,[4] and on the latest discovery at Baginton,[5] Warwickshire (Pl. VI c). Here we have the running spiral treated purely in the linear style, while on the other three it appears in more developed form, approaching closely to that of the north British school of Celtic art. The Dover escutcheon just mentioned, as also those of the Mildenhall bowl, has a central device that seems to defy interpretation, though in the latter it seems to recall the *pelta*. Some indication of the relative date of certain pieces can be obtained from the shape of the hooks. Those of the Dover escutcheons are clearly descended from the Faversham piece noticed above, and so bring the leaflet and swastika-like elements in the main design of the disk into line with the Romanizing series, at the same time linking up the examples so decorated with those bearing an openwork *pelta*, the bowls from Wilton and Tummel Bridge.[6]

[1] *Proc. Soc. Ant.* xxii. 83, fig. 22.
[2] It should here, however, be remarked that the fragments out of which the bowl figured in *Proc. Soc. Ant.* xxii was reconstructed include pieces of two bowls. The larger pieces belong to the type with simple rim and probably are those to which the escutcheons belong. But with them is also preserved a single piece of a doubled rim, such as belongs to Mr. Kendrick's more developed class.
[3] Ibid. 76, fig. 9. [4] Ibid. 75, fig. 5. [5] *Antiquities Journ.* xv. 1.
[6] E. T. Leeds, *Celtic Ornament in Britain down to A.D. 700*, fig. 37.

Again, the Baginton bowl gives a further lead, since the leaflet thereon occupies only a subsidiary role to the running scroll, which, as appears from the print on the bottom of the bowl, is well on the way to the full swelling of the terminals that signalizes the fully developed trumpet-scroll. The print is interesting for more than one reason. It bears also as a central motif that employed on the bowl from grave 205 at Kingston, Kent, while at the same time the treatment of the scrolls around it is an improvement on that of the disk from the Londesborough collection,[1] and apparently, if I interpret correctly the inadequate illustration, on the bowl from Needham Market, Suffolk.[2] Its chief interest, however, lies in its central design, the basis of which is a hexafoil motif, described by the name 'Marigold' in a recent paper by Mr. A. W. Clapham. He there discusses its appearance on Irish grave-crosses, none of which are considered to antedate the middle of the seventh century.[3] He adds that the dating is merely a matter of opinion and is supported by no evidence. He suggests that the device, which is commonly found in Spain, Portugal, and southern France between the fourth and seventh centuries, and which may be regarded as the most characteristic feature of Visigothic art, was imported into Ireland by migrant alumni of Bordeaux from the beginning of the fifth century. It may well be so, but in view of the hesitation shown towards assigning the Irish crosses to a period, say, as early as the fifth or sixth century, it seems hardly necessary to go so far afield. For Mr. Clapham agrees that the trumpet-spiral 'had been at home in England for at least a century and perhaps two before the Book of Lindisfarne was written'. Nothing like it, however, appears in the early manuscripts of the continental monasteries[4] and, inasmuch as Irish Christian art was active in the earlier part of the seventh century, when Irish missionaries were founding monasteries like Luxeuil and Bobbio about A.D. 600, had the trumpet spiral formed an

[1] *Catalogue, Londesborough Collection*, p. 20, no. 59, now in the British Museum.

[2] *Reliquary and Illustrated Archaeologist*, vi. 245, fig. 4.

[3] *Antiquity*, vii. 48. [4] Loc. cit., p. 52.

integral part of that art, it must have found its way into those manuscripts.

The Baginton bowl presents the identical marigold, as it appears on the Irish crosses, and since the trumpet spiral soon begins to appear upon them also, both motifs can have been taken over almost simultaneously from the Celtic school in Britain. The marigold is exactly the type of pattern that would find its way into the pattern-book of the Romanizing phase of that school. There is a fine, undated example of it on an enamelled disk preserved in the Romano-British Room in the British Museum, and it is repeated on a buckle from the warrior's grave at Vermand (Pl. IV), and again on a bone or ivory roundel from a casket, more probably of Roman than of Merovingian fabric, found at Séry-les-Mézières, Dept. Aisne.[1] It occurs, too, on a Dover escutcheon[2] and in a quatrefoil form on one from Faversham, and in a modified form of the last on one of those from grave 205 at Kingston, on a pewter brooch from York,[3] and most strikingly on the very Celtic-looking bronze-topped lead weight with 'fill-ups' of triple knots from Mildenhall, Suffolk (Pl. VI b).[4] More remarkable is the fact that it is one of the patterns that was really taken up by the Saxons from the native. In Saxon art the five-pointed star is so common that a variation like that on a saucer-brooch from Duston with six arms looks as if it had been derived from the same Romanizing source that unquestionably supplied the Solomon's seal motif on a pair of similar brooches from Mitcham in the London Museum. Here, again, we can turn to the warrior's grave at Vermand[5] and the fitting that displays one of the best examples of the hippocamp as described earlier in the chapter. But the hexafoil actually needs no support from the five-pointed star; it is taken over like the rest, for it occurs on saucer-brooches from Bidford-on-Avon and Kempston, with no chip-carving

[1] Pilloy, i. 81, and unnumbered plate. [2] *Antiquity*, vi. 1695, fig. 5.
[3] *V.C.H. Yorkshire*, ii. col. front. no. 16. [4] *V.C.H. Suffolk*, i. 345, fig. 12.
[5] Loc. cit., fig. 7. The Mitcham use of this pattern may, however, have come viâ north Germany; see F. Roeder, 'Neue Funde auf kontinental-sächsischen Friedhöfe der Völkerwanderungszeit' (*Anglia*, Bd. 57), Taf. xvi.

facets like those of the Duston piece to confuse it with the ordinary star-design.

Looking once more at the escutcheons, we find further evidence of a native background to motifs eventually employed in Anglo-Saxon art. On two Dover pieces the centre is occupied by a swastika-like design. While it seems indubitable that the *pelta* must, as Mr. Kendrick maintains, have played an important part in the evolution of the interlocked scrolls that adorn many of the escutcheons and form so outstanding a feature of the early manuscripts and of Irish art in all its expressions, it may nevertheless be questioned whether the initial steps that led to the construction of these complicated designs are not based upon a motif like that employed upon the two Dover escutcheons. In Fig. 2 I have collected together examples of the dominant element in the ornamentation of several of the escutcheons; the gradual evolution will be readily appreciated in those in which the quadruple treatment is retained. Even on the first Barrington piece the spiral scrolls are simply an enlargement and an elaboration of the spot at the ends of the arms of the swastika on those from Dover and Northumberland; and, if the presence of the leaflets between the arms on the second Dover escutcheon be held in mind, it becomes easy to account for its presence in the subsidiary arms with which the craftsman proceeded to link up the spiral ends with one another externally. The subsequent introduction of the leaflet into wider portions of other parts of the design in the more developed examples is in the natural order of a pattern's growth. When the Celtic artist discarded the quadruple for the triple concept there is no absolutely radical change; the necessary filling of the space is attained by duplicating the arms, but in a reverse direction. Compare in this respect the identical Winchester and second Barrington pieces; the secondary elements are lightly indicated in the former, and drawn in full in the latter.

It was through the swastika with its spot-finials that the zoomorphic treatment of other specimens was reached. The spot made a natural appeal as a possible eye, as can clearly be seen on the Barlaston escutcheon, when the design is stripped of its

secondary elements (Fig. 2), and it becomes more than probable that through such semi-Romanizing pieces as this can be traced such an example as that illustrated from a Saxon saucer-brooch from Broughton Poggs, Oxfordshire,[1] especially as it is enclosed

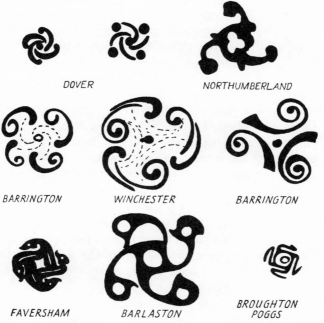

DOVER NORTHUMBERLAND

BARRINGTON WINCHESTER BARRINGTON

FAVERSHAM BARLASTON BROUGHTON POGGS

FIG. 2. Swastika elements in designs on escutcheons of bowls ($\frac{1}{1}$).

in a classical egg-and-tongue border. Thus we obtain a clear lead to the whole group of saucer-brooches, beginning with examples on which can be traced the gradual transformation of the arms of the swastika into animal legs, until finally the design becomes a whirligig of legs around a central boss.[2]

It is particularly in the south-eastern counties that this

[1] *Proc. Soc. Ant.* i S., iv. 73, fig.

[2] *Archaeologia*, lxiii. 172, fig. 11. The swastika occurs, it is true, in north Germany (F. Roeder, 'Neue Funde', Taf. xvi), but there, too, was borrowed with other elements and motifs from the same provincial Roman source that had long supplied Britain. The Saxons were bringing no new thing with them, but could find it here ready-made.

classical substratum is to be detected among Anglo-Saxon finds, so much so that it raises a doubt whether other objects beside the pieces already examined have any right to be regarded as Anglo-Saxon at all. About some there can be no question whatever. Such are the buckle from Gilton (grave 11)[1] or the openwork plate from grave 41 in the same cemetery,[2] or, even more interesting, two silver-plated iron belt-mounts from Alfriston.[3] One of them from grave 20, which contained a square bronze plaque with fourfold pattern based upon the *pelta*[4] that must be responsible for the fourfold mask device used on a saucer-brooch from Croydon,[5] in spite of its corroded condition still allows a running ivy-pattern in purely classical taste to be detected. The other from grave 24 is better preserved, and has round a trellis-work middle a border of vines with birds pecking at the bunches of grapes, such as would call for less surprise perhaps at the end of the seventh century, in the days of the Bewcastle and Ruthwell crosses and of the Ormside cup, but is unexpected in a pagan grave of the sixth century. It too belongs, however, to a sub-classical period preceding the invasions, and does not stand alone in that respect; for the same decoration appears round the bottom of the wall of the bronze box, a manifest piece of loot, buried with a Saxon warrior at Strood, Kent (Fig. 3).[6]

The ornament on these pieces has its counterparts in a whole series of products of late classical art. These are so universal in their diffusion throughout the Roman world that, even though occasional traits convey a definite atmosphere, Syrian, Egyptian, or Gallic, attempts to localize them demand extreme caution. No better example can be cited than the group of helmets that includes those from St. Vid, Dalmatia, Giulianova, Picenum, and others from Germany (Gammertingen and Gültingen) and France (Baldenheim, Châlons-sur-Saône, and Vézeronce).[7] All

[1] B. Faussett, *Inventorium Sepulchrale*, 29, pl. VIII. 11.

[2] Ibid. 15, pl. VIII. 7. [3] *Sussex Archaeological Collection*, lvii, pl. XXIX.

[4] Ibid. lvi, pl. XI. Cp. on bronze plaques for coffers. *Annales de Soc. Arch. de Namur*, vi. 365, pl. V.

[5] *Proc. Soc. Ant.* xv. 332. [6] *Collectanea Antiqua*, ii. 158, pl. XXXVI.

[7] J. W. Gröbbels, *Der Reihengräberfund von Gammertingen*.

save that from Châlons have on the band surrounding the fore-
head a narrow strip embossed with birds among vines or
arcades with pendent bunches of grapes, together with other
motifs that do not affect the immediate argument (Fig. 4).
These helmets, it is true, are now regarded as products of an
east European school working for semi-barbarian customers,
who carried them—it is suggested that their owners may have
been the Alans—in their migratory campaigns westwards; but,

Fig. 3. Bronze casket: Strood, Kent

as Henning rightly remarks,[1] their decoration contains much
that is common to the art of the late fourth and fifth centuries,
and that is the element with which we are here concerned, not
those more exotic features by which the immediate origin of the
helmets can be more nearly judged.

In some cases, even on the helmets, the treatment of the vine
and other decoration is more sophisticated than on others, but
it is admitted that they all belong to one class and to one period,
and that more probably fifth century than sixth, in spite of
the fact that one or two of them have been found in graves of
the latter century. The same general style can be seen in the
Ravenna school of carving, and on the extensive series of
Christian sarcophagi in southern Gaul

What remains certain amid a world of conjecture is the fact

[1] *Bull. de la Soc. Cons. Mon. hist. d'Alsace*, 11e série, xxi. 267 ff.

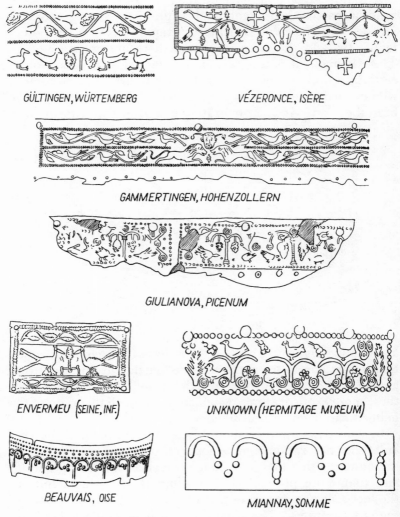

GÜLTINGEN, WÜRTEMBERG

VÉZERONCE, ISÈRE

GAMMERTINGEN, HOHENZOLLERN

GIULIANOVA, PICENUM

ENVERMEU (SEINE, INF.)

UNKNOWN (HERMITAGE MUSEUM)

BEAUVAIS, OISE

MIANNAY, SOMME

FIG. 4 Late classical ornament on helmets, buckets, &c.

that as a style it was so firmly rooted in the west that even the great migrations could not eradicate it, and so it crops up in various forms and survivals. Generally speaking, however, in the west it is only as survivals, which implies that objects on which the decoration appears in purer form antedate the sixth century and therefore in England belong to the age before the invasions. Such, clearly, are the plates from Alfriston, with which may be compared that from Envermeu, Normandy (Fig. 4).[1] The Long Wittenham stoup may be later, though its parallels abroad strongly suggest that it is not of Anglo-Saxon manufacture, but an import.

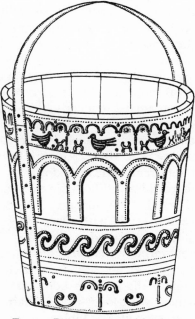

The process of dissolution and adaptation that these designs underwent in Frankish art strengthens the assumption of their having suffered by unintelligent imitation, devoid of any conception of their meaning, rather than by the mere carelessness of traditional reproduction by descendants of Romano-Gallic stock.

FIG. 5. Bronze mounted bucket, Buire-sur-l'Ancre: detail

This seems to be indicated by the use of elements in the designs disintegrated in a manner similar to that observable in the progress of early Germanic zoomorphic ornament. It is well illustrated by several of the bronze-bound Merovingian buckets (Beauvais, Buire-sur-l'Ancre, Miannay (Figs. 4–5), and Marchélepot),[2] where the curious mingling of arcades and vines

[1] L'Abbé Cochet, *La Normandie Souterraine*, 345, pl. XII. 4.
[2] C. Boulanger, *Le Cimitière Franco-Mérovingien et Carolingien de Marchélépot, Somme*, 116–23, figs. 127–30 and pl. XVII.

gradually fades away into a series of arcs with three dots at their points of juncture, and this is all that is left in England, on the bands of buckets from Faversham[1] and Howletts[2] and also, though rarely, on the flat, annular brooches, from which we started our present examination of the material.

Viewed from the standpoint I have endeavoured to establish, the pieces described above tell their own story sufficiently well. Nevertheless, any additional evidence that may serve to clinch the matter must be welcome. Such it has been my fortune to discover during a visit to Bifrons House[3] for the purpose of examining afresh the collection upon which Baldwin Brown laid great emphasis, for reasons to which I shall return later. One object affixed to a card and photographed by him seems to have escaped his notice. Below a disfiguring coat of rust I was able to detect a design which I felt certain would yield to expert treatment. The trustees of the Conyngham Estate kindly allowed me to remove it to Oxford, where Mr. W. H. Young's skill has more than fulfilled my expectations. The hoop of the buckle (Pl. VII *b*), for such is the object in question, has proved to have been overlaid with silver wires hammered into a trellis-pattern of grooves scored in the iron.[4] It is, however, in the plate and counterplate that the chief interest lies. Both are overlaid with a repoussé silver plate secured by rivets at each corner. The design, the same in both cases, shows a full-face half-figure of a man with long, curling hair and hands upraised, wearing a patterned cloak. On each side is a leaping lion, over its back a bird, and below its belly a deer or lamb. The human figure cuts both the upper and lower borders, the latter of which is filled with a running spiral design, while in the upper is perhaps one of the best self-advertisements of antiquity, a Latin inscription reading VIVAT Q VI FECIT, 'Long live the man who made (me)'.[5] The workmanship, in spite of this self-eulogy, is

[1] B.M. 69/10–11/17. [2] A. E. Relph Collection.

[3] By kind invitation of the Hon. Mrs. Talbot.

[4] The Relph Collection from Howletts includes two other buckles decorated in the same technique.

[5] Cp. on a buckle from Mont-de-Hermès, cited by Sir Martin Conway (*Proc. Soc. Ant.* xxx. 64).

crude enough, but it cannot be Saxon. It is surely an import, and pre-Saxon at that: the more certainly so by reason of the design, which can unhesitatingly be interpreted as Daniel in the lions' den. The motif appears very commonly in later Frankish art, especially on huge bronze buckles of the seventh century, but it is a legacy from Gallo-Roman times, derived in all probability, as Sir Martin Conway has shown, from the Near East.[1]

It occurs frequently on Christian sarcophagi in France, usually portrayed in good classical style. But amongst these sarcophagi is found debased workmanship which has preserved a classical tradition without the ability to reproduce it. A good example is that from Charenton-sur-Cher figured by le Blant[2] (Pl. VII a).

The buckle-maker has gone yet farther. Though his Latinity is equal to the occasion, his art is poor, and in addition he has combined more than one idea in his design. Daniel and the two lions are perfectly congruous, but the birds would seem to be 'fill-ups' borrowed from the common motif of confronted birds, doves or peacocks, with a chalice or vase or Christian symbol between them, as on many sarcophagi. An English parallel is to be seen on the buckle from Stanwick, Yorkshire (Fig. 6),[3] a buckle which Mr. Reginald Smith rightly compares with one associated with the admittedly early find from Dorchester, Oxfordshire.[4] The smaller animals on the Bifrons buckle are less easy to explain, but in all we have a product of the latest pre-Saxon period, and probably, by reason of the 'tausia' technique, one of continental workmanship.

[1] Ibid. 63 ff. [2] *Les Sarcophages chrétiens de la Gaule*, pl. xv.
[3] B.M. *Anglo-Saxon Guide*, fig. 108.
[4] See my *Archaeology of the Anglo-Saxon Settlements*, fig. 8.

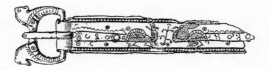

FIG. 6. Bronze buckle, Stanwick, N. Riding, Yorks ($\frac{3}{4}$)

II

THE INVADERS; LIFE AND DEATH

IT is against the background sketched in my first chapter that we have to picture the invasions of the Anglo-Saxons. We have to bear in mind that the main body of the new-comers were migrants from a region which, to judge from the remains recovered from numerous large cemeteries along the coast from Holland to the Cimbric peninsula, cannot be regarded as having attained a high level of culture, in spite of, or rather by reason of, the consistent antagonism of its inhabitants to Roman civilization. Something, it is true, they had taken from that source, but it is meagre in comparison with that which their more northerly neighbours in Denmark and Scandinavia had absorbed by way of commerce. The Anglo-Saxon invaders before and at the time of their migration were, comparatively speaking, an impoverished people, a race of pirates carrying on the traditions of Carausius' day, who, after continued checks at the hands of Valentinian II and others in the closing years of Roman rule in Britain, at length obtained a permanent foothold in this island. At what point their first success was accomplished is uncertain. The annals would place it in Kent, but to read between the lines of earlier history it is practically certain that their chief inroads were at first directed to the shores stretching from the north to the Wash, more particularly in the neighbourhood of the Humber, whence they must soon have penetrated to York. The defences of the Saxon shore farther south may still have offered some deterrent to invasion, since Hengist comes at first by invitation to aid the Britons in repelling the Picts and Scots, and the Hallelujah victory shows at least that raids had already been made on the south from a northern quarter.

In course of time, as they established themselves in more settled conditions, signs are not wanting that the immigrants developed a greater well-being and a material culture that, compared in some respects with that of their homeland, might

be regarded as relatively luxurious, but in others it is equally certain that they retained many of their primitive habits, those of a people essentially of a simple agricultural stock. Nothing demonstrates this more clearly than the rude nature of their dwellings. Before 1922 little or nothing was known of these, though they had assuredly been encountered without their true character having been recognized. Even now the number that has been explored is so small, compared with the extensive area over which the invaders established their hegemony, that it may seem unfair to generalize from such meagre material. The evidence is, however, slowly accumulating, and so far nothing has come to light to suggest that the class of dwelling already discovered is not typical. Some day a more exalted variety may be found, corresponding in some measure to the hall of Heorot described in *Beowulf*, but even should that prove to represent a truer picture of the dwellings of chieftains and the like, some allowance must be made for poetic licence, and it may be doubted whether at its highest the Saxon hall was any better than the simple farmstead from Salling, south Jutland, now installed in the open-air museum at Lyngby outside Copenhagen[1] (Fig. 7). For the bulk of the people, we can now be assured, were content with something that hardly deserves a better title than that of a hovel, only varying in its greater or lesser simplicity, Such now have been explored in Suffolk (West Road) and Cambridgeshire (Waterbeach),[2] Huntingdonshire (Orton and St. Neots),[3] Gloucestershire (Bourton-on-the-Water),[4] Oxfordshire (Cassington),[5] and Berkshire (Sutton Courtenay[6] and Radley), and in every case they have proved to be of the same primitive type. An excavation of varying size was made into the ground to an average depth of $1\frac{1}{2}$ to 2 feet, with a preference for a gravel floor where this was procurable

[1] *Frilands museet ved Lyngby*, p. 41.
[2] *Cambridge Antiquarian Soc. Comm.* xxxiii. 133; *Antiquaries Journal*, vii. 141.
[3] T. D. Kendrick and C. F. Hawkes, *Archaeology in England and Wales 1914–31*, p. 323.
[4] Ibid. and *Antiquaries Journ.* xii. 284.
[5] *Congress of Archaeological Societies, Report for 1934*, p. 28.
[6] *Archaeologia*, lxxiii. 147 and lxxvi. 59.

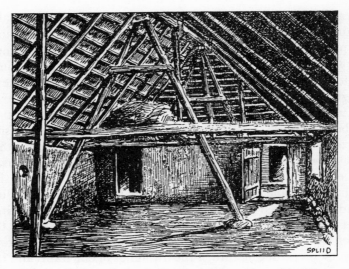

FIG. 7. Salling, Jutland: interior construction of building

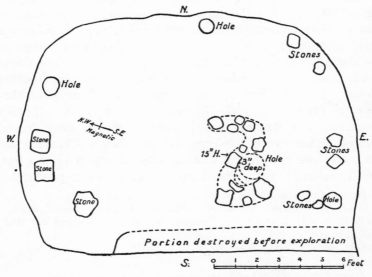

FIG. 8. Sutton Courtenay, Berks: plan of House VI

(Figs. 8 and 9). Above this was erected a gabled superstructure supported either by slanting poles secured to a ridge-pole, as at

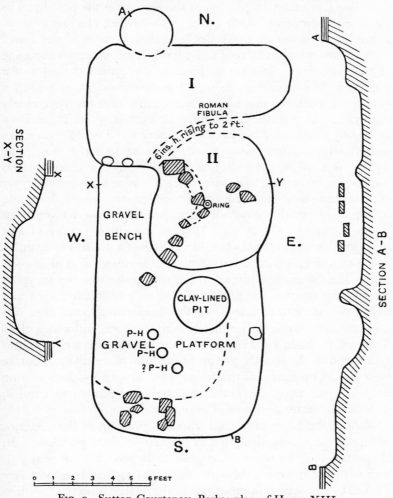

FIG. 9. Sutton Courtenay, Berks: plan of House XIII

Bourton-on-the-Water, or to a ridge-tree proper borne on a pole inserted some 2 feet into the gravel at either end of the excavation, either in the floor itself or in a recess cut into the

bank, as was frequently the case at Sutton Courtenay. In one instance an interesting discovery suggests a practice of safe-guarding the house, by placing at the bottom of the post-holes in the one the fore-feet, in the other the hind-feet, of a dog or wolf. From the position of the holes intended to receive the lower ends of the rafters, the roof must have come down to the edge of the excavation, leaving no head-room against the sides of a mere tent-like structure, so that the accommodation within a cottage or a cabin, some 12 feet by 10, must have been extremely cramped. At Sutton Courtenay, in examples no more than 10 feet by 8, it must have been even more so. The floors of more ambitious buildings have, however, come to light. One $17\frac{1}{2}$ by $10\frac{1}{2}$ feet might even suggest a local hall, but there was no means of interpreting its nature, since it was perhaps more empty of relics than any explored, and the absence of post-holes made it impossible to diagnose what its character would have been when complete. Of another (Fig. 9) measuring 21 by 11 feet it is possible to form a better idea. It has a small rectangular space at one end with a narrower area leading off it along one side of the dwelling, while the other side and end were occupied by raised platforms, the gravel having only been excavated to a depth of 1 instead of 2 feet. In the deeper, narrower area was a hearth, and cut into the platform at its south end was a clay-lined pit, perhaps a slaking tank. This and the iron scoriae found lying around the hearth give an impression of a smithy. Scoriae were found on many of the floors, so that as nowadays among Scandinavian peoples every man may have been his own smith, at least for many purposes of everyday life.

Most of the floors produced traces of a hearth in the presence of large stones, sometimes found in their original position. In shape the hearths were circular or S-shaped (Figs. 8 and 10), and with them were associated not only large cooking-pots (see Pl. VIII *b*) but also numerous pot-boilers, large quartzite pebbles usually reddened by heat. In one or two cases additional culinary accommodation seems to have been provided in the form of pits outside the house itself, as in Sutton Courtenay VII.[1] Such

[1] *Archaeologia*, lxxiii. 163.

was certainly true of the most ambitious dwelling out of thirty examined at Sutton Courtenay.[1] This was a house with two rooms, disposed in such a manner that two corners intersected, leaving a communicating doorway from one to another. Closely adjacent was a large circular excavation that must have been

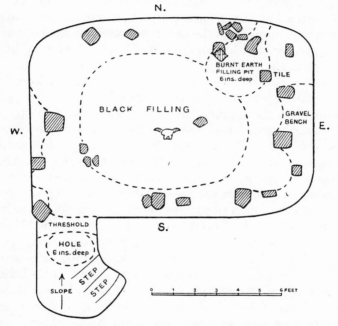

FIG. 10. Sutton Courtenay, plan of House XII

connected with it by a hatch or some such means, and this pit appeared to have been used for cooking, while the other rooms served as living-rooms. Of these the one was provedly constructed rather later than the other, and had a small hearth installed within it, while on the floor of the first was buried, beneath a thick covering of clay, a man in the prime of life furnished with a comb and knife. A brooch belonging to the woman, unquestionably imported from the region between Elbe and Weser, was found behind the post-hole of the adjoining room.

[1] Ibid. 167.

In such cabins, with bare head-room, amid a filthy litter of broken bones, of food and shattered pottery, with logs or planks raised on stones for their seats or couches (Fig. 10), lived the Anglo-Saxons. The fact that the house described above represents the most pretentious effort among thirty hardly leaves hope that at first even the chieftains could provide themselves with much greater comfort or luxury; though discoveries in Kent, a district that throughout the pagan period shows signs of having enjoyed greater wealth than the rest of England, might produce a more pleasing picture.

To add to the crowded conditions of these huts, we have some evidence of the presence of looms of upright type, about $4\frac{1}{2}$ feet in width, with their posts driven into the floor, and opposite them a large stone placed conveniently as a seat for the weaver against the side of the excavation,[1] and lying near the posts baked clay-rings for use as weights for the warp (Pl. IX b). One floor at Sutton Courtenay produced fourteen examples, some lying in line with the position of the presumptive loom; at Cassington ten such rings were found packed closely together on edge, as if they had been strung upon a pole (Pl. IX a).

Amid the litter upon the floor have been found iron implements, knives, chisels, awls, saws, a flax-hackle, a cow-bell, nails, &c.; broken combs, perforated pins, and small heddle-sticks of bone; spindle-whorls of bone, clay, and pieces of Roman pottery; pieces of decorated bone, cut antler and bone, besides broken pots capable of restoration, and casual sherds. And that these dwellings were those of the people whose cemeteries have so frequently been explored is proved by occasional discovery of bronze brooches (for example, a disk-brooch at Cassington, Oxfordshire, which along with the knives and combs are among the commoner accompaniments of the dead.

But amid all the evidence of comparative squalor and discomfort one relieving feature may possibly be indicated by a construction of an unusual kind found at Sutton Courtenay. It consisted of an exceptionally large and deep excavation in the gravel (Fig. 11). Owing to a collapse of the sides, which were

[1] *Archaeologia*, lxxvi. 75; *Antiquaries Journ.* xii. 286.

$7\frac{1}{2}$ feet in height, an exact computation of its area was impossible, but on a rough calculation it was estimated to be from 14 to 16 feet square. At about 2 feet below the surface there were

FIG. 11. Sutton Courtenay: plan and section of House XXI

indications of the former presence of a large beam stretching across the middle of the pit, and since at this same level a small recess in the gravel wall at one corner contained remains of a small hearth, the building appears to have had two stories, recalling the description of the *subterranei specus* of Tacitus' *Germania*. This arrangement would give some $4\frac{1}{2}$ to 5 feet of

head-room below, where was found a large mass of clay spread by pressure of the material filling the pit over a low, oval hurdle-work, 1 foot high, 5 feet long, and 2½ feet wide, of alder-rods woven round short oak stakes driven into the gravel (Pl. VIII*a*). The top of the clay was mixed with pebbles; below were three successive layers of clay thickly impregnated with charcoal. At one side of the hurdle-work an oak log, 4 feet long, hewn flat on its upper side, was held in position by three sharpened stakes driven into the gravel. Resting on the clay were the remains of a large cooking-pot (Pl. VIII *b*). Here again the meagreness of the finds compared with those of ordinary hut-floors, and coupled with the elaborate nature of the hearth, seems on the one hand to exclude a mere dwelling furnished with a basement-room and on the other to allow of the suggestion of a steam-bath such as is well known in Scandinavia and other northern latitudes.

There is, however, another, and humbler, explanation for this discovery. Recently at Dorchester, Oxfordshire, there came to light at the base of a large pit, 8 feet deep into the gravel, a low circular wall, containing a ring of staves secured at their base to a square, mortised framework. Within the staves was a mass of clay, as at Sutton Courtenay, and its presence precluded at once the possibility that the construction at Dorchester was intended to serve as a dipping-well. All round the site large quantities of Roman pottery of all periods have been found, and quite close by also a pottery-kiln. Though this, as sherds recovered from it showed, was later in date than the stave-lined pit, this latter might well be interpreted as a puddling-pit for the clay for pots made on this site. It is possible, therefore, that at Sutton Courtenay not only in the hurdle-work and clay have we a Saxon equivalent of the Dorchester system, but that in the pit which contained it we have even got the potter's workshop itself.

But, if the incomers seem to have been indifferent to the ordinary amenities of life in their mode of habitation, they were by no means careless of the equipment of their persons, either with weapons in the case of the men or with jewellery of a simple kind in that of the women; and in the disposal of the

dead elaborate care was taken to ensure their passage to the future world with suitable gear, after either cremation or inhumation. Of the two rites cremation was with some very

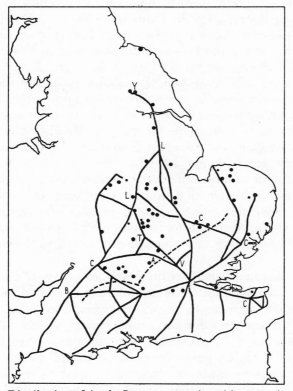

FIG. 12. Distribution of Anglo-Saxon cemeteries with cremation-burials

rare exceptions[1] the general practice in vogue amongst them before they quitted north Germany, and it is through the distribution of the cremation-cemeteries that some estimate can be formed of the direction, extent, and rapidity of the invaders' penetration of the country. A map of the larger known cemeteries (Fig. 12), in which cremation is the exclusive or

[1] Fr. Roeder, 'Neue Funde auf kontinental-sächsischen Friedhöfen der Völkerwanderungszeit', 8.

predominant rite employed, corroborates the view that a series of inroads from Yorkshire to Norfolk preceded those into the south-eastern counties, where evidence of the rite is relatively very scarce. These inroads bit deep and rapidly into the heart of the country, up the Humber to York, up the Trent to Burton-on-Trent, from the Wash into Lincolnshire, into the counties bordering the Fens and beyond them into Northamptonshire, and even as far west as Oxfordshire, Berkshire and Warwickshire. Evidence is now available to demonstrate that even in the midlands the rite began earlier and persisted longer than has hitherto been assumed to have been the case. The destruction of objects on the funeral pyre itself, or the want of careful observation of the often fragmentary remains of ornaments collected with the ashes into the vases in which these were placed or even inserted after the cremation, has deprived us of much evidence that would have been of inestimable value in determining the age of particular cemeteries. Even so the material available for examination is by no means insignificant, and it is widely enough distributed to deserve close study.

The cremation urns from the large cemeteries of the region between the Elbe and the Weser frequently contain miniature sets of toilet implements, shears, tweezers, and knife, usually made of bronze. In some cases the tweezers, which are in any event more normally made of bronze, as also is often the case in England, may be perfectly serviceable implements, but the knife and shears made of that metal must be regarded as models. As such they appear more than once in English urns. Complete sets, fashioned from strips of bronze, totally unpractical articles, are preserved from urns found at Sancton, Yorkshire, in the collections at Hull and Oxford, and from Frilford, Berkshire (Ashmolean). But in contrast to Germany, where, according to Baldwin Brown, they are invariably of bronze, in England they are frequently made of iron, e.g. a knife and shears in an urn from Waldringfield, Suffolk, are in the British Museum. Other such implements are known from Castle Acre, Norfolk, from Kettering, Northamptonshire, from

Girton, Cambridgeshire,[1] and from Long Wittenham[2] and Abingdon, Berkshire. The best-known example is the knife, tweezers, and shears from Eye, Suffolk,[3] found with a triangular comb, but the fullest evidence comes from the cemetery recently explored at Abingdon.[4] Here several sets, all made of iron, came to light, in several cases accompanied by miniature combs, some of them very pretty toys, others slightly larger, but with unserviceable teeth (Pl. X). These miniature combs, usually narrow forms with rounded butts, are uncommon, but parallels can be cited from Girton[5] and St. John's Cricket Ground, Cambridge, and from Bidford-on-Avon (urn 25).[6]

The form is an early one like that of triangular shape,[7] well known from Gallo-Roman graves, and consequently when encountered in an Anglo-Saxon context may well be regarded as indicative of an early date. An example with schematic teeth occurred at High Down, Sussex, corroborating the practice of cremation in that cemetery by the South Saxons already demonstrated by the instance cited in my *Archaeology of the Anglo-Saxon Settlements*[8] and by cremation-burials at Hassocks.

Some cemeteries like Little Wilbraham, Cambridgeshire, apparently show no trace of the practice of depositing model objects in the urns after cremation; there the dead were supplied with full-sized combs or fragments of such.[9] The significance of

[1] E. J. Hollingworth and M. M. O'Reilly, *The Anglo-Saxon Cemetery at Girton College, Cambridge*, 22–3.

[2] Model implements from urns v and ll are in the British Museum (*Archaeologia*, xxxviii. 342, fig.; xxxix. 139).

[3] J. Y. Akerman, *Pagan Saxondom*, 43, pl. xxii.

[4] E. T. Leeds and D. B. Harden, *The Anglo-Saxon Cemetery at Abingdon, Berkshire*, 24–7.

[5] Loc. cit., p. 27 and pl. v. 3, not necessarily Roman as there suggested.

[6] Stratford-on-Avon Museum. [7] Cp. loc. cit. pl. v. 4.

[8] p. 47. This case, a saucer-brooch, was stoutly denied by the late Sir Hercules Read, who published an account of the cemetery, in the face of my careful notes made while the collection was still at Ferring Grange in Mr. Henty's possession. On his death a large part was presented to Worthing Museum, where the brooch is to be seen bearing every sign of having been subjected to fierce heat and accompanied by its original label: 'Found inside a pot containing calcined bones, Oct. 27, 1900'.

[9] The Hon. R. Neville, *Saxon Obsequies*, 23.

this variation is difficult to gauge; possibly it is due to nothing more than local habit or to some difference in origin, for even at Little Wilbraham the combs deposited include a large proportion of early types.

It is impossible to assert that the urns containing the miniature implements are exclusively those of one sex.[1] Most naturally they would seem to indicate the burials of women. There is, however, plenty of evidence of the deposition of combs, tweezers, and the like with men, whereas the occurrence of arms in any form with cremation-interments in this country is extremely rare. A curious instance is a *francisca*, a weapon connected with the Franks rather than with the Anglo-Saxons, at so northerly a site as Saltburn-on-Sea; a spear-butt was found close by an urn at Abingdon.

Equally it is impossible to be absolutely certain about the age of a cemetery, merely because it has yielded cremations accompanied by these miniature implements. That they carry on a tradition of a continental practice is self-evident; that they therefore always indicate an early date must be regarded as non-proven. For illumination on that point it is necessary to look farther. Just as the relative date of a series of graves may be fairly deduced from the changes of fashion that can be detected in the women's gear deposited in them, so inferences of the same nature may be drawn about cremations, provided that a sufficiently large number of urns containing objects of an equally distinguishable kind are available for study.

At first sight the material would appear to be so scanty as to be almost negligible, but on closer inspection the museums up and down Anglo-Saxon England will be found to preserve objects, recovered from cremation-urns, that can be interpreted by the same standards which are applicable to their counterparts from inhumation-burials. These objects, when separated from the urns in which they were originally placed, can, of

[1] Fr. Roeder, op. cit., p. 6, describes the contents of an urn containing the cremated bones of a man. They were accompanied by bronze tweezers, shears, triangular comb, all in miniature, as well as a razor and part of a belt-plate (pls. II and VII).

course, be recognized only by the fact that they show traces of having, as Bryan Faussett would have put it, 'passed the fire'. There must be much else that would have been equally valuable, but unfortunately dissociation from the urns has largely destroyed its value, since it exhibits no traces of burning and must have been added to the urn after the collection of the ashes and their deposition therein. Some of the more telling examples are worthy of consideration, and here it must at once be said that it is mainly the wide range of brooch-types associated with cremations that serves to establish the persistence of the rite down to the beginning of the seventh century and in a few cases beyond.

For the beginning of things only a few examples can be cited. From Castle Acre, Norfolk, there is a group of badly twisted bronze that includes an early cruciform brooch; at Northampton there is preserved a fragment of another from Kettering of rather larger size and apparently of a more advanced type; the Girton cemetery has produced others.[1] The most distinctive early piece comes from still farther inland. The distribution of the characteristic north German equal-armed brooch in England has often been noted, ranging as it does from Cambridgeshire (Haslingfield and Little Wilbraham) to Kempston, Bedford-shire, and beyond, as far west as Sutton Courtenay, Berkshire, the last, as already noted, obtained from a dwelling containing a burial in the room adjoining that in which the brooch was found. Like this last, all the others cited, so far as is known, accompanied inhumation-burials, though it is always possible that one or more of them was originally placed in an urn after deposition of the ashes. In 1934, however, the evidence of such association was secured at a distance of little more than a mile from the Sutton Courtenay site in the large cemetery on Calde-cote Farm immediately south of Abingdon.[2] Here, with other fragments of bronze, early in point of style, one of them an object of uncertain nature decorated with openwork mouldings similar to those of a buckle-plate from Sarre, Kent,[3] a piece to which close analogues are known from the Gallo-Roman or

[1] Loc. cit., p. 26. [2] E. T. Leeds and D. B. Harden, op. cit., 16, Pl. iv b.
[3] *Archaeologia Cantiana*, vi. 174.

early Frankish cemeteries in the Aisne region of France, was a large portion of the bow and a small fragment of one of the arms of an equal-armed brooch dated according to Roeder's reckoning to *c.* A.D. 450, thus reinforcing the suggestion I have advanced in two papers[1] that weighty evidence exists to support an advance from the eastern counties reaching the Thames Valley by the beginning of the sixth century.

Evidence for the immediately succeeding period is more difficult to produce. Possibly the small square-headed brooches from urns at Little Wilbraham and Girton fall to be reckoned there; it is even not excluded that some are earlier specimens, since they, too, are known from the continental cemeteries of the invaders. But later the picture becomes clear once more. The most noteworthy proof, perhaps, comes again from Abingdon, namely, two pieces of a large square-headed brooch found in an undecorated vessel, itself not one of early form. This brooch has on examination proved to have been cast in the same mould as one from an inhumation-burial at Luton, Bedfordshire, where it was associated with a pair of saucer-brooches decorated with a degenerate version of a pattern employed on a saucer-brooch found in a second Abingdon urn, seemingly rather earlier than the other. The Luton pattern occurred in a cremation-urn at Bidford-on-Avon.[2] From Kettering,[3] again, we have part of the disk of an applied brooch ornamented with a design that is known from numerous examples with a widespread distribution from Cambridgeshire to Berkshire.[4] Further, there is the saucer-brooch from Marton,[5] near Rugby, Warwickshire, on which the Saxon artificer endeavoured to reproduce in casting the effect of a Kentish form of circular brooch with garnet settings that can safely be assigned to the latter part of the sixth century. Of later square-headed brooches there are more than one example, firstly, that from Little Wilbraham,[6] a second

[1] *History*, 1925, and *Antiquaries Journ.* xiii. 299 ff.
[2] *Archaeologia*, lxxiv. 284, no. 145, pl. LVIII, fig. 3 *b*.
[3] Northampton Museum.
[4] *Antiquaries Journ.* xiii. 243 type (1).
[5] *Archaeologia*, lxiii. 192, pl. XXVIII. 5. [6] *Saxon Obsequies*, pl. 11.

from Brooke, Norfolk, in the British Museum, and a third, at the last stage in their evolution of which evidence has been preserved to us, from Girton, Cambridgeshire.[1]

Finally, there are remains from the richly appointed pyre in the barrow at Asthall, Oxfordshire,[2] amongst which was a fragmentary ornament decorated in a style that belongs to the late sixth or, more probably so far as England is concerned, to the early seventh century, a date supported by traces of an associated Coptic bowl. These bowls, assigned by some to the fourth or fifth century, have recently been proved to belong rather to the late sixth or seventh, as had already been more than forcibly indicated by their occurrence in Lombard graves in Italy, which would hardly allow them to be dated before A.D. 568.

This survey affords an admirable idea of the stubbornness with which the older burial rite died. For the gap, typologically speaking, between the Abingdon equal-armed brooch and the Girton square-headed piece is almost as wide as can possibly be conceived within the range of fashion and style illustrated by Anglo-Saxon remains recovered from pagan cemeteries, and the gap is a valid measure of the historical time that elapsed between the deposition of the two pieces.

The plea of heirlooms, often advanced against the value of the typological method for fixing the relative dates of Anglo-Saxon objects, loses all meaning in the face of the numerous associations in grave groups, more especially as by far the greater number of the graves in any given cemetery yield ornaments of the humblest kind, that must represent the entire wealth of a single member of a community not richly endowed with worldly possessions. It is just when some more richly furnished grave comes to light that the associated objects contained therein support the reliability of the method. The evolution in the form of the cruciform brooch, for example, is self-evident, and a grave like that discovered by Mr. Lethbridge at Holywell Row, Suffolk,[3]

[1] C. Fox, *The Archaeology of the Cambridge Region*, pl. xxxv. 2.
[2] *Antiquaries Journ.* iv. 113.
[3] *Cambridge Antiquarian Society, Quarto Publications*, N.S. iii. p. 35, fig. 6.

with its unusual quantity of jewellery associated with a very old woman, unquestionably indicates the range of types that, given the necessary wealth and length of years, it was possible for such a woman to acquire. Even if it be granted that some pieces might have been handed down from one generation to another, there is one point that has to be borne in mind. Some cemeteries contain no cremation-burials at all, but at the same time yield a strikingly large proportion of inhumations devoid of any equipment whatever, while in the remainder the objects are never of early types. Such cemeteries show that the settlement at that place was established late, but they evidently did not fall into disuse until the influences of Christianity had long made themselves felt. Of some twenty graves explored at Chadlington, Oxfordshire, only two contained more than a knife, and most had not even that, while at Camerton, Somerset, out of more than a hundred graves only some fifteen yielded objects of any significance, and those, as will be shown later, all of demonstrably late character. Between the initial cremation period and the close of the pagan cemeteries there can at an outside estimate be about two hundred and fifty years to fill, and the range and variety of the material from Anglo-Saxon cemeteries can, if we assume a normal death-rate, only be explained by postulating members of a community closely following the fashion of their own particular day.

If the distribution of the settlements attested by the discovery of their cemeteries be viewed in the light of these considerations, the picture of the invasions so presented takes on a somewhat different aspect from that portrayed by the historical accounts. The distribution of cremation-cemeteries, even allowing for some long survival of the rite, gives a clear indication of the depth to which the invasions had penetrated by the middle of the sixth century. In the northern counties the opposition of the native British seems to have checked any advance west of a line running northward from the Trent from its bend at Nottingham and from the Humber along the Roman road to York and onward to the Tyne. Farther southward a deeper thrust was made up the Trent to the neighbourhood of Lichfield,

and south of this again into the whole of the midlands as far west as Warwickshire and the upper Thames Valley. That the settlements of the last-named region were established by way of the eastern counties, as I have suggested in the past, has received powerful corroboration from the evidence supplied by the recently explored cemetery at Abingdon. For, even though it was impossible to investigate more than one-half or two-thirds of the ground, a high proportion of cremations (82 to 119) cannot be interpreted otherwise than as confirming the evidence of early occupation already afforded by the well-known cemetery at Frilford only a short distance away.

On the other hand, as will be seen later, the apparent rarity of cremation in the lower Thames Valley, where no large cremation-cemetery like those of the northern or eastern counties has come to light, does seem to indicate that the trend of the invasions followed a gradual course from north to south. That there were other factors to account for the scarcity of cremation in Kent is certain, and will be the subject of subsequent inquiry, but with Sussex in mind it becomes almost self-evident that either the date assigned to the invasion of that district coincides with the definite relaxation of cremation in favour of inhumation, of which signs can be detected even in East Anglia and the eastern midlands, or the rarity of cremation must be ascribed to some cause still hidden from our ken. The discovery of some untouched cemetery may necessitate a fresh evaluation of the evidence, but as things are, cemeteries like those at High Down and Alfriston, with their large content of pre-invasion material, do suggest that in them we can approach very closely to the time when Aella and his men sacked Anderida and planted themselves on the southern slopes of the Downs.

There is one point in regard to cremation on which I have not touched as yet. It has been customary to give the various occupied areas the tribal significance that attaches to the names by which they were subsequently known. In a large measure this is due to Bede, who in his account of their origins correlates the English districts with others on the Continent. I do not

question the correctness of Bede's statements, so far as his own day was concerned. Indeed, archaeology is prepared to confirm his record for an even earlier period. But it is by no means certain that all the archaeological material brought to light, particularly in the eastern counties, is assignable to one element of the invaders rather than to another, and special caution is essential in dealing with cremation-cemeteries. Thus the predominance of these cemeteries in the *Anglian* territories has led to a preference for dubbing the pottery associated with them as 'Anglian'.

Objections to this particularism have impressed themselves upon my notice by two recent observations. The first is the results of the excavation of the cemetery at Abingdon. We have already seen that there was ample evidence of the practice of cremation in the centre of England, for example at Long Wittenham, Frilford, Brighthampton, Bidford-on-Avon, and Baginton, and in every case except the last it is associated with cemeteries which on all counts would be regarded as Saxon. In none of these cases, however, except Baginton, a Mercian cemetery, is the proportion of cremation to inhumation very large. At Abingdon it would seem to be otherwise. The proportion is 2 to 3 (the actual numbers recorded are 82 to 120), and both types of burial, irrespective of whether their associated relics were early or late in their class, were distributed in a seemingly haphazard manner throughout the area that could be explored. Again, no distinction, or very little, could be drawn in the relative age of such inhumations or cremations as could be fairly considered early. The Abingdon equal-armed brooch, if correctly diagnosed from the fragments, belongs to Roeder's Class 5 and is dated by him to ±450, while that from Sutton Courtenay is assigned to his Class 6 with a date ±475, to which date it is probably correct to assign an imperfect tutulus brooch of a special kind, decorated with running spiral or tendril ornament from a grave in the Abingdon cemetery. Clearly there is evidence of a thrust by Saxons right across country at an early stage, involving an inference that, if they entered England by the east coast, as I have maintained, they either gave East

Anglia, or at any rate Norfolk and northern Suffolk, a miss, or passed through them leaving that region to subsequent occupation by Bede's *Orientales Angli*. But is it certain that that was so? The small cruciform brooch of the Castle Acre cemetery could equally well have occurred in a Saxon cemetery, as is shown by a find at Westerwanna, the great cemetery of Hanover, that has yielded so many specimens of the equal-armed brooches.[1] Again, we have the more recently explored cremation cemetery at the top of a rise about $\frac{1}{4}$ mile east of Caister by Norwich.[2] The cemetery had, however, been known for many years before this scientific exploration was carried out, and urns had either been unearthed or destroyed in the course of rabbiting in the warren that had established itself on the site of the cemetery. Not only urns, but also a few relics. Among these was an almost flat disk, showing traces of having passed the fire (Pl. XI *b*). It is cast and decorated with a running spiral pattern around a pearled circlet containing a central boss or dot, heightened by chasing. On the border are still to be detected faint traces of spots, and diagonal and vertical lines. There can be no question as to what it was. It is the central element of a brooch that is regarded by Roeder as one of the initial stages alike of the English saucer and applied brooches. What is more, a specimen that is very nearly its double is illustrated by him from an urn from the same cemetery at Westerwanna (Pl. XI *a*).[3]

[1] F. Roeder, 'Typologisch-chronologische Studien zu Metallsachen der Völkerwanderungszeit' (*Jahrbuch des Provinzial-Museums Hannover* N.F. Bd. 5, 1930), Taf. VIII.

[2] Not yet published.

[3] F. Roeder, 'Neue Funde auf kontinental-sächsischen Friedhöfen der Völkerwanderungszeit' (*Anglia*, Bd. 57), Taf. XXIV.

Among chance finds collected by the Rev. J. Corbould-Warren, the owner of the site, this piece so aroused my interest that he very kindly asked my acceptance of it as a memento of a visit to see the rich series of urns unearthed by Commander Mann. Initially it was the pattern, so common in the Midlands and Sussex, that attracted my attention; not until later did I appreciate the full significance of the piece and so discover its likeness to the Westerwanna brooch, both in point of construction and ornament, particularly the former. The under edge of the disk is slightly bevelled, so that the

Evidence like the above may be slight, but it does seem to indicate that by intensive care hereafter in the examination of the contents of the urns the problem of the relative part played by what we know as Angles and Saxons both historically and archaeologically may be brought nearer to its solution.

rim, a separate element (see Roeder's illustrations, Taf. xxiv and xxv), when affixed to it received a corresponding tilt, the feature from which the whole class derived its name.

III

THE KENTISH PROBLEM

ON the occasion of the International Congress of Prehistoric and Protohistoric Sciences held in London in August 1932, Mr. T. D. Kendrick startled the archaeological world by advancing a novel and revolutionary hypothesis in regard to Kentish jewellery.[1] Briefly, he maintained that certain recognized masterpieces found in Kentish graves of the early Anglo-Saxon period were the work of purely British craftsmen, inspired by continental cloison jewellery of the fifth and early sixth centuries, and that the Jutes could lay claim only to certain classes of jewels of a humbler and less intricate kind.

It was, in fact, an attempt to fill up the notorious gap in the art history of England during the period succeeding the withdrawal of Rome. The arguments marshalled by Mr. Kendrick in support of his theory are both ingenious and plausible, but they are too much so to succeed. For to picture a people, after a long period of subordination to a foreign culture, followed by a subsequent period of intense struggle ending in subjection to a second foreign power, as likely to possess the necessary impulses and background for the sudden development of a new and previously untried technical branch of the lapidary's and jeweller's craft, in a style totally divorced from all their inherited traditions, is to invite the student to indulge in a stretch of imagination that can only end in disaster.

The history of Celtic art—and a British art at that period must be Celtic—as it is known to us, with its amazing renaissance of long-cherished traditions evidenced firstly by enamel-work and subsequently by illumination, is in itself the best answer to Mr. Kendrick's theory. But if further answer is needed, it is to be found in the very material whose meaning he so curiously rearranged from its natural order to arrive at his theory of an epoch of Arthurian brilliance. In fact, it falls into a perfectly

[1] Since published in *Antiquity*, vii. 429 ff.

normal typological sequence along the lines followed by all students of the period in the past, and adopted, for example, by Dr. Nils Åberg in *The Anglo-Saxons in England*. Subjection of that sequence to a somewhat more intensive examination will serve to emphasize the wholly natural and uninterrupted course of development of the jeweller's craft in the Kentish workshops.

Let it be admitted that Mr. Kendrick's arguments derived from the history of the cloison technique on the Continent have at first sight a powerful claim to serious consideration. Nevertheless they assume that the introduction of the technique into England followed an absolutely consistent course, each continental change being succeeded by a similar and almost immediate change in this country. But such is not the case. Actually the first sight we have in Kent of the technique is in its very simplest form. From that stage it follows a course that can be paralleled more than once in Britain's art history, an insular evolution in which form and decoration, while adhering in some respects to continental models, strike out for themselves new and often improved lines.

My interpretation of the material I have added in an Appendix (p. 115).

If we leave the particular aspects of the problem as furnished by typology, and turn to more general consideration of the Kentish cemeteries and their contents, we realize at once how amply they serve to substantiate the normal interpretation of the evolution of Kentish jewellery. Obviously not all the settlements can have been established contemporaneously, but once established it is to be expected that they continued in existence throughout the pagan period and beyond. If so, however, it seems incontestable that in some cases their importance diminished as time progressed, the measure of that diminution being the absence of types that occur in a greater or lesser degree of plentifulness at other sites, where earlier material is more sparsely represented. The outstanding case is that of Bifrons, on the importance of which Professor Baldwin Brown laid particular emphasis. Here we have a cemetery entirely distinct from others like Kingston and Sibertswold in both the types and quality of

the objects discovered in its graves. It produced only one example of the Kentish circular jewelled brooch, and that of the earliest variant, while from it came an extraordinarily rich assortment of objects seldom or never found in other cemeteries in which the circular brooches occur in larger numbers. Some of these objects are common to Anglo-Saxon archaeology as a whole and would equally well be at home in areas like East Anglia or the eastern midlands; others are more peculiar to Kent itself, but even so are of classes that had gone out of fashion by the time the circular brooches had come fully into vogue.[1]

To put the matter in a simpler form, three, if not four, stages of Kentish archaeology can be recognized. They stand out in strongly defined outlines, clearly distinguishable from one another, illustrating the fortunes of the Kentish settlers in a manner to which the rest of Anglo-Saxon England can offer no parallel:

1. From *c.* A.D. 450 to 500, the JUTISH PHASE, the period of initial occupation, in which the material is scarcely distinguishable from that of other districts except for the absence of large cremation-cemeteries, and is equally scanty. It consists, in short, of types common to the tribes of Anglo-Saxon stock who migrated from north Germany to Britain. Though historically recorded as the scene of the first invasion, it is very doubtful whether Kent can in reality claim precedence in that respect. Apart from geographical considerations the scarcity of cremation, as contrasted with its frequency in more northerly districts, seems to indicate a period when the change from cremation to inhumation, of which traces have been observed recently even in north Germany itself, had gained a firmer foothold. But evidence that it was still practised by the first settlers when they came to Kent has been provided by discoveries in 1931 of cremation in hand-made vessels of typical Anglo-Saxon form and fabric at Easden,

[1] It is not certain that the Bifrons cemetery has been completely explored. There may still exist a later element undiscovered. As things are, the collection preserved at Bifrons House certainly represents a group of graves earlier than those explored and published by the Kent Archaeological Society (*Arch. Cantiana*, x. 298; xiii. 552).

near Sturry, close by the road from Canterbury to Margate. At Bifrons evidence for the rite is not so certain, though the cemetery produced objects of types associated with the culture to which the pottery of the cremation burials belongs (Pl. XII). Vessels of Saxon types at Bifrons House, though small, may have been used for the purpose. In type they closely resemble the Easden vases.

2. Early to late sixth century, the FRANKISH PHASE, one of pronounced foreign influence. It is unnecessary nowadays to dilate upon the markedly Frankish character of much that is found in Kent. One might even speak of Frankish pure and simple without any mental reservations whatever in regard to their place of origin, so close are the points of resemblance between many of the Kentish finds and others on the Continent. So much so that a suspicion is aroused as to whether the causes that lie behind the rapid alteration in the whole character of the Jutish culture are not something more than mere vagaries of fashion, and are not in reality due to economic factors for which we possess no historical evidence, but which seems to be implied by the very changes themselves.

This brings us to an aspect of the problem that is of supreme importance in any endeavour to interpret the settlement of Kent. If there is one part of Britain where history and archaeology are in the beginning mutually corroborative, it is Kent. All the settlements of any importance are situated along the Roman road westwards from Thanet. Southern Kent comes into the picture only in a minor degree, and in any consideration of early settlement can be largely discounted. Clearly the earliest settlers were of northern stock, scarcely distinguishable from other portions of the Anglo-Saxon invaders as a whole, and they would naturally find entry at the mouth of the Thames. A crucial point to bear in mind is British trade with the Continent in the latter days of the Roman occupation. Apparently at that date the principal continental channel of foreign trade with Britain was the Low Countries and the Rhine. That the trade suffered considerable dislocation when the *limes* fell and the Germanic hordes were pouring into Gallia Belgica and Gaul can hardly be doubted, but that commercial ties established

over so long a period should be brought entirely to a close and the door shut and bolted to all hopes of future intercourse is unthinkable. It only needed more settled times for the old connexions to be renewed, and it was this renewal that allowed eastern Kent to raise itself to a cultural standard far above that of other parts of England.

But was there not something more than a mere revival of trade? In *The Archaeology of the Anglo-Saxon Settlements* I ventured to suggest that the Frankish features of the Kentish culture were so strongly marked as to indicate that the first settlers might even have been people of Anglo-Saxon stock who during the movements that preceded the downfall of the Empire in the West had shifted from the north towards the Rhineland, where, coming into contact with a higher civilization than their own, they had adopted it and had brought it with them to Kent. That was probably an overstatement, if not a misinterpretation of the facts, since, as already noted, I had under-estimated the existence and amount of early material which Kent has to show in common with other invaded districts. It is actually only after the Jutes were firmly established in Kent that a change takes place. This change is, however, so far-reaching and comprehensive as to be hardly explicable by a mere revival of trade alone. We are confronted by a complete transformation, not only in brooch-forms, but, what is even more significant, in the adoption of a wheel-made ceramic of Frankish type in place of the hand-made vessels of normal Anglo-Saxon fabric. Commercial relations may well account for changes of fashion in jewellery, but will scarcely explain so radical a change as that presented by the appearance of an entirely new class of pottery. This, it may be objected, could have been imported, just as were the products of Gallic and Rhenish potteries under the Empire, but it is hardly probable. Absolute proof to the contrary may be impossible to adduce, nevertheless I feel the facts are inconsistent with a simple renewal of commercial relations alone. Something of a more intensive nature must have taken place.

At this stage it will be well to review the constituents of this

unquestionable Frankish element introduced into Kentish culture in the first half of the sixth century. In the matter of weapons, in addition to the usual sword and spear we have examples of the throwing-axe, or *francisca*, and of both the varieties of the continental javelin, the pilum and the angon, though not in the numbers in which they are found on the Continent. It is to be noted, however, that these weapons are met with outside Kent only in very rare instances: one angon from High Down, Sussex, otherwise only at Croydon, Surrey, Taplow, Buckinghamshire, and recently in a grave at Abingdon, Berkshire, where both pilum and angon were found in the same grave, an unparalleled occurrence in this country.

The pottery has already been mentioned, and here the characteristic biconical vessel, often decorated with roulette stamps (examples from Faussett's excavations in the Mayer Collection at Liverpool are contrasted in Pl. XIII with others of Saxon type), the bottle-vase, so striking a feature of Frankish cemeteries in the Rhineland,[1] even, too, the trefoil-mouthed jug and a second form with tubular spout, as well as other minor Frankish forms, can all be accounted for. In glass, rare at any time outside Kent, we have a whole range of forms, the conical beaker, the concave-sided beaker with rounded base, often with a knob at its middle; the round-bottomed cup or tumbler, and, above all, the lobed beaker, all types that occur in Frankish cemeteries of the late fifth and sixth centuries, as well they might, considering that most of them were undoubtedly manufactured between Flanders and the Rhine.

But, as usual, it is the jewellery that provides the clearest evidence: small circular,[2] quatrefoil, or rosettiform brooches with simple garnet cloisons, a quatrefoil form with garnet set-

[1] Contrasted in my *Archaeology of the Anglo-Saxon Settlements*, figs. 19 and 27.

[2] The example from Broadstairs (*Proc. Soc. Ant.* xxiii. 280, fig. 5) with silver filigree in the centre is a well-known continental type and is certainly an import. No one denies that the equal-armed brooch was made in and carried by settlers from north Germany to England. It would be illogical to maintain that the same explanation is inapplicable to objects of Frankish fabric.

tings in each lobe and at the centre,[1] and bird and animal brooches. Again, there is a type that has a semicircular head-plate with three or more radiating knobs, and a straight-sided, lozenge-shaped, or oval foot. All these belong essentially to the whole Frankish world, as in a lesser degree does the variant of the last-named type with rectangular head-plate, usually with atrophied knobs and chased with linear decoration.

It is when we come to the square-headed brooches pure and simple that the field narrows down in a very appreciable measure. This class of brooch is peculiarly valuable both as a test of origin and as an aid, reinforced by the evidence of associated grave-finds, to a comprehension of the process of transformation in actual working among the Kentish settlers. The question of their origin I may defer for the moment, though that, as will be seen, has an important bearing on the whole problem of the relative chronology of Kentish objects. A close test, however, of the associated groups establishes one fact, namely, that none of the Kentish square-heads can be late. Some may even belong to the fifth century, the majority to the first half of the sixth, while a few remained in fashion until the end of the century. They have been found in association only with three varieties of the circular brooches, the simple cloison type in Bifrons 42, my Class Ia at Howletts,[2] and Sarre[3] 4, or Class Ib at Ash,[4] and Howletts.[5] We may also include an example from Howletts with Class Ia added as a disk to the bow. They have also been found with brooches with semicircular radiate heads in two or three cases, and once with bird brooches, and neither of these are late forms. Further, they are well represented in the west Jutish area of Hampshire and the Isle of Wight. At the same time in Kent itself once again they come from the early group of cemeteries, never appearing in Faussett's Kingston Down group.

The deciding factor for the date of the larger square-headed

[1] e.g. Chessel Down, *V.C.H. Hampshire*, i. 388, col. pl. fig. 4.

[2] Åberg, Tab. ii. 104, and Relph Coll., grave 18.

[3] *The Archaeology of the Anglo-Saxon Settlements*, fig. 21.

[4] Åberg, Tab. ii, 124. [5] Relph Coll., grave 7.

brooches in Kent lies in their origin. The majority of them, not only as a type, but also in details of their decoration, betray it at once, for the top of the foot is flanked by *rampant* animals, e.g. that from Milton-next-Sittingbourne (Fig. 13*a*), instead of the drooping heads with gaping jaws, such as are usual on these brooches in other parts of England, but are comparatively rare in Kent.[1]

(*a*) (*b*)

Fig. 13. Bronze square-headed brooches from (*a*) Milton-next-Sittingbourne, Kent (⅔) and (*b*) Engers, Hessen Nassau, Germany (⅔).

The former style owes no immediate relationship to the northern Teutonic series, but is derived from the continental mainland, where, as in Kent, the form of brooch with lozenge-shaped foot devoid of any median bar predominates, as contrasted with the more usual Scandinavian type, where the foot is divided

[1] Åberg's terminology (*The Anglo-Saxons in England*, 74), 'biting animal heads transformed into entire animal figures', is very misleading. They are completely separate conceptions. I have adopted the heraldic term 'rampant' as a convenient label for the animal as it appears on the brooch when figured, as it usually is, with the head-plate upwards. In actual practice these brooches were probably worn, like the Roman cross-bow type portrayed on the diptychs, with the foot uppermost. So worn the animal's head would be turned downwards.

longitudinally by such a bar. The latter type does occur both on the Continent and in Kent, but usually supplemented by a cross-bar, a feature never encountered among the northern series. A further characteristic of the continental brooches, especially those of larger size, is the crouching animal along the lower edges of the foot. This scarcely occurs in Scandinavia at all; two examples from Seeland, Denmark,[1] and one from south Norway[2] are practically all one can cite, and in themselves stand apart from the general run of the Scandinavian brooches.[3] This feature is, in fact, the Romanizing animal which Salin regarded as lying at the foundation of northern zoomorphic ornament, a judgement which, in spite of efforts to trace back its entire origin to Asia, remains substantially true, since it is in north-eastern Gaul and the Rhineland that the form is at home, long prior to the movements that witnessed the spread of the Franks up the Rhine and into France.

Returning once more for a moment to the Kentish example of the great square-headed brooch with rampant and crouching animals on the sides of the foot-plate, seen in almost pure form on the specimen from the Bifrons grave, we find the counterpart in such foreign examples as a brooch from Engers, Hessen Nassau[4] (Fig. 13 b). The parallelism is accentuated by the flattened roundel on the bow, repeated on more than one Kentish brooch.[5] For even though on some the rampant animal has given place to the normal drooping heads of the Scandinavian series, the couchant beast lower down on the foot remains.[6]

[1] Salin, figs. 134 and 519.　　　　　　　[2] Ibid., fig. 518.
[3] These three examples are a good illustration of a pitfall that besets the path of archaeological research. By constant repetition of the same figures in archaeological literature an impression is apt to be produced in the minds of the unwary that they are representatives of a large class, when often they are, as here, exceptional pieces. Fröken Eva Meyer has recently traced the evolution of the square-headed brooches in Scandinavia at length (*Reliefspänner i Norden*, Bergens Museum Aarbok, 1934, Historisk-antikvarisk Rekke, no. 4), and there shows that brooches thus decorated are scarce, individual in character, and had no future, since they fell immediately under the influence of the other more common Scandinavian type, the variety without a median bar.
[4] Salin, fig. 634.　　　[5] Åberg, figs. 138–41.　　　[6] Salin, figs. 635–6.

It is the large square-headed type that provides the initial clue towards a correct estimate of the time when the Kentish jewellers began to evolve their distinctive Kentish types. Let us take first an associated group discovered within the last few years at Finglesham, near Deal (Pl. XIV). The square-headed brooch, its details worn down by long use, is particularly interesting, since at a glance its kinship to Rhenish specimens becomes patent. Indeed, it is only in minor details to be distinguished from the example from Engers, Hessen Nassau, mentioned above. With it were a pair of another type, with semicircular head adorned with radiating knobs and with straight-sided bow and foot, a type that is generally regarded as more likely to have been imported than to be of Anglo-Saxon fabric, a pair of bird-brooches that again were hardly made in this country, a lobed glass beaker with flared rim,[1] certainly an import, three gold bracteates like those from grave IV at Sarre, Scandinavian in origin, and finally a buckle and beads that can either be foreign or native. Here we have what has every appearance of an immigrant buried with possessions brought with her from the Rhineland, where alone the square-headed brooch can have been manufactured. The bracteates are of a class assigned by Scandinavian archaeologists to the latter half of the sixth century, but are manifestly the latest constituents of the group. They occur again, but in more advanced style, in grave IV at Sarre, where we have two variants of the true Kentish square-headed type. One of these belongs to a later phase of the use of the rampant beast, and besides having the vertical and transverse bars on the foot, is decorated on the head-plate with a motif consisting of two triangles with their apices impinging on a disk between them, as may also be seen on an example from Bifrons.[2] This same motif is repeated on the specimen from Howletts, to the bow of which is affixed a circular disk that is

[1] Lobed beakers are lumped together by Åberg under a seventh-century date, but a clear distinction should be drawn between those with a flared rim (Finglesham, Fairford, &c.) and the straight-rimmed type (Taplow). For the dating of the latter see *infra*, p. 76.

[2] Åberg, fig. 135.

nothing more or less than the earliest variety of the Kentish circular jewelled brooches.[1] It is to be noted that a duplicate of the disk, but mounted as a circular brooch, was associated with one of the small square-headed type bearing a less degraded version of the rampant beast. Mr. Smith, in describing the group of finds from Howletts to which these belonged, emphasized the predominance of early jewellery and the absence of the more developed forms of the Kentish circular jewelled forms. Since Howletts has produced not only small cruciform brooches that must be assigned to the Jutish period, but also two of the decorated annular type, which I have called pre-Saxon, Howletts can on this evidence alone rank as one of the early cemeteries of Kent. But there is more to come. In Dr. Relph's important collection from the same cemetery there is nothing that in any way contradicts Mr. Smith's assessment; indeed, there is ample material to confirm it. For again there are additional small cruciform brooches and other original Anglo-Saxon material, pottery and the like. And in this collection are two grave-groups that fall exactly into line with those already described. One contains two imperfect square-headed brooches like that from Bifrons cited above, again associated with the early circular type (my Ia), while the other contains a pair of square-headed brooches like that from Ash,[2] a later version of the Bifrons example, and with them a circular brooch of my type Ib with the continuous beaded rim and recessed middle that mark the earlier products of the class.[3]

The evidence for relative dating is therefore not merely based on the few associated groups cited by Åberg, but repeats itself again and again, and throughout presents one common trait, an

[1] There are certain smaller examples of these brooches that may actually precede this type in point of time, but, since some have the appearance of being cheap substitutes for other varieties at a more advanced stage, their value for relative chronology, based on typological standards, is thereby diminished. In any case they make no appreciable difference to the argument.

[2] Åberg, fig. 136.

[3] The occurrence of the latter feature makes it evident that Ia and Ib actually overlap in time.

entire absence not only of the finer cloison brooches, but also even of the other variants of the commoner circular class.

The general features of this continental style come out also not only in a large series of Kentish brooches of moderate size, but lie behind a whole group of smaller Kentish square-headed examples on which, though the lower couchant beast is discarded, the rampant beast is retained,[1] gradually fading away until traces of a head or merely the peculiar outline of the upper part of the foot remains to vouch for its prior existence (Pl. XV). This small variety is essentially, as Åberg holds, a product of the Kentish school; it is simply the application of a newly acquired style to a size that forms part of the regular jewel-box of all the Anglo-Saxon tribes, the small bronze square-headed brooch that they brought with them from north Germany.

The small square-headed brooches are a recognized concomitant of early sixth-century Kentish graves, but it is perhaps scarcely sufficiently realized that the larger varieties in Kent belong exclusively to the sixth century, and principally, at any rate, to its first half. They are, in fact, the sumptuous brooches of their period, doomed to be displaced later by another form and fashion.

What, then, are we to make of this apparently sudden transformation that takes place in Kentish art and culture? Was it due to the reopening of commercial relations with central Europe? Initially this may certainly have been an important factor, but if mere trade could effect so great a change, it needs to be explained why, as can be easily demonstrated by an examination of the archaeological material, the areas occupied by other tribes have produced so extraordinarily meagre signs of having fallen directly under the influences that produced this amazing revolution in Kent. For Kent during this second stage remains for practical purposes culturally distinct from the rest of England as it then was. We find, indeed, some exports of Kentish objects from Kent, either of actual Kentish fabric or imports from the Continent like glass vessels, which to judge from their relative scarcity elsewhere and their frequency in

[1] Åberg, fig. 130.

Kent itself must in most cases have been traded through Kent. But it is important to note that among these re-exports, if I may so term them, it is almost impossible to cite examples of those forms on which the whole of the ultimate Kentish development is based. These are gone before contact is established between Kent and the rest of England. By that time the dwellers in Kent had begun to work out a style of their own, not insular in its outlook, but continually borrowing fresh ideas from abroad, sometimes of form, sometimes of details of pattern, with the result that from the hour when they begin to evolve a distinct style of their own until the close of the period covered by the available material, their work is distinguished by an amazing freshness of ideas, sometimes almost revolutionary in their advance. Kentish jewellery, in short, exhibits not only what is admitted to be excellent craftsmanship, in some cases equalling and even excelling that of the continental work of its time, but in addition shows itself more lively in its conception and less tawdry in its appearance, and in its variety escapes at each stage of its progress the monotony that seems to mar much of its nearest continental counterpart, the contemporary Frankish art, one that extends from Germany to the Atlantic.

We thus arrive at a position where Kent, after an initial period of an Anglo-Saxon culture in its limited connotation, passes with amazing suddenness into one of a purely Frankish type, out of which is rapidly developed a Kentish style. In this the Anglo-Saxon element, as compared with the rest of England, plays a minor role, restricted to an unimportant use of zoomorphic ornament, and even this as it appears in Kent could have come from the Continent with the rest. Too much stress has perhaps been laid in the past on the Scandinavian side of this animal decoration. There is in England, at any rate, a very considerable leaven of the continental variety of the Teutonic animal style, and naturally it predominates in Kent.

But how did it come to take so strong a hold on the art of the Jutes? In 1913 I suggested that the source from which emanated the influences that lie behind the special Kentish development was the Rhineland, not only because the archaeological material

of the Ripuarian Franks seemed best to furnish the various elements out of which the Kentish culture is composed, but also because in that region could be found the parallels to certain features of the Jutish economic system, features lacking in north Germany whence the tribe was held to have sprung. Against this theory objections were raised, more particularly in regard to the date assigned to certain objects, partly perhaps because it was too drastic a re-reading of the sparse historical records to meet with acceptance from unenterprising minds.[1]

It is not without interest, therefore, to find that in one of the latest studies of the system of Kentish land-tenure, Mr. J. E. A. Jolliffe, in his *Pre-Feudal England: The Jutes*, finds himself compelled to the same conclusion which I advanced many years ago upon archaeological grounds. He has subjected the land system of the Jutes to a critical examination, and maintains that it is intimately related to that prevailing in Ripuarian Germany, adducing in support of his thesis not only the identity of the rate of *wergeld* in both areas, but also noting points of resemblance of service and in the rules of inheritance.

He says (p. 117): 'Some, who think that a century of neighbourhood in Britain will not explain the fact that the Jutes speak the common language of England, may be ready to believe that the peasantry of the south-east were Frisians, Saxons, Angles, Warni, with Frankish leaders and Frankish art and organization, perhaps with the elusive Saxones Eucii among them, but the fact has to be faced that there is nothing but language to suggest it.'

Mr. Jolliffe has in one respect borrowed from my earlier interpretation of the Jutish puzzle, but in actual fact more than language comes into the question. The earliest archaeological material actually coincides with history and language, the latter

[1] e.g. Brenner in *Bericht der Römisch-Germanischen Kommission*, vii, followed by Kauffmann in *Deutsche Altertumskunde*, ii. 692, n. 6. The latter appears to have relied entirely upon Brenner's judgement, since he gives no additional reasons for his objections. It may be noted that Brenner's dating (see for example Gutorm Gjessing, *Studier i Norsk Merovingertid*, p. 10) is no longer accepted at all points and may, therefore, not be wholly accurate at those where he joined issue with my theory.

therefore being that of the first comers and at any rate of the ruling house thereafter. It would, therefore, be imperative on others to acquire it if they wished to enter into relations with, for example, the Saxons of Sussex, or with the tribes beyond the Thames.[1] It is, however, as we have seen, only at the second stage of the Jutes' cultural history that archaeology, land-tenure, and the like meet upon common ground.

In view of the unmistakable evidence of foreign influences it is perhaps desirable to gain a clear perspective of the continental background against which the objects showing such influences have to be set. It is admitted that outside the material here assigned to Period I there is little that can have originated in north Germany. The influences emanate from farther south in Frankish territory, and it is necessary to appreciate which part of the wide area assigned to the Franks on ordinary historical maps is affected. Let it be remembered that the Franks appear first in the middle of the third century on the lower Rhine, an important branch being the Salii on the lower Yssel, where they were subdued by Julian in A.D. 360 from his base at Xanten. Subsequently many of them served in the Roman army. The other branch, the Ripuarii, higher up the Rhine, among them the Ampsuarii, the Chasuarii, and the Bructeri being the most important, founded a kingdom at Cologne in 460, and thence spread up the Rhine, eventually coming into serious contact with the Alemanni and defeating them in 496. In 507 this kingdom passed to Clovis. Meanwhile the Salii had moved towards the Scheldt and north-eastern Gaul, and after the death in 454 of Aëtius, whom they had supported against Attila at Chalons, they advanced steadily forward until they defeated Syagrius at Soissons in 486, and eventually advanced to the conquest of the Visigoths in western Gaul in 507. So they became masters of the greater part of France as well as of the Rhine Valley.

[1] Mr. Jolliffe's reference on p. 101 to interpreters *de gente Francorum* hardly meets the case; it only means that there were persons speaking the language of Kent in France. His reference to Frankish tenures in Kentish codes is more to the point.

It will be realized from this brief survey by Schumacher[1] that they could scarcely have brought influence to bear upon any part of this country before the sixth century; and this, to judge from the archaeology, appears to be precisely the time when they did so, almost as if the acquaintance with inner Gaul gained by their march to the support of Aëtius had aroused in the Franks a longing for more desirable lands than the Low Countries to which they had been largely confined under the Empire. As Schumacher remarks, the successive changes of capital from Toxandria by way of Tournai, Cambrai, and Soissons to Paris marks the measure of their advance.

Admittedly their influence could have been active while they were still on the lower Rhine, but it is just the elements assigned to the early sixth century that appear alike in the Rhine Valley, northern Gaul, the Isle of Wight, and in Kent, and even so far west as Charente in such cemeteries as Herpes.

One of the enigmas of the archaeology of this period is the parallelism between certain products of the Frankish cemetery at Herpes in Charente, a department south of the Loire on the western seaboard of France, and others from Kent and the Isle of Wight. No theory to explain this has apparently been offered, and, indeed, to offer one is perhaps a hazardous venture. In this curious parallelism, nevertheless, there may possibly be found one of the keys to the Kentish problem itself. Attention has been drawn more than once to the most prominent illustration, two large square-headed brooches, the one from Herpes, the other from Sarre, clearly the products of one and the same workshop.[2] But the parallelism does not stop there. Not only do we get a second case in another type,[3] the English example of which comes from Finglesham, Kent (Pl. XVI), but the Herpes cemetery has also produced several of the small square-

[1] *Siedelungs- und Kulturgeschichte der Rheinlande*, iii. 44–5.

[2] Baldwin Brown, op. cit., pl. CLV. 5–6; Åberg, figs. 119–20; Burlington Fine Arts Club, *Art in the Dark Ages in Europe, c. 400–1000 A.D.*, pl. VI, D. 19, and N. 2.

[3] Berlin, Staatl. Museum für Vor- und Frühgeschichte, V. a 1569. Compare also Åberg, fig. 129, from Chessel Down, Isle of Wight. The rampant beast also appears on his fig. 128 from Herpes, also in Berlin.

headed class that, as noted above, are essentially Kentish. In addition jewelled buckle-plates with zoomorphic decoration, specimens of which when found in English districts outside Kent are always attributed to the Kentish workshops. Along with these we have at Herpes other more essentially Frankish brooches, the rosettiform, small cloison, and the like, such as also appear in Kent and the Isle of Wight. The strangeness of the phenomenon lies, however, in the concurrence of the square-headed type, since it would seem that in France it is only in the Charente cemetery that they appear in Kentish guise. I believe the smaller variant does not occur elsewhere in France, though other rather infrequent manifestations of the larger type are known,[1] but only at Herpes does the rampant beast appear.

The Frankish element in the Herpes cemetery can hardly begin before the conquest of the Visigoths by Clovis in 507, and thus the change from Visigothic to Frankish falls within the same period as the transition from Jutish to Frankish in Kent. One might well ask whether Clovis did not settle his newly conquered territory with a band of (Ripuarian?) Franks, from a locality which also supplied immigrants into Kent.

The change that thus takes place in Kent falls into line with the gradual westwardly shift of a large part of the Franks, and may indeed be due to settlement of some body of them in this country. I do not for one moment believe that it is possible that the Jutes should have undergone such a complete transformation simply as the result of mere commercial imports. Nor will it help matters to adduce the Saxon shore in northern Gaul as a possible solution for the change, so long as the one thing that is entirely lacking in France is evidence of an Anglo-Saxon culture even on the limited scale on which it appears in Kent. Again, the Belgian cemeteries such as those around Namur are little, if at all, richer in early sixth-century Frankish types than Kent

[1] N. Åberg, in *Die Franken und Westgoten in der Völkerwanderungszeit*, 251 and Taf. IV. 45–63, even overestimates their frequency, since it is certain that within his nos. 56–9 there has been some duplication between those mentioned from museums and those cited from archaeological literature.

itself. Pry is perhaps the best example.[1] It is from the Rhineland that all parallels in later periods can best be drawn. Even when Kent had hammered out a style of her own, she did not, as we shall see, disdain to borrow further from the continental reper-tory, but again it is the repertory of the Rhineland, not that of France.

From first to last, including the matter of land-tenure, that is the region with which Kent stands in most intimate relation-ship. Amid all the great movements of the Franks at the close of the fifth century it is therefore not inconceivable that a large body of Franks made their way to Britain. There is no certainty that the system of land-tenure as reflected in ninth-century charters and land-laws was that in vogue among the first settlers in Kent. As for mere commerce as the explanation of the change, we should expect to find it, as we cannot do, diffusing the foreign influences more widely into the heart of England from some centre like London, under such a revival as that experienced by Cologne after its first sack by the Franks, and not merely, as actually occurred, in sporadic fashion from one small corner of the island.

[1] *Ann. Soc. Namur*, xxi. 311.

THE KENTISH PROBLEM (*cont.*)

IN the first two stages reviewed in the last chapter we have seen the settlers in Kent introducing two continental cultures. In the third stage we find them doing what has been the lot of all immigrant cultures in the past, developing an insular character. So we arrive at what may justifiably be termed:

3. The KENTISH PHASE: late sixth century onwards. It is not possible at present to fix with absolute exactitude the beginning of this insular development of the culture of eastern Kent, but it is moderately certain that it could not have been initiated much later than the middle of the sixth century. On the one hand, the style of the types of jewellery evolved from Frankish models demands that they must follow in close succession to their prototypes; on the other, they constitute so large a series that, if they began later, it would hardly be possible to fit them into the period that may be deemed to have lapsed before the effects of Christian teaching discouraged or forbade the deposition of personal possessions in the graves of the dead. Discontinuance of that practice may well have been a slower process than it is generally thought to have been, but it must have reached completion in Kent as soon as in any other part of Anglo-Saxondom. To place that consummation as late as the middle of the seventh century may seem, if anything, too lavish, taking into consideration one's reluctance to conceive of any want of efficacy in the influences exercised by the Church after the baptism of the royal house of so small a territory as the Kentish kingdom appears on archaeological grounds to have been. But, as we shall see later, the archaeological material is possibly sufficient to allow of the period being extended still farther, and if we may judge from the analogies of continental archaeology, we might safely add yet another half-century even for Kent. Veeck[1] in treating of the culture of Württemberg does

[1] *Die Alemannen in Württemberg*, 91 ff.

not hesitate to carry the period down to A.D. 700, and students of Frankish archaeology in France assign a large part of the material that comes within their purview to the seventh, and some even to the eighth. While, therefore, it is essential that Kent should not be stripped of everything that may be set beside the products of contemporary France and Germany, this is the inevitable corollary of the acceptance of Mr. Kendrick's early dating of some of the most important and spectacular elements in Kentish art.

We need, therefore, to ascertain whether any additional criteria are available by which we can determine the relative date of the jewellery and the like that is needed to fill the otherwise serious lacuna created by Mr. Kendrick's theory.

German archaeologists have in recent years recognized that a marked change came over the art of the Rhineland during the course of the sixth century. The dawn of this change is placed by them about the middle of the sixth century, as it appears to coincide approximately with the fall of the Thuringian kingdom before the power of the Ripuarian Franks in A.D. 531.[1] The phenomenon on which this judgement is based is the absence from the Thuringian material of something that is deemed to be a distinctive element in Frankish art, and this absence is ascribed to the catastrophe that not only robbed Thuringia of its independence but left its people apparently without powers of recuperation for many years to come.

The fresh element on which so much stress is laid is a skein-like twist or entrelac that is considered to be closely linked with the whole development of Salin's Style II, whether on the mainland itself or in Scandinavia. Before, however, examining the potent influence which it exercised upon Teutonic art, it will be well to appreciate what it was destined to replace. Its adoption marks the disappearance of the spiral coil or tendrilled motif (*Rankenornament*) that plays so important a role in the preceding period. This latter can be illustrated by numerous examples alike in Scandinavia[2] and, in even clearer fashion, in

[1] Herbert Kühn in *Mannus, Ergänzungsband*, vi. 368 ff.
[2] Salin, figs. 128, 134, 502, 518, and 523.

Germany, on the equal-armed brooches of the Elbe region, on the radiate brooches, and on square-headed forms.[1]

Similarly, the characteristic chip-carving technique (*Kerbschnitt*) and the maeander pattern[2] give way before the plait and zoomorphic ornament. Herbert Kühn,[3] assigning the *floruit* of the maeander and scroll to a period ranging from A.D. 450 to 550, maintains that the plait is not derived from classical sources, but was evolved from a blend of the earlier motifs in Germany itself, particularly through a phase of *Kerbschnitt* that produces a kind of sharp-angled twist (Pl. XVII*a*), the angles of which are gradually softened until the 'skein' motif is reached.[4] He is the more inclined to ascribe the process to a Germanic source, because every stage of it can be observed on brooches with radiate semicircular heads and oval feet, a variety that is lacking among Ostrogothic and Visigothic jewellery, is scarce in Scandinavia and France, and is essentially mid-German in origin.

Kühn's assumption, if correct, means that the beginning of Salin's Style II can, so far as the Continent is concerned, be put back at any rate half a century from Salin's starting-date of *c.* 600 A.D. In that event its first appearance in England might be placed in the latter part of the sixth century, since this phase of Teutonic zoomorphic ornament is intimately linked with the entrelac. While, however, this opinion has won considerable support in recent years, it is by no means certain that it is correct. Kühn's derivation of the entrelac is ingenious, but it is somewhat forced. If the Germanic craftsman was satisfied to borrow so much from late provincial Roman art, the entrelac was ready to hand, if he had a mind to use it. That he should evolve it afresh from his own inner consciousness is hardly credible. It is far more probable that the correct interpretation is, as Zeiss maintains,[5] that which sees in it a loan from the

[1] Salin, fig. 138, the type that appears at Bifrons, &c.

[2] Lindenschmit, *Handbuch*, Taf. XVI. 3. [3] Loc. cit. 368 ff.

[4] e.g. *Franken und Westgoten*, Heilbronn, fig. 190, Wurmlingen, fig. 197, or even at Gilton, Kent, fig. 198, manifestly an importation.

[5] *Germania*, xviii. 282.

Lombards after their arrival in Italy. In that event no other than a classical source of inspiration is conceivable, and the earliest possible time for its adoption by craftsmen north of the Alps has to be postponed to the close of the sixth century. In any case its appearance in England can hardly fall before that time.

If the fully developed motif be sought in England, it is best illustrated by the brooch of unusual shape from Malton (Barrington A), Cambridgeshire (Pl. XVII *b*),[1] though in reality it is nothing more than an adaptation from the foot-plate of the normal large square-headed type. In the same form the motif appears on a whole group of brooches from the Rhineland and south Germany in the sixth century.[2] It becomes even commoner on the successor of the radiate semicircular headed type, that with a knobbed rectangular head, again a mid-European development,[3] and even more strikingly on specimens from Keszthely, Hungary (Fig. 14 *a*)—an excellent parallel to the panel treatment of the Barrington brooch—and from Waiblingen, Württemberg (Fig. 14 *b*).[4]

As already noted, the appearance of the new motif coincides with a great development of zoomorphic art in Germany. It is now widely admitted that the style, which when introduced into eastern Scandinavia gave birth to Salin's Style II, is continental in origin and that its elements are in some measure contemporaneous with what may be termed the equivalent of Scandinavian Style I that predominated in Western Scandinavia. It seems certain that some of the most distinctive features of Style II, for example the griffin-like head (Pl. XVII *c*), are due to Gothic influences from eastern Europe penetrating west. But even before such features were formally adopted into the canons of western decorative art, the plait had been instrumental in giving a completely new outlook to the western designer. Already by the middle of the sixth century the single animal

[1] *Archaeologia*, lxiii. 180, fig. 15.
[2] e.g. Nordendorf, Åberg. *Fr. u. W.*, fig. 242.
[3] e.g. Monceau-le-Neuf and Armentières, Aisne. Ibid., figs. 206 and 208.
[4] Ibid., figs. 243 and 244.

that first appears in Frankish art as a cowering or couchant beast, and which, moderately naturalistic in conception, is employed to border certain classes of brooches, buckles, and the like, subsequently undergoes the linear transformation that is responsible for the dismemberment of the animal to meet the exigencies of decorative space, and in due course yields place

a *b*

FIG. 14. Brooches from Hungary and Württemberg with
skein ornament (after Salin)

to a system in which it becomes subservient to the plait. So much so that in Scandinavia we meet with a succession of animal heads acting as finials to intricately interwoven bands that may be regarded as the contour-lines of the original body of the animal extended to such length as is requisite to complete the plaited design.[1]

On the Continent it is more usual to find interlacing employed to combine two or more animals into a balanced design in which not only the jaws but even the limbs are made to play their part in heightening the effect of intricacy in the pattern (e.g. on the unquestionably imported brooch from Market

[1] Gutorm Gjessing, *Studier i Norsk Merovingertid.* 11.

Overton, Rutland (Pl. XIX *b*)). We have as a result the forma-
tion of a style so distinctive that it can be easily recognized
wherever it appears. It is with this continental treatment that
Kentish work exhibits the closest affinity. It is inconceivable that
the style should have been evolved independently in Kent, and
that is what on chronological grounds alone is involved in the
relegation of many of the finest pieces of Kentish jewellery to
the Arthurian period. For it is particularly on the buckles orna-
mented with filigree that the Kentish counterpart of the style
appears. That it is executed in filigree only means that the
Kentish craftsman, the growth of whose individuality can be
clearly traced as the period advances, has translated into his
favourite medium the ornamental system in vogue on the
Continent of his time.

One feature of his work bears this out. More marked than at
any earlier period we now observe the practice of filling in the
bands of the interwoven animal with spots or bars. This is a
trait that occurs repeatedly in Kentish work (Pl. XVIII). It is
very noticeable in Kentish bracteate pendants,[1] and again on
the buckle with filigree ornament from Faversham.[2]

Outside Kent it is excellently illustrated by the goblets from
Taplow, Buckinghamshire[3] (Fig. 15 *a*), and Farthingdown,
Surrey (Fig. 15 *b*), and by the skilfully interlaced design on the
bronze plates from Suffolk[4] in Bury St. Edmunds Museum
(Pl. XVIII *e*).

The zoomorphic ornament may in some cases, as Mr. Ken-
drick maintains, have strong claims to be regarded as an English
expression, but there are too many features that can be paralleled
from continental workmanship to allow us to credit English
craftsmen with an individuality that owes nothing to external
influences. Such a suite of belt-plates as that from Sarre[5] pre-
sents not only animal heads of Styles I and II, but also one of
Style II employed in interlacing that closely imitates the con-
tinental formula. While, as has been noted already, from *c.* 550

[1] e.g. Åberg, figs. 246–50 and 252. [2] Ibid., fig. 218.
[3] British Museum, *Anglo-Saxon Guide*, fig. 72, and *V.C.H. Surrey*, i, pl. opp.
p. 257, fig. 6. [4] Åberg, fig. 289. [5] Ibid., figs. 234–6.

the Kentish designers began to shake themselves free from foreign forms, it is quite certain that they were unable to ignore foreign art completely. The influence of plait-work is one example. The more ambitious cloisonné jewellery affords another. The treatment of the cloisons on a brooch from Nordendorf, Bavaria,[1] immediately recalls that on those of my Class II with stepped garnet enclosed in a semicircle, repeated in the outermost ring

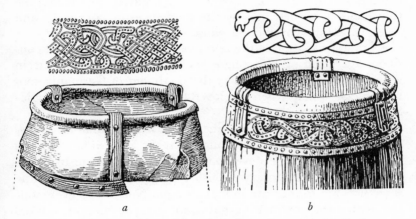

a b

Fig. 15. Wooden goblets with embossed metal mounts, (a) Taplow, Bucks., and (b) Farthingdown, Surrey. (Both ¾)

of the great Kingston brooch. A close analogy is also provided by the design of a damascened example from Heddesheim, near Ladenburg, Baden;[2] we shall see it again on a Gilton tab.[3] Even more significant are two damascened circular belt fittings from Pfalheim, Württemberg, found in the same grave.[4] On the one we have a further example of the same treatment, on the other a version of the linked steps of the Sarre and Aylesford brooches (*infra*, pp. 118–19). The honeycomb pattern is also a common feature of damascening.

The original Germanic brooch-forms, that with small, flat

[1] Lindenschmit, *Handbuch*, pl. xx. 1.
[2] Ibid., pl. xxii. 8. [3] Åberg, fig. 239.
[4] W. Veeck, *Die Alemannen in Württemberg*, pl. 78 b, 4 and 6.

cloisons, and more particularly the square-headed type, had fallen into disrepute in Kent. They were replaced by a development that follows once more the Frankish fashion which was producing circular composite forms with cabochon-settings, heightened by filigree. One only requires a glance at the continental series, however, from France, Germany, and even Italy, to realize how the Kentish jeweller, while developing this cloison technique to a degree of skill and beauty seldom attained on the Continent, was informed by the tendencies of late sixth- and seventh-century continental work.

A full appreciation of the relations between Kentish and continental art during this phase is, however, difficult to attain without some consideration of the treatment of Germanic zoomorphic ornament when employed by Kentish and other Anglo-Saxon craftsmen.

In 1906 Professor Haakon Shetelig in his examination of *The Cruciform Brooches of Norway*[1] found that the English forms in the earlier stages of their development exhibit complete independence from contemporary Danish types, and at the same time show nothing to indicate influences from Norway or even contact with forms common in that country. He maintained, however, that some of the later examples of the English series must have derived some of their features from Norwegian types. This pronouncement seems to exclude all idea of direct contact with Scandinavia in the early period of the settlements, and, indeed, apart from the influences on the cruciform brooches noted above there is little reason to believe that Scandinavia played any prominent role in the evolution of Anglo-Saxon forms or ornament. At best it was second-hand. All that one can cite as imports from that quarter, from which ideas might have been taken, is the small series of gold bracteates found in Kent. The absence of the necessary contacts observable in archaeology finds some measure of corroboration in the researches in other fields. Chadwick concludes that communication with the northern kingdoms ceased before the middle of the sixth century, the English having apparently abandoned

[1] p. 102.

their seafaring habits after they became established in their new home.[1]

If these views are sound, and generally speaking the evidence of archaeology speaks strongly in their favour, it becomes necessary to consider how far the usual interpretation of zoomorphic ornament in England will bear the test of close investigation. That interpretation has for many years rested on Salin's *Altgermanische Thierornamentik*, a contribution of supreme importance to this branch of study. For, despite the fact that in recent years it has been subjected to considerable criticism, with the result that much in his system has been shown to be untenable or requiring serious modification, yet it unquestionably laid the groundwork for further research and still forms the basis upon which other scholars have built their theses. The fault of Salin's system, if indeed it is a fault, since it has served to open the eyes of others to the intricacy of the problems involved, is that it lacks flexibility. Having worked out a system which he regarded as applicable to Scandinavia, he proceeded to measure continental and English ornament by the same yard-stick, and that is where he seems, particularly so far as the early Anglo-Saxon period is concerned, to have missed the truth.

When the main stream of immigration was flowing to Britain in the fifth century of our era, zoomorphic ornament among the invaders was still in its infancy. It was, as Salin rightly held, nothing more than a loan from later Roman provincial motifs, and those very limited in range. Indeed, it is hardly possible to cite any use of the ornament in north Germany beyond that employed on the equal-armed brooches and a few buckles, namely, the crouching animals moulded after the pattern of provincial Roman forms and associated with tendril and spraliform motifs taken from the same art. The great square-headed brooches already in vogue in Scandinavia, whose large surfaces offered so inviting a field for decoration, were, it must be remembered, unknown to, or rather not yet current among, the eventual immigrants to Britain. That being so, it is clear

[1] *The Origin of the English Nation*, p. 19.

that, so far as the greater part were concerned, they came un-
equipped with anything upon which they could have built for
the future. I may be permitted to anticipate here by stating
that the mass of Anglo-Saxon material on which zoomorphic
decoration appears has to be relegated to a comparatively late
date in the history of the pagan cemeteries from which it has
been recovered.

If, then, Scandinavia has to be excluded, from what source in
the whole area of Teutonic ornament are these later formative
influences to be sought? It has already been shown that the
Rhineland exercised a far more important influence upon
Anglo-Saxon culture and ornament than has perhaps hitherto
been appreciated, that that influence is more patent in the
archaeology of Kent than elsewhere in England, apart from all
questions of social import, and, further, that the period at which
this influence made itself first felt is to be placed in the first
half of the sixth century.

It is from the Rhineland that Kent must have acquired a
working knowledge of what I may for convenience term the
rampant and the crouching animals that appear on Kentish
brooches of the Frankish phase. It is from these two animal
forms that the greater part of such Anglo-Saxon zoomorphic
ornament as can be equated with Salin's Style I was derived.
Though the rounded surfaces soon show signs of flattening out,
the animals still retain a certain solidity of form that betrays
their immediate ancestry. This can be clearly seen on the great
Bifrons brooches[1] and on the tab from Sarre (Pl. XX a),[2] and so
far as one may judge, this characteristic seems to have survived
throughout the first half of the sixth century, since it can be still
seen on brooches from Suffolk and elsewhere which, as I shall
show in my next chapter, were modelled on Kentish prototypes.
Within quite a short time the head of the animal tends to become
atrophied, a process that can be observed in a series of Kentish
pieces. On the earliest of the Kentish circular brooches with
garnet settings and zoomorphic decoration, the animal type
is almost constant. Two projections beyond the outer contour-

[1] Åberg, figs. 306, 2, and 6. [2] *British Museum Guide*, fig. 62.

line of the eye are all that remain; the jaws that can still be seen on the Kentish buckle-plate from Fairford (Pl. XX *b*) are often omitted or barely indicated. It is the upper projection that is in a large measure responsible for the ultimate development of a widely diffused animal style in England.

Meanwhile, however, two influences are beginning to make themselves felt. The first is the right-angled contour-line of the back of the head, one of the distinguishing features of Salin's Style II, one that, moreover, whatever may have been its initial date in Scandinavia, can at any rate be traced back to the middle sixth century or earlier on the Continent; its germs are already to be detected in certain of the English examples cited above. The second is the bird's head with powerfully crooked beak that has a long history behind it in Gothic art (Pl. XVII *c*). It was already in common use among the Franks by the sixth century and consequently was bound to make its appearance in the Frankish period of Kent, where it assumes a highly important role, but there it seems until quite late to have been kept distinct, at least in its purest form, from the quadruped. Outside Kent the artist allowed his fancy more play and had no hesitation in amalgamating the two. The effect can be clearly understood from an examination of animal ornament as practised in the eastern counties, particularly Suffolk and Cambridgeshire (Pl. XX *e*). There animal forms to which parallels can be found in Kent assumed the beak. The use of these forms falls comparatively late in East Anglian art, and the amalgamation mentioned above has nothing strange in it, since the beaked head had already for some time previously been adopted to decorate the lateral lobes that were being added to the feet of cruciform brooches.

It must not, however, be thought that until the connexions contracted with Kent opened their eyes to these novel ideas, the tribes north of the Thames were entirely lacking in knowledge of a zoomorphic style. Many of the saucer-brooches, particularly the applied variety, are decorated with animals (Pl. XX *c–d*), but these are usually unintelligently expressed. In fact more often than not they consist of a mere collection of *disjecta membra*,

thus postulating a considerable period of decadence before the animal style received a reviving fillip from Kent, the source from which the artists of the rest of Anglo-Saxon England obtained many of their ideas. But the earlier development of zoomorphic style outside Kent remains at present an unsolved problem, the more so as none of the north German prototypes are decorated in a style that could supply the immediate key. There is, in fact, quite an appreciable gap between the animals employed upon the equal-armed brooches and those expressions of zoomorphic ornament in the eastern counties that can reasonably be placed next in point of time, so wide, indeed as almost to induce a belief that these latter were also based on external loans and did not form part of a continuous native growth. What does, however, emerge from a study of these pieces is that alongside the unmistakable borrowings from Kent there exists a large body of material with a crude animal decoration that is in process of rapidly perishing of inertia. It may be that the circular form itself of the brooches was largely responsible, since they lend themselves so easily to a geometric style of decoration, and whenever this was brought into use, it cut the surface up into bands and panels, often insufficiently large to receive more than a portion of an animal, sometimes no more than a single limb.

It is even possible, however, that these northern tribes may also have been influenced from continental sources direct. There is a form of square-headed brooch in the Rhineland that develops a kind of frill round the base of the foot.[1] It is a type that makes its way into north Holland, e.g. Wieuweerd, Friesland (Leeuwarden Museum), and Looveen bij Wijster, Drenthe,[2] and can be paralleled in England by a specimen from Londesborough, Yorkshire.[3] Its influence is possibly perpetuated on other examples, notably on the fine piece from Bidford-on-Avon,[4] and in a lesser degree on examples like Åberg, figs. 103–6.

[1] Lindenschmit, *Handbuch*, pl. XVI. 2, XVII. 2; Salin, fig. 135; Åberg, figs. 122–4.

[2] *Nieuwe Drentsche Volksalmanak*, 1932, Afb. 6. 36 *a–b*.

[3] Åberg, fig. 110. [4] Ibid., fig. 99.

The position in regard to zoomorphic ornament in the east midlands and in the West Saxon area resembles that of the eastern counties. Occasionally animals of fairly intelligent execution occur, for example, on a Fairford brooch,[1] not indeed unlike some Kentish work, but there are types like a second Fairford piece[2] where the head is less schematic and is furnished with an ear, and seems to carry on a tradition of a simple prototype.[3] One thing is certain. Neither Wessex nor the midlands, if we except possibly a brooch from Rothley Temple, Leicestershire, appear to have borrowed anything in its early animal ornament directly from Kent. The marked notch behind the projecting crest of such a piece as the Sarre tab is never forthcoming, and the beaked head gets little farther west than the eastern midlands, where it is to be seen as on the shield-boss from Barton Seagrave, Northamptonshire, on a saucer-brooch from Shefford, Bedfordshire (Pl. XX d),[4] and on similarly decorated specimens from Market Overton, Rutland, and from an unspecified provenance, now in the British Museum. On these it is certainly a loan from East Anglia. Otherwise it appears on the late derivatives of florid cruciform brooches of East Anglia that culminate in the outrageously barbaric specimen from Stapleford, Leicestershire,[5] and it is doubtless from them that it was adopted on the late square-headed brooch from Holdenby, Northamptonshire.[6]

The lively controversy about the origins and relations of the ornamental systems known to archaeologists as Salin's Styles I and II has been productive of a whole mass of literature. Salin's original thesis that in Scandinavia Style II was a natural development from Style I, brought about by the introduction of continental motifs and ideas, has since been disputed, and it has been demonstrated that even in Scandinavia the process was by no means so simple as Salin imagined. For, as Bröndsted[7]

[1] *Archaeologia*, lxii, pl. xxvi. 4. [2] Ibid., pl. xxvi. 2.
[3] One can almost recognize in such pieces the germs of the animals of the manuscripts. [4] Ibid., pl. xxvi. 8. [5] *V.C.H. Leics.* i. 235.
[6] *Northants Nat. Hist. Soc. Journ.* xv, pl. 2. Åberg, fig. 91.
[7] *Nordisk Kultur*, xxvii: *Kunst*, 116.

puts it, 'the fact is that just as Style I was not evenly distributed through Scandinavia, but had its centre of gravity westwards, so we find in the case of Style II a more marked unevenness in its diffusion, this time with a pronounced eastwardly inclination'. So far as Scandinavia is concerned, Style II is first and foremost Swedish, appearing only sporadically in western Denmark and Norway. The matter of its northern development is, however, outside my theme, except so far as the dating of the style in Scandinavia helps to estimate the date of its beginnings in central Europe.

Nor is it necessary to discuss at length the variant championing of east and west for the honour of its birth. One comment is perhaps permissible. Scandinavian art, through the early intercourse of the northern Goths with south Russia and through its very geographical proximity to Russia, may in the fourth and fifth centuries have derived much of its inspiration from Scythic and Asiatic art, but this is hardly applicable to the whole of Germanic art. The almost complete evacuation of north Germany in the fifth century, if the evidence of the grave-fields is as corroborative of Bede's statement as it appears to be, leaves an undoubted gap, temporary though it be, between northern and western Europe. The Franks and other tribes of western Germany would, as Salin maintained, come under a set of influences, similar in some respects, different in others, conveyed from the same general source in eastern Europe by the tide of the great migrations. These, though they could sweep across Europe, as under Attila, appear politically speaking to have affected such tribes as the Franks, Alemanni, and Burgunds but little. And even though from a cultural aspect the whole movement opened up untried stores of artistic ideas to the western artist, it is not until the sixth century that the effect of these contacts manifests itself in a marked degree in western Germanic art.

As a study of central and western European material clearly shows, the griffin head never appears on the earliest pieces of the Migration Period. The crouching animals borrowed from Roman provincial art hold their own for quite an appreciable

length of time. It is only during the transformation effected by the introduction of interlacing that the griffin head thrusts itself into prominence.[1] Apart from other considerations, this provides a strong argument for the ascription of the Wittislingen brooch[2] to a period as late as the seventh century. I cannot agree with the early dating suggested by Gutorm Gjessing.[3]

After this digression we can return once more to Kent, where we find ample corroboration even in the sparse material on which zoomorphic decoration is employed. For the Jutish period there is apparently nothing to show. With the Frankish art on the square-headed brooches we meet with animal forms in Style I or in a local variant of that style. Certain examples like that on the bronze tab from Sarre[4] are a linear version of the cowering beast at the foot of the Frankish brooches, but, as Mr. Kendrick has observed, the forward accentuation of the crest on the head must be regarded as an English development. More Frankish in appearance are the beasts on buckles of the type from Herpes, Charente, figured by Åberg.[5] Beside parallels from Faversham and Ringwould cited by him, a further speci-men from Howletts,[6] with animals almost identically portrayed, was associated with shoe-shaped bronze studs and with a fine iron axe, which had a bronze plate inlaid with copper bands covering each side of the shaft-hole. Equally English are the animals on the buckle-plates, like Åberg, fig. 208, of which several examples are known, five of them exported to districts outside Kent itself. They are also represented in the Frankish cemetery at Herpes.

Only during the Kentish period, when interlacing makes its appearance in England, is the typical Style II head brought into use. These two novelties must have been introduced to Kentish artists for all practical purposes simultaneously. In the buckle from Faversham[7] a pair of animals with beaked heads and angled eyebrows have their limbs entwined. The belt-plates

[1] Compare Salin, fig. 641, with figs. 186, 676, and 681.
[2] Salin, fig. 151. [3] *Studier i Norsk Merovingertid*, 8.
[4] Salin, fig. 702. [5] Fig. 209.
[6] Relph Coll., grave 19. [7] *Antiquity*, vii (1933), 435, pl. III. 6.

from Sarre have already been noticed. Åberg compares these pieces with mid-European examples; they may even be imports, since the combination is curiously like that on the bronze tweezers from O. A. Saulgau-Grosstissen, Württemberg.[1]

Along with the latest of the Kentish square-headed brooches there was found at Gilton[2] a small plate on which is a pair of confronted birds with similar heads, and grave 23 at Gilton (Pl. XIX a) contained a large buckle and counterplate with interlaced filigree animals, a small griffin plate,[3] and the tab nielloed with step pattern enclosed in a semicircle in the style of the Kingston and other brooches of Class II (Appendix, p. 117), as also on the Sarre pommel,[4] on the upper edge of which the skein motif appears. A late example from Gilton (grave 69) is the gilt bronze disk figured by Åberg,[5] where the combination of the typical head and interlacing is fully developed. At every turn we meet with the same combination in one form· or another, e.g. the Asthall ornament (Pl. XIX c)[4] associated with an elaborately decorated bottle-vase of Frankish or Kentish type and apparently a bronze Coptic bowl.[7]

As the Kentish goldsmith's art advances, a more prominent role is assigned to filigree, a technique admirably suited to the consummation of designs in which interlacing had in the universal fashion of the age become an essential. Kentish bracteated pendants on which zoomorphic ornament is employed exhibit a similar combination of the Style II head attached to interwoven ribbon-like bodies, usually filled with spots, or where the animal element is omitted either in pure plaited strands[8] and even in spotted bands.[9] And so we come by a natural, unlaboured sequence to designs like those of the Crundale pommel[10] and the Faversham bracteate,[11] in which, as is now generally agreed, can

[1] Salin, fig. 654.
[2] *Inventorium Sepulchrale*, 17, pl. VIII. 6; Åberg, fig. 279.
[3] Åberg, fig. 278. [4] *Arch. Cantiana*, vi. 173; Åberg, fig. 274.
[5] Ibid., fig. 282; Salin, fig. 709. [6] *Ant. Journal*, iv. 120, fig. 6.
[7] A solid bronze lug evidently belonged to such a bowl (ibid., fig. 5 k).
[8] Canterbury; Åberg, fig. 252.
[9] Chartham Down; ibid., fig. 252.
[10] Salin, fig. 709. [11] Åberg, fig. 250.

be traced the genesis of the animal-designs of the Book of Durrow.

In the light of the foregoing we can confidently evaluate the position which the contents of the famous grave at Taplow must take in the scheme of English archaeology. Clearly not all the objects are of the same date. The drinking-horns exhibit a manifest variation in style indicative of such a difference. The form of their finials accords with the decoration of the mounts encircling their mouths. On the larger pair (Pl. XXI a–b) the simpler head of the finial, with its curved contour behind the eye and the characteristic notch in front, is associated with the earlier Kentish style of zoomorphic ornament to be seen on the mount.[1] In the pendent triangles below, a single animal[2] is distorted to fit their space, but on the band above[3] there can be detected evidence of the new stylistic movement in the partial interlacing of the animals' limbs. The second, and smaller, pair of horns has as its finials heads with angled contour behind the eye, which, though not exactly similar in detail (Pl. XXI c)[4], are both fashioned according to Style II, that is so strikingly combined with interlacing on continental work.[5] The mounts (d) from the mouths of the horns to which these finials belonged are decorated with a row of human masks that might tell us little, were it not for the repoussé technique in which they have been executed.[6] Compared with the sharp, angled technique employed on the mounts of the large horns, we have here a soft, low, rounded relief, that agrees with that of the mount of the goblet (Fig. 15 a), which bears all the signs of considerable advance in intricate interlacing combined with spotted filling.

[1] There are some curious points of resemblance between these mounts and the Duston saucer-brooch (Pl. XXc), one of a midland group of these brooches on which a rosette encircles the central boss.

[2] Åberg, fig. 9. [3] Ibid., fig. 8.

[4] For the other see B.M. Guide, fig. 72.

[5] It comes near the mark to say that when this type of head appears on the Continent it is invariably in combination with zoomorphic work in the interlaced fashion of Salin's Style II.

[6] The mounts and finials are now dissociated; but their gilding is of the same tone, and one of the mounts still retains portions of horn attached to it.

One obvious objection to this diagnosis of the material may be thought to exist, namely the triangular plates affixed to the body of the larger horns immediately above the final mount. These admittedly reproduce exactly the style of the ornamentation of the goblet-mount, and for that reason may be held to prove that the two decorative styles employed on one and the same object are contemporary. Not only, however, the quality of the repoussé technique argues in a contrary sense, but also on a close examination it will be recognized that the quality of the metal and the colour of the gilding do not harmonize with those of the rest of the work. These plates must, I feel sure, have been added as secondary embellishments, and thus bear interesting witness to the progress of a widespread ornamental development.

Even without straining the date of the Taplow find unduly in a downward direction it is impossible to conceive that any Kentish artist could have created such a design as that of these triangular plates and of the goblet-mount independently of the continental influences that gave birth to a whole system of ornament, similar in character, in Scandinavia. On any other showing England must be held to stand aloof from all the artistic movements of the late sixth century.

A word may be added about the lobed glass beakers in the Taplow grave. All that needs to be said is that they are hardly valid as evidence in support of an early date. If lobed goblets of a type similar to that of all the four Taplow beakers can occur at Vendel, Uppland, Sweden, in graves XII and I,[1] for neither of which a date before the middle of the seventh century is suggested by Scandinavian archaeologists,[2] there is nothing to prevent similar glasses from occurring in English graves in the late sixth or early seventh. It is to the latter period that the Taplow grave has usually been assigned.

In any case one must distinguish between the straight rims of the Taplow beakers and the flared lip of the earlier class. Contrast, for example, the three beakers in Dr. A. E. Relph's

[1] Hjalmar Stolpe et T. J. Arne, *La Nécropole de Vendel*, pl. xxxix. 16, and pl. vii. 5.
[2] Gutorm Gjessing, *Studier i Norsk Merovingertid*, 21–4.

collection from graves at Howletts (one is figured in the Catalogue of the Burlington Fine Art Club's Exhibition of 1930, *Art in the Dark Ages in Europe, c. 400–1000 A.D.*, pl. IV, B. II). One was found with a spear, a bronze buckle, and a hand-made pot of Saxon type, and another with a circular brooch set with garnets of Class I B, two silver square-headed brooches like Åberg fig. 136, and five amber beads. The contents of this grave are closely comparable with those of Sarre 4, but the former has one or two earlier pieces. The cemetery at Howletts with its Saxon pots in three graves in the Relph collection, as well as three early cruciform brooches in addition to those noted by Åberg, gives every indication of a range from the close of the fifth to the latter part of the sixth century. Like Bifrons, to which it is closely adjacent, it has for some unknown reason failed to produce any of the later types of Kentish jewellery, or any sign of the class of decoration which is their frequent concomitant.

The progress of events bringing with it more settled conditions in England, with facilities for the renewal of foreign intercourse and commerce, was favourable to sounder economic conditions and their natural corollary, the promotion of luxury trades and the importation of foreign goods. How far the advent of Christian missionaries was responsible may be a matter for question, but it is at least significant that the bronze bowls of acknowledged Coptic fabric which have so frequently been found in Lombard graves of the late sixth and early seventh centuries should have been imported into England (Pl. XVI *b*), especially into Kent, in such numbers; no less than twelve are recorded, apart from the Chessel Down and Cuddesdon bronze vessels, which belong to other types derived from the same source. The Lombard evidence of their date is fully supported by a grave-find at La Grazza, Tarragona, Spain,[1] where a flagon of a type associated with a Coptic bowl at Pfalheim, Württemberg,[2] contained a large hoard of 800 gold coins, out of which a parcel of 134 that were examined ranged from Rekkared (586–601),

[1] H. Zeiss, *Die Grabfunde aus dem spanischen Westgotenreich*, 146, pl. 29, 19.
[2] W. Veeck, *Die Alemannen in Württemberg*, 31, pl. 20, B. 2–3.

one specimen, to Svinthila (621–31), thirteen, Chintila (636–9), twelve, and Chindeswinth, one, that can be dated later than 653. Strzygowski attributes these bowls to the fourth and fifth centuries,[1] but he gives no reasons for his dating, and both the bowls and the types of flagons associated with them at Pfalheim and other Rhineland sites have recently been found in Nubia[2] under circumstances that make for a time very closely coinciding with that of the usually accepted date of their deposition in graves in Italy, Germany, England, and Spain. The trade that brought these vessels to England evidently flowed through the Rhineland and brought with it eastern shells and various classes of Egyptian beads, particularly the amethyst pear-shaped drops which do not appear until the Kentish period is in full swing, and persist for some time beyond.

[1] *Catalogue du Musée du Caire, Koptische Kunst*, nos. 9044–5.

[2] *Illustrated London News*, 24 June, 1933, pedestalled vase of Taplow form in a grave at Ballana; 10 March, 1934, two tall silver flagons; 11 June, 1932, two of shorter type.

THE CULTURAL RELATIONS OF EAST ANGLIA WITH THE MIDLANDS AND NORTHERN ENGLAND

THE distinction between the tribal elements connoted by the nomenclature of Angles, Saxons, and Jutes, and the known facts regarding their territorial association, are substantiated in a remarkable degree by the differences between their women's jewellery. Certain varieties they have in common, even though these may occur more freely in one area than in another; some may even be indicative of an element in the population imperfectly recognized. But with these reservations there seem to have been in Anglo-Saxon England, as among peasant folks in Europe to-day, tribal, or rather perhaps territorial, entities in which the womenfolk followed certain fashions of ornament in preference to others.

Initially the distinction was far less marked than later, when the settlers in different areas seem to have welded themselves together under petty chiefs or kings such as those whose exploits the Anglo-Saxon Chronicle records. Thus there was an extensive area comprising such parts of northern England as were occupied and secured by the invaders from the Tyne southwards to Norfolk and northern Suffolk. All this region is culturally one; it is the province of the cruciform brooch in its more developed forms. To it must be added Cambridgeshire, Huntingdonshire, and the greater part of Northamptonshire with Rutland, and, in a lesser degree, Bedfordshire, with the proviso that this latter area is to be regarded as debatable land. It is remarkable how in the two first-named districts, Cambridgeshire and Northamptonshire-cum-Rutland, one meets with cemeteries—Little Wilbraham, Cambridgeshire, is perhaps the most striking—that reflect archaeologically a dominant fashion of the cruciform brooch, in close proximity to others that have yielded evidence of a mixture of styles and forms of jewellery, whether cruciform, saucer, or applied, the latter types being distinguished by

nothing so much as their extreme rarity in the greater area of northern England described above.

The methods of inquiry used in the interpretation of Kentish archaeology will be found equally illuminating if applied to a survey of the material found in other parts of England. Through an examination of the more exotic forms of the cruciform brooch and of the large square-headed type we can on the one hand obtain an admirable idea of the close ties of kinship, policy, or commerce by which the constituent tribes of this great Anglian[1] area must have been intimately connected, while on the other we can estimate with considerable accuracy their relations to the other tribes known to history as Saxons and Jutes. We may conveniently begin from the Kentish side of the problem.

Kent, as we have seen, can be linked up with the Continent, and already I have indicated the crucial point, about, or a little after, the middle of the sixth century, at which Kentish influences on East Anglia begin to make themselves felt. If we can establish the potency of these influences in East Anglia, we shall be better equipped to observe their effects still farther afield and thus link up other areas of Anglo-Saxon occupation into one great cultural chain with Kent, whose position, chronologically speaking, is more closely ascertainable than theirs. One of the useful signposts is the rampant beast, a feature of Kentish art at first sight inconspicuous, but nevertheless supremely interesting, and acquired by that art along with other things from the Rhineland. It is, of course, not the sole gift of Kent to its less advanced contemporaries northwards and westwards, but the fact that it is taken over by other tribes and used to ornament their most outstanding artistic products, barbarous though these may be, enables us to estimate with a high degree of exactitude the relative chronology of such objects. We can thus bring them into a more comprehensive system of Anglo-Saxon archaeology in which we can discount the difficulties that beset attempts to correlate objects not only manufactured by the different tribes, but diverging increasingly in character as they recede farther in time from the common cultural stock of the first invaders.

[1] The adjective is here used in its ordinary historical acceptation.

As in Kent, there are two main lines along which this problem can be attacked, by examination of the two most elaborate forms of brooches in vogue among the Anglian tribes, the cruciform and the large square-headed groups. If there is one irrefutable example of the application of the typological method to the study of this period's material remains, it is that of the cruciform brooch. From its beginnings on the small scale in which it appears, for example, in the Jutish period in Kent (see the map (Fig. 16) on which the distribution of the earlier varieties is plotted), its evolution can be clearly traced north of the Thames, where it was retained until the close of the period which our evidence embraces. There we can note a steady growth in size and an increasing elaboration of decorative detail, until at last it betrays its origin only in its general form. The earlier examples need not detain us. In them the sole zoomorphic feature is the horse-like head on the foot. It is strange to note how the addition of excrescences to the knobs and the expansion of the nostrils of the animals slowly fall victims to the craze for zoomorphic decoration. The process has long been known from the work of Reginald Smith, Shetelig, and Åberg, and to these the reader must be referred, leaving me free to start at a stage which demonstrates the process we are examining. From this, either by a rapid leap or by a sudden vogue for size observable everywhere in this later period, the whole brooch tends to flatten out (Pl. XXIIa). The beginnings of decoration appear on the knobs, on lappets added to the side of the foot, and, to a lesser extent, on the foot itself. It is at the next stage that the real interest begins. The knobs are enlarged and are decorated with animal or, more usually, bird-like heads and masks, and the lappets receive similar treatment. But now we encounter a remarkable specimen from Soham, Cambridgeshire, recently added to the collections in the Museum of Ethnology and Archaeology at Cambridge (Pl. XXIII).[1] Here, on each side of the foot, appears the rampant beast. It is so far unique at this stage, and, to judge from the large tale of cruciform brooches of earlier forms discovered in the eastern counties on which it is lacking, its appearance

[1] *Proc. Camb. Ant. Soc.* xxxiv. 89, pl. xi.

here may be accepted as the time-signal of the adaptation of this Kentish loan by Anglian craftsmen, thus establishing a date about the close of the sixth century. This is confirmed by examples of the square-headed type which also manifest their indebtedness to their Kentish counterparts, not only in the presence of the rampant and crouching beasts on the foot, but also in the arrangement of geometric or zoomorphic patterns on their head-plates. Local individuality here finds expression in lateral and terminal masks and in the use of spiral ornament to fill the panel of the head-plate. It should here be emphasized that certain early traits like the running spiral, which by the middle of the sixth century are disappearing or have disappeared in Kent, have a longer life in other parts of England, which were less exposed to direct continental influences.

Returning to the cruciform type, we find an Anglian variety that has become still more florid. The knobs have expanded into masks and beaked heads, the latter of Kentish type, and the lappets are chased with rampant beasts that are rapidly arriving at the decadent stage as it appears on many of the Kentish square-heads (Pl. XXII b–c). The absence of this particular variety from the cemetery at Holywell Row, Suffolk, that produced so many advanced specimens of the cruciform brooch in its simpler form, is of special significance for the date both of the particular cemetery and of this florid type, which may well be placed in the seventh century.[1] It is noteworthy that examples known outside East Anglia, as from Sleaford, Lincolnshire, still retain the older drooping bird-heads.[2] The final appearance of the rampant beast on this class is on a huge specimen from the Nene valley at Woodstone, Huntingdonshire.

Its appearance on such pieces as these last has also a time-value, since they themselves are preceded by a fairly large class that is obviously derived from the more advanced East Anglian

[1] The brooch from West Stow, Suffolk (Åberg, fig. 88) is a cross between this and an earlier form, which always has drooping bird-like heads on the lappets. These appear on the West Stow piece in a modified form, with the mouth turned upwards like that of the rampant beast. The type is indicated on Fig. 16 by +.

[2] British Museum, *Guide to Anglo-Saxon Antiquities*, figs. 18–19.

type, and is essentially a mid-Anglian creation, well represented, for instance, at Market Overton, Rutland. And it is in the midlands that the nadir is reached in such examples as those from Longbridge, Warwickshire, and Stapleford, Leicestershire. An imperfect specimen from Brooke, Norfolk, provides a half-way intermediate stage between the East Anglian group described above and the mid-Anglian group.

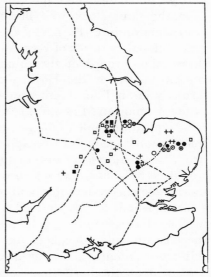

We have in these brooches an excellent illustration of regional parallelism, represented in two stages with a preponderance in favour of East Anglia over mid-Anglia. So far as the latest type of cruciform brooch is concerned, the two areas appear to be distinct. Even here mid-Anglia clearly was indebted to East Anglia, and there is not only further evidence that it remained so, but that East Anglia's influence spread still farther afield.

FIG. 16. Distribution of florid cruciform brooches, on Pl. XXII: ● = (a); ◔ = (b); ■ = (c); □ = (d).

It is on the great square-heads that the rampant beast seems to die hardest. This form is apparently the medium through which it first became known to the tribes north of the Thames, as is clearly proved by the fact that the brooch itself on which it appears is always modelled on the Kentish form, that is to say, it lacks the median bar, which is almost universal on other varieties of the great square-heads outside Kent. Examples from Suffolk (Pl. XXIV a), from Lakenheath (Pl. XXIV c) and Holywell Row, Suffolk, and from Rothley Temple, Leicestershire (Pl. XXIV c), bear this out. Even the crouching beast is still in evidence, as also is the panel arrangement of the zoomorphic

ornament on the head-plate in exact imitation of the Kentish style. The Suffolk brooch, like some of those from Kent, is of silver, but outside Kent they are otherwise invariably of bronze. The lateral masks are an Anglian feature, as is also the more exotic rendering of those at the end of the foot. As in Kent, so here we find cases where only the outline betrays their descent from the same stock, well illustrated by those from Duston, Northamptonshire (Pl. XXIV *d*), and Welbourn, Lincolnshire.[1]

Additional evidence of East Anglian influence is provided by three other groups of the square-headed class. The first is usually known as the Haslingfield type[2] from the specimen formerly in Sir John Evans's collection from that site, and now in the Ashmolean Museum (Pl. XXV *a*). It is not, however, the most typical example. One point of interest about the group is that on some examples the lappets have the drooping, beaked head, while others are decorated with the rampant beast. It would be difficult to say which was the earlier of the two. On morphological grounds it should be that with the rampant beast, since then it is clearly derived from some such brooch as the Suffolk silver specimen already mentioned, and through it from the Kentish square-heads of the Bifrons class. Nothing shows this more patently than the arrangement of the zoomorphic ornament on the head-plate coupled with the absence of the median bar on the foot. The type belongs essentially to East Anglia. Outside that area, apart from an example found at Market Overton, Rutland, itself manifestly of East Anglian fabric, so closely does it resemble one from Barrington, Cambridgeshire, it is only represented by a late derivative at Sleaford, preserved in the British Museum. On the basis of style, Åberg argues its contemporaneity with the whole of the florid cruciform type, but the essential point to note is its close relationship to his figures nos. 84, 85, and 88, the earlier expressions of the type, as a parallel expression stylistically in the square-headed form. It is not, therefore, one of the latest developments, but falls about the turn of the seventh century.[3]

[1] Baldwin Brown, iii, pl. LXIV. 3. Compare Pl. XV *supra*. [2] Åberg, fig. 116.
[3] Portions of a brooch of this type were among the contents of a cremation-

More richly represented is the Kenninghall type[1] (Pl. XXV b) from Ipswich, the distribution of which confirms its East Anglian origin, though it, too, occurs at Market Overton, as also at Billesdon, Leicestershire, nearby, at Holme Pierrepont, Nottinghamshire, and in an obviously debased rendering at Laceby, Lincolnshire.[2] This is the type that is represented at Ipswich by no less than five specimens, varying a little from one another in details such as indicate some deterioration in design and execution. A word needs to be said here about the quatrefoil device that appears on the head-plate of several members of the group. It has been compared with that on a hammered silver brooch from Norway.[3] This is not a very apt comparison, because the contacts between Norway and England were slight during the period in question. Also, while the Norwegian brooch is dated to the early fifth century, there is no reason to believe that the Kenninghall type is earlier than the end of the sixth, and the same is true of the English square-headed brooches outside Kent. We need only turn once more to Kent to find the device in common use upon the Kentish square-heads,[4] and it is from that quarter that the Angles must have acquired it, along with all the rest. The device appears often enough upon some of the late sixth-century cruciform brooches, especially in East Anglia, as on other types of square-heads.

From the Ipswich cemetery also come two examples of what may conveniently be called the Ipswich type,[5] a curiously broad, stunt form, which, like the Kenninghall brooch, frequently had a disk affixed to the bow (Pl. XXV c). Specimens from Kenninghall and from Barrington, Cambridgeshire, are almost identical in detail, and so are examples from Market Overton, from Lincolnshire, and Londesborough, East Riding, Yorkshire. Even the finest example, though embellished in several respects, still

urn found at Girton in 1881 (Cambridge Museum of Archaeology and Ethnology).

[1] British Museum, *Anglo-Saxon Guide*, fig. 21; Åberg, fig. 112. To Åberg's list should be added one from Hunstanton, Norfolk (*Proc. Soc. Ant.* 1902, 173), and another from Laceby, Lincolnshire, mentioned below.

[2] Lincoln Museum. [3] British Museum, *Anglo-Saxon Guide*, 30, fig. 20–1.

[4] e.g. Sarre, grave 4. [5] Åberg, fig. 115.

preserves the original design in the chasing of the foot. It has travelled as far north as Thornbrough,[1] near Catterick, in the North Riding.

There remains an ugly type (Pl. XXV *d*), the earliest specimen of which, stylistically considered, comes from Kenninghall,[2] and which otherwise appears south of the Humber only at Great Wigston, near Leicester. This is the type that travels farthest north, occurring at Driffield,[3] Hornsea, Darlington,[4] and White-hill Point, near Tynemouth.[5]

It becomes quite evident from a survey of the distribution of these variant types (see Pl. XXII and Fig. 16) that, while the florid cruciform brooch was born in East Anglia, it attracted the attention of mid-Anglian craftsmen who produced a variant of their own, to be succeeded in both areas by specialized decadents of the regional type. It is only at one outlying site, namely Sleaford, that loans from both districts are recorded. But the florid cruciform type is unknown farther north.

With the square-headed brooch the case is different (Fig. 18). Here three, and possibly four, varieties originated in the eastern counties, but unlike the cruciform, they spread farther afield to Yorkshire and beyond, the distance from their place of origin being probably the measure of their date. Thus the Kenning-hall I brooch reaches a little farther north than the Haslingfield type; the Ipswich type marches farther still, while the Kenning-hall II type penetrates even beyond the Tees.

Their distribution, moreover, throws light upon the route which this diffusion followed. For a glance at the map of the Roman roads in Britain will demonstrate that Market Overton, which has produced three of the variants in the above list in addition to one of the earlier florid cruciform type, is for practical purposes equivalent to Thistleton, one of the stations on the Ermine Street from Cambridge by way of Durobrivae to the north. The Lincolnshire finds at Sleaford suggest a further

[1] *Arch. Journ.* vi. 216, and plate. [2] Åberg, fig. 90.
[3] Mortimer, fig. 829. Omitted from Åberg's list.
[4] Two in the Evans Collection, Ashmolean Museum.
[5] Black Gate Museum, Newcastle; Baldwin Brown, op. cit. iii, pl. 45. 6.

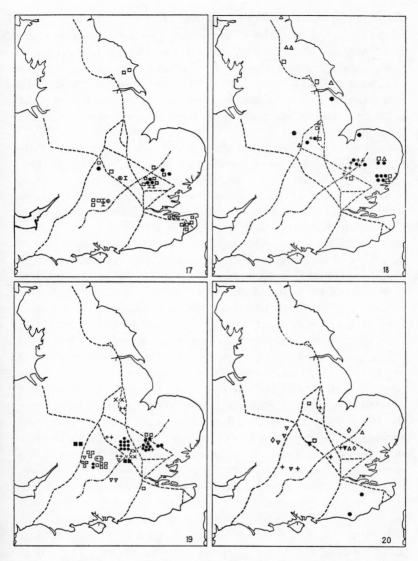

FIG. 17. Distribution of early cruciform brooches (*Ant. Journ.* xiii. 239–40)

FIG. 18. Distribution of East Anglian large square-headed brooches, on Pl. XXV: + = *a*; ● = *b*; □ = (*c*); △ = (*d*)

FIG. 19. Distribution of saucer and applied brooches with zoomorphic ornament (*Ant. Journ.* xiii. 243, Classes I–V, with additions)

FIG. 20. Distribution of large square-headed brooches, from the same mould or model, exclusive of those on Pl. XXV.

stage; though one of the Lincolnshire square-heads is unfortunately without exact provenance, and another, the late example, from Laceby, near Grimsby, has in any case only a relative significance. But when we cross the Humber to Londesborough and onwards to Thornbrough and Darlington, it becomes clear that the northern examples must have followed the great road leading to the Wall.

Clearly the simpler forms of the florid cruciform type and the Haslingfield square-head are the first to move, and so far their chronological precedence may be regarded as substantiated, while the other three types of the square-head mark a later stage in the history of the type. If that diagnosis is justified, it follows that Kenninghall I, the very simplicity of whose decoration would lead to a diametrically opposed conclusion, cannot be regarded as early, and so we gain additional corroboration of the thesis that the appearance of the guilloche, quatrefoil, and other geometric forms of ornament must be assigned rather to a revival of classical influences, derived, as already suggested, from continental sources, than to a survival of such motifs from the early history of this brooch in Denmark and Scandinavia.

The thesis may be developed further by an examination of the cultural relations which can be shown to have existed between East Anglia and the upper Thames Valley. In a paper published in 1934[1] I endeavoured to show how extensive were the connexions that archaeology can exhibit between these two regions, and every fresh line of research seems to add to rather than to subtract from the weight of evidence in favour of the correctness of the views I then ventured to put forward. Before, however, turning to these it will be well to demonstrate how the evidence of the more characteristic styles of patterns employed on saucer-brooches which I then adduced appears on a map (Fig. 19). Here at once we are confronted by a geographical picture entirely different from that drawn above. The whole trend of the connexions has changed. Indeed, it almost looks as if it pivoted on Bedfordshire. Every variety but one is represented at either Kempston or Luton. The only outliers to the

[1] *Antiquaries Journ.* xiii. 229.

north are either of types known from that county alone, or are as well represented there as elsewhere. One variety is apparently essentially West Saxon, and yet this has found its way through Cambridgeshire, just as more easterly forms of decoration have passed down to the upper Thames Valley following the same road as the equal-armed brooches at an earlier time. The discovery at Abingdon in 1934 of a fragment of this latter form, along with an undetermined object with an openwork pattern moulded in an early style, adds further grist to the mill.[1]

Once more we turn to the square-heads (Fig. 20), and we find a large group consisting primarily of specimens from Harlton, Cambridgeshire,[2] Luton, Bedfordshire, Abingdon, Berkshire, and Fairford, Gloucestershire, two of which come from the same mould, while the others, including an outlier as often before from Market Overton, are manifestly based on the same model. The latter pieces are actually rather smaller in size and less clearly executed, suggesting once more that Bedfordshire rather than Cambridgeshire was the centre of diffusion. This consideration is reinforced by evidence of other striking parallels, two of another variety from Northampton itself and Stapleford, Leicestershire,[3] that again stand out in regional contrast along exactly the same lines as did the local florid cruciform type to the parallels in East Anglia, where a comparable phenomenon is provided by a closely similar pair of square-heads from Linton Heath and Tuddenham, Cambridgeshire.[4]

There are other parallels that call for notice here owing to their distribution. The first, to which I have already called attention elsewhere,[5] manifestly originates in Warwickshire. It consists of the fine example from Bidford-on-Avon, one from Offchurch, no less than three (the third has recently come to light) from Baginton, all sites within the county, and, lastly, one which has as its provenance Cherbury Camp, Berkshire. The first-named is infinitely superior in execution to the rest, which,

[1] E. T. Leeds and D. B. Harden, op. cit., pl. IV a.

[2] C. Fox, *Archaeology of the Cambridge Region*, pl. 28, fig. 4.

[3] Åberg, 196, Table II, 15 and 19 (the latter provenance incorrectly stated to be Saxby). [4] Åberg, 195, Table II, 7 and 8. [5] *Ant. Journ.* xv. 110.

however, are clearly modelled upon it. Indeed, some of them appear to have been cast from one mould; differences in detail can be explained by the final chasing of the rough-casting.

From the midlands also comes a brooch found at Duston, Northamptonshire,[1] the counterpart to which from grave 21 at Linton Heath, Cambridgeshire,[2] is preserved at Audley End.

In the same collection is an even larger brooch from grave 32 in the same cemetery.[3] It is unquestionably very late. The chasing is almost flat and in some places amounts to no more than mere scoring of the surface, a trait that replaces the careful earlier work also on the midland florid cruciform brooches and again on the large saucer-brooches of the latest West Saxon series. An exact parallel to the Linton Heath brooch is that from Ragley Park, Warwickshire,[4] while a poor copy, on which the chasing is even more carelessly executed, comes from Quy, Cambridgeshire (Pl. XXVI).[5] Two points in these brooches may be noticed in passing. The one is that on them the craftsman has substituted for the double-furrowed bow that is normal on Anglian square-headed brooches, the high, panelled form, which, as on the Haslingfield type, was taken over from the Kentish square-headed brooch and thus, though indirectly, from the Rhineland series. The other point is the unusual animal figure repeated on each side of the foot, a standing beast with long ears, its head turned backwards and its tail curled up over its back. It has no analogue in early Anglo-Saxon work and almost seems to herald some of the spirit of Bröndsted's Anglian beast of the late seventh century.[6] For the rest, the remaining decoration of the brooch illustrates to the full the general conservatism of zoomorphic ornament in England, since it adheres closely to the canons of Salin's Style I.

[1] *Proc. Soc. Ant.* xix. 311; Baldwin Brown, op. cit., pl. LXVI. 3.

[2] *Arch. Journ.* xi. 100.

[3] Ibid. 103. I am under a deep obligation to Lord Braybrooke for kind permission to renew acquaintance, first formed twenty-five years ago, with the important collections formed by the Hon. Richard Neville in the middle of last century.

[4] *Archaeologia*, xliv. 482, pl. XVIII. [5] Ashmolean Museum.

[6] J. Bröndsted, *Early English Ornament*, 56 ff.

Some idea of the period to which belong these traces of inter-
course between one region or one tribal element and another
may perhaps be gathered from the data supplied by the Ipswich
cemetery, one that presents some remarkable features. It is
difficult to diagnose with any exactitude the date at which the
settlement came into being. From its situation it ought to be
almost as early as any, but though cremation-graves came to
light, they hardly appear to have been sufficiently numerous
for any east coast cemetery used from the first landing of the
invaders, and in other respects it produced nothing the least
early in character. It rather gives the idea of a secondary settle-
ment. Cremation is still in vogue; in one case the ashes were
accompanied by an unusual disk-brooch[1] that suggests native
imitation of Kentish models of the latter part of the sixth
century, a suggestion in some measure confirmed by the presence
in two graves of keystone-garnet brooches of Kentish fabric (my
type 1 B). It is to be noted, moreover, that apart from the large
square-headed brooches of which the cemetery yielded no less
than eight, the only other form of brooch discovered was the
broad, annular type that has an extraordinarily wide general
distribution in Anglo-Saxon England. The absence of other
common forms like the small square-headed type and its con-
geners is difficult to explain, considering their prevalence imme-
diately westwards in north Suffolk and Cambridgeshire, except
on the hypothesis of a comparatively late settlement. In that
case the cremation furnishes a good instance of the late survival
of the rite. The whole archaeological content of the cemetery
appears, in fact, as something anomalous in view of its geo-
graphical position, and raises the question whether it does not
represent a tribal entity in some measure distinct from the
occupants of the area that includes such cemeteries as Kenning-
hall, West Stow, Icklingham, Holywell Row, and the like.

It illustrates, nevertheless, one point in common with others
farther inland, namely, the infiltration of Kentish products.
Analogous material occurs at Little Wilbraham, a three-key-
stone garnet brooch in grave 172, and, even more definitive, a

[1] *Archaeologia*, lx. 349, fig. 14.

pair of brooches with radiate semicircular head and straight-sided foot found in grave 133 in association with a cruciform brooch of middle or late sixth century. Contemporary imports from Kent occur also at Burwell (a gold brooch with garnets), and radiated brooches at Barrington and Linton Heath. Baldwin Brown, remarking on the frequency of this latter type among the Franks and in southern Germany, gives a list of the known occurrences in England.[1] Out of thirty, sixteen come from Jutish cemeteries, one (should be four) from Cambridgeshire, one from Suffolk, three from Woodstone (Hunts.), one from Searby (Lincs.), two from Sleaford, one from Kilham (Yorks.), and two or three from Warwickshire. Leaving on one side the Jutish examples, the remainder seems again to bear witness to intercourse with Kent, passing through East Anglia and so onward by the route taken by the large square-heads.

The Historical Aspect

Endeavours to correlate archaeological data with historical records of the Anglo-Saxon period have frequently been made, but of late the main result has been either to recognize the extreme difficulties besetting such attempts, or to reach conclusions that place the two in diametric opposition to one another. But, if the latter result is reached in certain cases, that is not to say that such divergence invariably follows. The archaeological records are steadily becoming more ample, and on closer examination of them we seem to find a reflection of the political conditions of their time. At the beginning of the period under review the various petty states have still hardly consolidated their position. For the most part they are in direct antagonism to one another, and intercourse between them can scarcely have been established. Where any such connexions can be shown to exist, a community of blood or interest may be safely assumed. Such is the state of affairs about the middle of the sixth century, and in some cases, as is known, this must have persisted until the beginning of the next.

Kent, though steadily rising in wealth and power, has not

[1] Op. cit. iii. 256.

as yet attained to the position it occupied from about 600. That it is advancing along the road to that hegemony which Bede accords to Æthelbert (A.D. 570–617), whom he describes as ruling all the peoples as far north as the Humber, seems borne out by the objects of Kentish fabric or exports, jewellery, glass, and the like, which in the latter part of the sixth century begin to find their way to East Anglia and the midlands. The flow is, however, for the most part meagre in volume, and does not imply political domination in the manner in which we find it illustrated by similar changes on the Continent. One may cite the marked changes that take place in the upper Rhine area after the subjugation of the Alemanni by the Franks under Clovis in 496, or the complete transformation of the archaeo-logical picture in France south of the Loire after his defeat of the Visigoths in A.D. 507, or again from about 567 onwards in Italy after the coming of the Lombards. In England there is little sign of such thorough-going substitution of one culture for another except in Kent itself, and from an archaeological standpoint we are justified in holding that any such domination as Bede describes must have been of a superficial and merely nominal character. Nowhere do we encounter anything in the least resembling the rapid changes that took place 500 years later, after the Norman conquest.

All students of Anglo-Saxon archaeology have commented on the extraordinary scarcity of relics, apart from cremation-urns and their meagre contents, in the area comprising historic Deira and Bernicia. Cremation may have persisted in the north even more stubbornly than farther south, but there is little to prove it, while plenty of evidence exists to show that by the middle of the sixth century the tide was already beginning to turn strongly in favour of inhumation. The character of the remains, however, as exemplified by the products of Yorkshire cemeteries, exhibits nothing like the development observable, for example, in East Anglia. We are forced to conclude that culturally, *anglo-saxonice*, the north lagged behind the south. As a kingdom, Bernicia under Ida comes into being about 547, Deira about 560 under Ælla. Ida died in 549 and was followed

by five sons in succession, the last of whom, Æthelric, in 588, added Deira to Bernicia on Ælla's death, and at his own death in 593 bequeathed the joint kingdom to his son Æthelfrith (A.D. 593–617). The period from Ida's accession to Æthelric's death was one of perpetual and fierce warfare with the Britons, who at one stage appear to have driven their opponents hard. Under such conditions signs of cultural development are hardly to be expected. When they come they take the shape of imports from farther south and seem to portray a country settling down to more pacific conditions after a long period of incessant struggle against adversity. This fits in well, for example, with the tale the great square-headed brooches have to tell, since the residue, apart from imports, consists of several specimens such as those from Driffield[1] and Fridaythorpe,[2] East Riding, or Thorn-brough, near Catterick, North Riding, that have gone far along the road reached by the most decadent examples yielded by any of the English pagan cemeteries. History seems here to support the witness of archaeology that only from about 600 could commerce or other means safely carry the products of the south to the north. That we get so little of the very latest is perhaps explained not only by the spread of Christianity in that region, but also by the adverse times that Northumbria underwent once more on the death of Edwin about 633.

There is a possible alternative suggestion, namely, the espousal of Edwin's cause by Raedwald, King of East Anglia, his defeat of Æthelfrith in 617, and the establishment of a natural con-nexion with the north by his restoration of Edwin to the un-divided Northumbrian realm. In its favour is the domination gained by Edwin himself after Raedwald's death in 623 over both Mercia and East Anglia. The line of contract was assured by his lordship over the Lindiswaras.

When we turn to the area later known as mid-Anglia, the position is more difficult to diagnose. It would appear that the

[1] Mortimer, *Forty Years*, fig. 828, from a grave adjacent to one that yielded the example of the Kenninghall II type, and itself with a curiously Mercian look.

[2] British Museum; *Ipek*, ix, Taf. 29. 15.

northern portion of it, at any rate, had by the end of the sixth century established close relations with East Anglia, and this seems to fall better into line with Raedwald's power than with anything that preceded it. The archaeological material, however, rather points to a sort of buffer-state, drawing upon its neighbours, but preserving a limited degree of cultural independence. It is not, however, excluded that the archaeological evidence, more especially that of the latest material which brings Warwickshire (Mercia) into the picture, reflects temporary connexions created by Penda's conquest of East Anglia in 635 and his establishment of his son, Peada, as his representative in mid-Anglia.

The southern portion of the same area is from the outset, and still remains during the period under review, indubitably Saxon in its archaeological character. As I have ventured to maintain elsewhere, there is nothing that warrants its being labelled as Anglian, using the term in a cultural sense, whatever it may have become after the heathen burying-grounds had been deserted. The historical significance of this must remain a moot problem, so long as historians ignore the entire absence of early Saxon material south of the Berkshire and Wiltshire Downs. All the early connexions of the upper Thames lie eastward into Bedfordshire and Cambridgeshire. It is not until the period of the great square-heads that we detect a certain degree of cultural independence such as accords well with the establishment of a permanent state towards the close of the sixth century. Subsequently the easterly connexions still persist; but later still, definite relations with the lower Thames supervene, giving West Saxon culture a complexion distinct from that of its relative east of the Ouse watershed.[1] The brief entry of 593, recording Ceolwulf's antagonism to the Angles, perhaps reflects a state of things that may account for this development, though we have no details to indicate the particular Anglian tribe concerned. Possibly it foreshadows the long struggle that ensued with Mercia, culminating in Penda's defeat of Coenwalch in 645.

[1] *Ant. Journ.* xiii. 245.

VI

THE FINAL PHASE

THE study of Anglo-Saxon archaeology has in the past been profoundly influenced by historical records of the introduction, or rather resuscitation, of Christianity in England. It cannot for a moment be deemed to have lapsed entirely, since the writings of Gildas and the statements of Bede and others bear ample witness to some degree of survival in the face of the invasions, even though it were in the degraded condition that evoked the strictures of the first-named author or in circumstances of stress and opposition due to the paganism of the Anglo-Saxons at their first coming. One result of this attitude has been that the arrival of Augustine's mission in 597, the account of the conversion and baptism of Æthelbert under the influence of his Christian queen Bertha, the daughter of the Merovingian king, Charibert, has been heavily overstressed. This over-emphasis has led to a belief, now very largely discounted, that west to east orientation connoted burial under Christian influences. It also has given rise to the view that when Christianity was adopted in any given district the pagan burial-places rapidly fell into disuse, and the practice of depositing personal possessions, whether arms, jewellery, or other equipment with the deceased quickly came to an end. The main result of this attitude has undoubtedly been a tendency to antedate the bulk of the relics discovered in Anglo-Saxon cemeteries, a tendency from which the writer himself has in the past not been entirely free. Otherwise, granted these swift effects of Christianity, it seemed impossible, from considerations of the principles of evolution, to arrange those relics within the comparatively brief period of time between the first landing of the new-comers and the approximate date at which the forces of conversion were supposed to have completely changed their burial customs. The principal reason underlying this interpretation of the material may fairly be said to have been the early date of Æthelbert's conversion.

But was that assumption justified? In previous chapters I have tried to justify the long-accepted view that the finest, or perhaps more properly the most magnificent, jewellery of the Kentish craftsmen has to be dated to the seventh century, and to show that the attribution of this jewellery to native craftsmen influenced by Teutonic styles at an earlier period is absolutely untenable. If the latter view be, as I hold it should, relegated to the limbo of lost causes, everything points, as Mr. Reginald Smith affirmed long ago, to some of the more pretentious pieces having been deposited in the graves in which they were found as late as 625.

The evidence that I have presented to show that the practice of cremation lasted far longer than has been hitherto suspected, and the consequential arguments for a later dating of certain classes of ornaments in vogue outside the Jutish area, render it even more probable that a larger body of the material should be assigned to the seventh century than one would previously have been inclined to believe.

Let us consider for a moment the group of cemeteries explored by Bryan Faussett on the downs south of Canterbury. We have seen that there are few or no early objects among the relics recovered from them. Their *floruit*, in fact, seems to cover the latter half of the sixth century and the early decades of the seventh, for they have produced some of the most important groups from which the survival of deposition of objects with the dead have been deduced, the outstanding feature of these objects being the richness of the cloisonné jewellery.

But is that the end of these cemeteries? Far from it. Actually they include a high proportion of graves containing no relics whatever, a phenomenon not indeed unknown in other cemeteries where there is less cogent proof of long-continued use. At the same time it is characteristic, as will be seen, of certain cemeteries outside Kent which can on various grounds be deemed to be late, one of these grounds being that their material is even in advance of the extravagantly florid jewellery that is so marked in the non-Kentish districts.

Furthermore, if the pages and plates of Faussett's *Inventorium*

Sepulchrale be carefully studied, it will be noted that even in Kent there is a small residue of objects which cannot be brought into the preceding periods of artistic production in that county, and which for that reason requires to be examined on its own merits. The result of that examination will show that pagan practices died slowly, and that, not only in the less cultured parts of England, but even in Kent, there is to be detected a homogeneous class of material that must postdate the period of the zenith of Kentish cloisonné jewellery as known to us, and thus allows us to advance our recognition of the progress of Anglo-Saxon art and archaeology a stage farther into the seventh century.

The realization of this fourth period can only be obtained by a multitude of cross-references from Kentish material to that from other districts, and perhaps the easiest road towards that realization is by way of the small but particularly characteristic group from a series of graves at Uncleby in the East Riding of Yorkshire, excavated by Canon Greenwell in 1868 and described by Mr. Reginald Smith in 1912 (Pl. XXVII).[1] The objects are preserved in the Yorkshire Museum at York. The paucity of relics and their close resemblance to others found in Kent led Mr. Smith to suggest that the interments were those of converts who had come under the influence of Paulinus and his deacon James in the second quarter of the seventh century. This suggestion, as will be seen, is greatly weakened by the discovery of grave-furniture of identical character in widely separated parts of the country. In any case, whatever might be true of Yorkshire, the argument seems to leave Kent a quarter of a century behind the northern county in its comprehension of the implications of acceptance of the tenets of Christianity.

In point of fact the relics from Uncleby reveal some slight connexions with the preceding period of Anglo-Saxon archaeology, such as the presence of amethyst beads and of others of red glass paste inlaid with yellow and green, like those which form so marked a feature particularly of graves in East Anglia. The principal novelties are the use of bronze buckles of small size and especially of diminutive annular brooches, barely an

[1] *Proc. Soc. Ant. London*, xxiv. 146.

inch in diameter, made of narrow rounded metal, either plain or decorated with groups of transverse lines. Others of the brooches are somewhat larger, but in no case as large as the annular brooches of an earlier date. These examples are again plain or ornamented with transverse mouldings and, in addition, with one or two pairs of confronted animal-heads. The pairs of heads vary in type. Either they are rounded, with wide-opened, outward-curving jaws, or they are of elongated form, in a style resembling Salin's Style II, with hooked, closed, beak-like jaws, recalling examples from all the earlier stages of Teutonic ornament.

The richest grave from the cemetery contained a silver pen-annular brooch, of flatly rounded metal with corded borders, the ends terminating in animal-heads analogous to the first type described above, and with cabochon garnets in gold filigree settings for eyes. Accompanying it were a silver pin, a bronze thread-box, knife, steel, a bronze bowl with drop handles on a tripod ring stand, a gold pendant,[1] and finally a bronze buckle. As Mr. Smith remarks, the bowl compares with one from Gilton, Kent, and the buckle with one from Sibertswold[2] in the same county.

One grave produced a fragment of gold cloisonné work, pro-bably genuine Kentish work. The beads demand notice. They are scanty, but typical. Apart from the amethyst and coloured beads already mentioned, they are almost invariably small, and either biconoid or roughly cylindrical, in clear dark or bright blue, or in dull red, dull green, or grey opaque glass, all forms and colours that repeat themselves again and again in associated groups assignable to this period.[3] There were none of the com-mon dark-blue glass ring-beads, none of amber and none of variegated paste, especially those with guilloche and spot inlays.

Finally, the cemetery produced four cylindrical bronze thread-

[1] Two were found in the cemetery, but which belonged to this grave Mr. Smith was unable to determine. [2] *Inv. Sep.* pl. IX. 12.

[3] It is noteworthy that the sole authenticated discovery in Scotland of objects assignable to the period reviewed in these chapters are beads of this class found at Hound Point, Dalmeny, Linlithgowshire, in 1915.

boxes and four long knives (scramasaxes), a bossed pendant of silver, and, lastly, a small safety-pin brooch barely an inch long.

Comparable in some degree is the cemetery explored by Mortimer at Garton Slack, also in the East Riding (Pl. XXVIII).[1] Here again we have small buckles, small annular brooches, one accompanied by a gold circular pendant with garnet centre, bronze thread-box, amethyst and other beads; another by a pear-shaped pendant of jet in a gold mount. Two flat annular brooches of large size mark the transition from the preceding period. These were among the contents of thirty-two graves (in which, incidentally, no weapons of any kind were found) lying 46 feet distant from another group of thirty-odd interments which were entirely devoid of relics. These latter graves would seem to answer better to Mr. Smith's converts. A grave explored also by Mortimer on Painsthorpe Wold[2] contained amethyst and the usual simple beads, an annular brooch, thread-box, knife, and the remains of a satchel with bronze fittings, amongst which a tab decorated with plait-work is worthy of notice.

South of the Humber from Riby Park, near Grimsby, where several skeletons arranged in regular rows were discovered during the war, comes an interesting group of objects now in the County Museum at Lincoln.[3] Here again we have the same small annular brooch, the same amethyst and dull paste beads as at Uncleby, a scramasax, and, lastly, a remarkable vase, red in colour and in form strongly reminiscent of some of the cruder beakers of the Bronze Age, but, as the stamped decoration shows, clearly not of that date. From Searby in the same latitude a few miles west comes a penannular brooch with a pair of confronted animal-heads with gaping jaws. An annular brooch of the same class, but with the second type of confronted heads, from Faversham, is in the British Museum.

Important cemeteries containing graves in which the dead persons were furnished with equipment closely resembling that

[1] *Forty Years*, 247, pls. LXXXIV–XC.

[2] Ibid. 117, pls. XXXIV–XXXV, figs. 278–81.

[3] To the former Curator, Mr. Arthur Smith, I am indebted for the facts regarding these discoveries.

from the more northerly cemeteries have been explored by Mr. T. Lethbridge in Cambridgeshire. Alike at Burwell[1] and at Shudy Camps he has excavated large numbers of graves, a considerable proportion of which were entirely devoid of relics. The remainder almost without exception produced nothing except the classes of objects which serve as the hall-mark of the period. The same small buckles, bronze thread-boxes, the same types of beads and scramasaxes[2] repeat the former story. In addition, Mr. Lethbridge draws attention to the frequent occurrence of small boxes, the existence of which is evidenced by bronze clamps and latches. Curiously, the small annular and penannular brooches appear to be lacking; but these cemeteries have produced examples of what I shall hope to show later must be regarded as the distinctive jewellery of the period. Special notice must be drawn to the remarkable thread-box from a grave at Burwell. It has a projecting flap to which the suspensory chain was attached, and this flap is decorated with a pair of heads in Salin's Style II, accompanied by two aimless guilloche twists. These in themselves afford a criterion of date; in addition the interlaced beasts on the walls of the box cannot possibly be earlier than the seventh century, and the treatment of the beasts will scarcely admit of their ascription to the early seventh century at that. When added to the fact that the box exhibits signs of considerable wear, it offers important corroboration of the late date of the series of graves in which it was found. In itself, too, though it might be regarded somewhat in the light of a long-cherished piece, this box presents features which favour the argument for a long survival of pagan custom and thought. On its lid are embossed crudely executed scenes, among which can be clearly detected a hero slaying a monster, which, as Mr. Lethbridge notes, may fairly be interpreted as representing Beowulf and the dragon, or Sigurd and Fafnir. Two graves at Burwell contained large annular brooches, in

[1] *Recent Excavations in Anglo-Saxon Cemeteries in Cambridgeshire and Suffolk* (Cambridge Ant. Soc., 4th publication, New Series, no. III. 47).

[2] The appearance of this weapon is in England, as on the Continent, indicative of advanced date.

one case attached to a chatelaine, so that here again we have a link with earlier cemeteries. This and the large number of objects in graves nos. 42 and 127 at Burwell hardly warrant Mr. Lethbridge's description of these cemeteries as Christian. Once again the element of paganism is clearly discernible, but in view of the large number of unfurnished graves it is evidently on the wane.

The same phenomenon is encountered again in the midlands. Saxon cemeteries are rare in north Oxfordshire, but in recent years I have been able to explore graves at North Leigh and Chadlington, where such as contained any relics at all, apart from knives, thread-boxes, and scramasaxes, yielded the remains of a spherical 'pommel'—to use Faussett's description of a similar object from grave 76 on Kingston Down[1]—constructed of graduated tiers of bronze disks surrounding a tube and divided by bronze septa between which were inserted small slabs of shell. The Chadlington example was in addition mounted in a framework of beaten gold filigree.

In the above survey we have been dealing almost exclusively with areas occupied by Anglian and Saxon tribes, and in none of the cemeteries reviewed has there been any trace of the most characteristic ornaments of these people, whether it be elaborate cruciform, large square-headed, saucer, or applied brooches. All these had either gone out of use or fashion, or their deposition in the graves was deemed unnecessary for the welfare of the deceased in their future life. The former seems to be the truer interpretation of the facts, since, as already noted, and as will appear more clearly from the sequel, some of the graves were by no means poorly furnished.

We must now direct our attention to Kent, where we shall find exactly the same phenomena. But first by way of an initial step in linking the non-Kentish finds with those from Kent itself, we may turn back for a moment to Yorkshire. Grave no. 31 at Uncleby furnishes one more extremely important contribution towards the definition of this late period of semi-pagan Anglo-Saxon culture, namely, a bronze buckle with an oblong plate

[1] Loc. cit., p. 55.

decorated *à jour* with a stepped opening at each end and between
these another of cruciform shape. If then we turn to plate IX of
Inventorium Sepulchrale, we shall find four buckles decorated in
a similar manner, though varying in their treatment (Fig. 21).[1]
So far as English material is concerned these Kentish examples
might tell us little, were it not for the Yorkshire parallel, since
they were found with little that is of value for comparative
chronology, less, indeed, than that accompanying the Uncleby

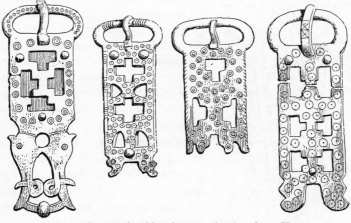

FIG. 21. Bronze buckles decorated *à jour* from Kent

specimen. One example from grave 94 at Sibertswold,[2] how-
ever, provides valuable corroboration of quite another kind. It
is unique among examples of zoomorphic ornament in this
country in having a pair of animal heads at the hinder end of
the plate. These animals have protracted jaws with the trian-
gular point at the base of the lower jaw which is so marked a
feature of Salin's Style II, but what is quite astounding is that
the jaws are so elongated as to allow the lower to be coiled back-
wards below and across itself until its tip protrudes at right
angles above the upper jaw. This peculiar treatment is no fancy
of any Anglo-Saxon craftsman, but is once more a loan from the

[1] Another from Breach Down, Kent, is in the British Museum.
[2] *Inv. Sep.* pl. IX. 7; here Fig. 21 left-hand example.

Continent applied to an English form of buckle that to the best of my knowledge has no counterpart abroad. It is to be seen on a belt-plate from Murr, Württemberg,[1] assigned by Veeck to the late sixth century (it might well be seventh), on that from Amt Stockach, Baden (Fig. 22),[2] and even more strikingly on a

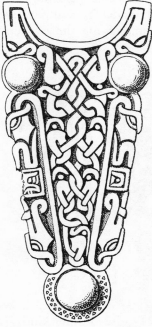

huge iron buckle inlaid with silver from Fétigny, Kanton Freiburg, Switzerland,[3] one of a class invariably assigned by continental archaeologists to the seventh.

Up to the present we have been concerned with a number of inconspicuous objects, which would seem hardly valid evidence on which to base a theory of a stage in the evolution of Anglo-Saxon culture, and we may fairly ask if this is sufficient for that purpose. In view of the finer jewellery of the earlier periods, however barbaric much of it may seem, whether it be the more elaborate specimens of non-Kentish production, or even the technically and to some extent artistically magnificent output from Kentish workshops, we should feel it strange if we were forced to admit that everything in the way of skill and aesthetic perception had faded suddenly out.

FIG. 22. Bronze buckle, Amt Stockach, Baden (after Salin) (¼)

That would leave nothing to carry on the tradition of Early Anglo-Saxon craftsmanship towards the later period of Anglo-Saxon art, when it manifests itself in so striking a degree. In reality there is no blank to fill. This period has a jeweller's art of its own, as distinctive as any that preceded or followed it.

[1] W. Veeck, *Die Alemannen in Württemberg*, pl. L. 14 *a–b*.
[2] B. Salin, *Altgerm. Ornamentik*, fig. 680.
[3] Ibid., fig. 306; von Jenny und Volbach, *Germanischer Schmuck*, pl. 35, fig. 4.

It is from Faussett's cemeteries that some of the best evidence for its existence is to be derived. The two outstanding examples are Sibertswold, grave 172, and Barfriston, grave 48. The contents of the former consisted of eight gold-mounted pendants, four of oval or drop-shaped form set with amethysts, a fifth set with an oval plaque of mosaic glass-paste, and two others set with inlaid glass. In addition there was a circular gold pendant with a wheel-like design executed in fine imitation plait-work filigree, a four-pointed central star with garnet cloisons in the rays and a boss of garnet and shell in the middle, and between the spokes of the wheel four small cabochon garnets in filigree settings, the whole in a simple, quiet taste, compared with the ornate work of the latter part of Period III. The grave also contained two gold coins, minted at Verdun and Marsal respectively, iron shears, another iron instrument, and a vase of coarse red ware. Compare with it the contents of Barfriston 48. Here we have a similarly mounted set of pendants, oval, triangular, or circular, of amethyst or garnet, accompanied by two glass vases with pointed bases, a small bronze pin, and a short string of two amethyst and seven other beads.

Two or three points here call for notice, the use of cabochon instead of, or rather in addition to, flat slabs of garnet, change of fill-up filigree from ♡ to S and annulets, introduction of pseudo-plait filigree, and the class of pendant with a single cabochon jewel. So far as I have been able to discover, all these are distinctive of a class of jewellery predominant in this period. The small cabochon settings we have already seen in the small brooch from Uncleby; they appear on a neat, flat, annular, silver brooch from Barrington, Cambridgeshire, which can be contrasted with the well-known example from Welford, Leicestershire,[1] with its superimposed gold plate, decorated with bosses of shell inset with flat garnets and adorned with S-loops and rings of twisted filigree. Beaded settings which surround all but one of the pendants are again something new, and, as bearing out its claim to be regarded as a change of style, not of course a newly invented technique, it is worth noting that in no case recorded

[1] J. Y. Akerman, *Pagan Saxondom*, pl. XXXII.

by Faussett was the type of drop pendant with cabochon jewel found in any association that can be said to indicate a date before the seventh century.

But it is from the Merovingian coins in the Barfriston grave that we derive the most valuable evidence as to the date of this and analogous jewellery. We may pass over the specimen coined at Verdun; it has features that are incapable of close dating. It is otherwise with the *triens* struck at Marsal. It bears on the obverse a head to right, and the legend MARSLLOVIIC, a bungled version of MARSALO VICO, and on the reverse TOTO MONETARIO and a *croix ancrée* that gives the clue to its date. This last is held by French numismatists to have been the invention of the mint-master Eligius, who struck coins for Dagobert I (A.D. 628–38) and Clovis II (638–52). His name appears on coins struck at Marseilles, Arles, and Paris, and he has been identified with the famous jeweller Eligius or Saint Éloi who appears at the court of Chlothair II (A.D. 584–628), and became an ecclesiastic of great influence and importance under his successors, being created Bishop of Noyon in 640. It has been contended by Barthélemy that the identification will not stand, since the mere fact of this election would at once preclude the idea of his having been a mere mint-master under Clovis II, but apart from the common combination of jeweller and monetarius in those times—we may think of our own St. Dunstan—it is noted by Engel and Serrure[1] that among the numerous names of persons of note of the period the homonyms are very numerous, but that the name of Eligius has no parallel, and as his name appears on coins of Dagobert I and Clovis II it is impossible to dissociate him from the ecclesiastic, statesman, court official, and artificer, who appears in the later Saint Éloi. The authors of the *Traité* conclude with these words: 'Est-il besoin de demander si le monétaire Eligius et le ministre Eligius sont le même personnage? Pour notre part nous ne pensons pas. L'identité de Saint Éloi est un des faits les plus nettement démontrés de l'histoire numismatique de France.'

Here, then, we have an excellent reason for dating the Siberts-

[1] *Traité des monnaies du Moyen Âge*, i. 78.

wold grave to a period after 630, and so to one that confirms the grouping within a special period of the material already reviewed. That the change of fashion represented by the novelties constantly recurring in these groups was initiated in Kent we may well believe. In the other less well-to-do Anglo-Saxon districts their occurrence is more sporadic and usually in humbler associations. If it is desirable to gauge the possible range of types within which the change of fashion can be observed in Kent itself, good illustrations are provided by a grave-group from Chartham Downs, and by that from Sarre which contained the great jewelled brooch, called Sarre I in my Class III *d*.

The former, discovered in 1730, is recorded in transcripts from the original account of the excavations by Dr. Mortimer, Secretary of the Royal Society, both by Douglas[1] and by Bryan Faussett,[2] and the principal contents of the grave, with the exception of the glass vase figured on another sheet, are here reproduced from one of the admirable water-colours with which Faussett illustrated the manuscript text of his own collections (Pl. XXIX*a*).[3] Here, as will be seen, a gold pin, part of a linked pair, a cabochon garnet pendant, and typical amethyst and plain, opaque glass beads are all present. The earlier traits are provided by one or two beads, of varieties commonly associated with sixth-century grave-groups, and by the circular, jewelled brooch, which, however, when examined closely, can be seen to exhibit several features that mark it down as one of the latest of Class II. These are annulet filigree, cabochon settings in the bosses, and the rather simple cloisonné design with Y divisions, recurs in the framework of a pendant from Forsbrook, Staffordshire (Pl. XXX*a*),[4] containing a solidus of Valentinian I (375–92), that of course affords no criterion of the real date of the

[1] *Nenia Britannica*, 99, pl. v, 1, where the glass vase is figured.

[2] *Inventorium Sepulchrale*, 163 (barrow A).

[3] Bryan Faussett MS. 6, p. 50. Reproduced by kind permission of the Director of the Liverpool Public Museums. The gold pendant (top right) comes from another grave, but clearly belongs to the same period. Another sheet (Pl. XXIX*b*) shows a large series of the small buckles, found with women such as commonly occur as the sole relic in graves in the later cemeteries.

[4] British Museum, *Guide to Anglo-Saxon Antiquities* (1925), 62, pl. IV. 2.

jewel. The same design is executed in pseudo-plait filigree on a gold pendant with bevelled garnet centre from Kingston Down (grave 96), along with amethyst and other beads and a thread-box.[1]

The other limit, if indeed there is any distinction at all, except in so far as the Chartham Downs brooch belongs to a class which has a longer ancestry, is provided by the Sarre group with its huge brooch with bevelled and cabochon garnet settings and annulet filigree, associated with coins of Mauricius Tiberius (578–602), Chlothair (585–628), and Heraclius (613–50), in every case barbarous copies. The beads of this rich grave are once more amethyst and the usual plain-coloured opaque glass.

On the basis of the foregoing survey we can confidently place other fine jewels within the same period (Pl. XXX). With these goes, firstly, the necklace from Brassington Moor, Derbyshire,[2] consisting of drop-shaped and triangular garnets with rounded faces in the same beaded settings as those from Sibertswold, and, in addition, biconoid beads of coiled gold wire, or imitations thereof, as well as two small, bossed, circular gold pendants of a class that occurs in silver in contemporary finds at Cowlow, Derbyshire (Fig. 23 a),[3] and also in Cambridgeshire and elsewhere. A close parallel to this necklace is afforded by the necklace from Desborough, Northamptonshire,[4] with similar stone-set and plain circular gold pendants and beads of coiled wire, and at its middle a Latin cross with the typical cabochon garnet at the junction of the arms.[5] Lastly, the beads and pendants from Cowlow, Derbyshire, and from Roundway Down, Wiltshire (Fig. 23 b), which are all of the same type as those on the other necklaces and are accompanied by pairs of pins set with cabochon garnets and linked together by chains.

[1] *Inventorium Sepulchrale*, 57, pl. IV. 11.
[2] Sheffield Museum, *Catalogue of the Bateman Antiquities*, 222, J. 93–707, (H. 2.) figured. [3] Sheffield Museum, loc. cit. 221, J. 93–704 (H. 36).
[4] British Museum, *Guide to Anglo-Saxon Antiquities*, 75, pl. IV. 4.
[5] The buckle from Tostock, Suffolk (Pl. XXX g), must also be placed here. Its large, bevelled slabs of garnet are secured by dog-tooth mounts in the manner of the Barfriston pendants. Its rivets, too, though without settings, imitate the cabochon jewels in form and have similar beaded collars.

In the British Museum is preserved a small group of relics
discovered in 1862[1] by J. Y. Akerman at a spot two furlongs

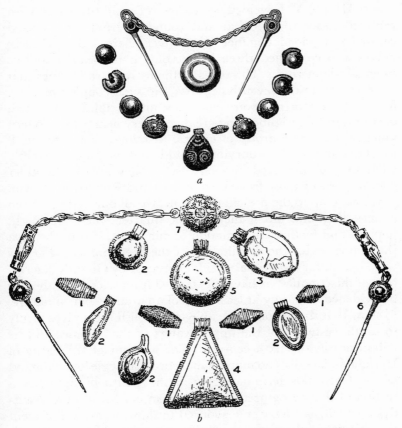

FIG. 23. (a) Jewelled pins and necklace, Cowlow, Derbyshire.
(b) Jewelled pins and necklace, Roundway Down, Wiltshire.

west of the large cemetery excavated by him at Long Witten-
ham, Berkshire, in 1860 and 1861.[2] In all, ten graves were found,
most of them, if not all, orientated east to west. Some contained
no relics; one had a knife only; another a tinned bronze buckle

[1] *Proc. Soc. Ant.*, 2 S., ii. 133.
[2] *Archaeologia*, xxxviii. 327 and xxxix. 135.

with elongated plate and counterplate of the form familiar from the huge Frankish specimens of the seventh century. Two others, graves III and VII, yielded each a pair of small silver pins with rounded heads, flat behind and round in front, with bossed centre, and joined together by a silver chain. One of these graves also contained three bright blue glass beads and two silver slip-knot rings. The relics in themselves are of types that must belong to the seventh century. No such coupled pins are found in the larger Saxon cemeteries, and certainly none such occurred in the neighbouring great cemetery nearer the modern village. This little group of graves, therefore, speaks for itself as a later and separate burying-ground, and the pins are exactly what may be expected in such cases. They are the humbler counterparts of those from Desborough and Roundway Down.

We have up to the present drawn nearly all our material from eastern England, but if there is one quarter where we might hope to find further confirmation of our thesis, it is in the area that came under the domination of the West Saxons. Farther west, except for the primary raids envisaged by Gildas's description of the conquest as having extended from sea to sea, there is no evidence, certainly at least none of an archaeological nature, to show that the Saxons were able to establish themselves firmly to south-westward of the upper waters of the Thames and its tributaries in the sixth century. The account of the battle of Dyrham in fact does no more than record a struggle for command of the Cotswolds terminating at Bath. South of Bath lies a section of that recognizedly post-Roman earthwork, the Wansdyke, which, as I have endeavoured to show, seems to represent the principal attempt of the British to raise a bulwark against the penetration of south-western Britain by the invaders.[1] That interpretation fits in well with the record of the great slaughter at Wodensbeorh in 592, that led to the expulsion of Ceawlin, the more pertinently because we find mention in the charters of a Wodensbeorh in the parish of Alton Priors lying immediately south of the Dyke a short distance from Devizes. It fits in equally well with the great scarcity of archaeological finds of the period

[1] *History*, 1925; *Ant. Journ.* x.

of the conquest in that area. The Dyke, running from Saver-
nake Forest to the Bristol Channel, lies directly athwart any
advance from the north into central Wiltshire and Somerset.
It is inconceivable that Coenwalch should be fighting at Brad-
ford-on-Avon as late as 652, if the Saxons had not received a
severe check to their attempts at progress beyond the Avon some
time previously.

The first Saxon cemetery of any size beyond the Avon came
to light only some eight years ago at Camerton, a place on the
Fosse, south of Bath. Excavated under the supervision of the
very Rev. Dom Ethelbert Horne,[1] it stands out as a grave-
field of peculiar interest when compared with all the larger
cemeteries previously discovered in the West Saxon area. It
yielded some 110 burials, all orientated west to east, a consistency
that at any rate is characteristic of late cemeteries. The majority
of the graves were devoid of any associated relics. Some few con-
tained only a knife. Only a mere fifteen in number yielded objects
from which comparisons could be drawn, and these produced
material exactly analogous to that from Uncleby and other places
described above (Pl. XXXI). There is the same general com-
bination of beads, omitting some odd examples in amber and
variegated glass, the same small silver bullae as at Burwell and
elsewhere, but again, as usually elsewhere, the same meagreness
in quality and quantity. One grave (no. 5) contained rather
more: five silver rings, six beads of blue (not the dark blue of
early graves) or yellow glass, a bronze pin, and two silver pen-
dants, the one embossed with a cross with wide-spreading arms,
in the angles of which are trefoil loops. This piece may be aptly
compared with the cross found in Canterbury, which is of the
same form and has trefoil loops engraved upon each arm.[2]

[1] To whom I am greatly indebted for information and illustrations.

[2] *V.C.H. Kent*, i. 382, fig. 26. Figured in the Burlington Fine Arts Club's
Catalogue of the Exhibition of *Art in the Dark Ages in Europe, c. 400–1000 A.D.*
(*1930*), A. 52, pl. III. The Canterbury cross is there assigned to the eighth
century. Its analogy to the foregoing pieces may allow of its being dated to
the late seventh. In any case it is clearly in the same tradition.

In form it recalls St. Cuthbert's pectoral cross (ob. 687), well worn before
deposition in his grave.

There is a pendant in Hull Museum similarly ornamented, and another from Wye Down, Kent, in the British Museum.

The second pendant from Camerton is embossed with an elaborately coiled serpent or pair of serpents. Here again we have a motif that never appears in earliest Saxon art, but occurs repeatedly on late pendants in Kent.[1] Several of these have the spotted bodies to which I have previously drawn attention. One from Wingham was found in a seventh-century context, and the same is probably true of that already shown from Chartham Down.[2] Some, as this last, are pure interlacing with no actual trace of zoomorphic features, but it may be noted that there is a gradual tendency to replace the Salin Style II head for one snake-like in form, as on the Camerton example. We may compare the specimen in the hoard from Wieuweerd, Friesland,[3] a hoard that contained worn coins of Chlothair II (A.D. 616–28). That it represents no more than a natural zoomorphizing development of the plait is likely enough, but once more the idea may be regarded as a loan from the Continent, where this snake form appears on such pieces of late cloisonné jewellery as the fine circular brooch that forms part of the rich Wittislingen grave-group.[4]

Novel ornamental ideas that we find in full vogue in the Lombard cemeteries, e.g. Castel Trosino and Nocera Umbra (the initial date of which is 568), in coin-associations such as copies of Justinian (527–67), Tiberius II (578–82), and Mauricius Tiberius (582–602), are by the time they have percolated to Germany, the Low Countries, and England found to be sinking down in time, and thus the general coin-associations have become Mauricius Tiberius, Chlothair, and Heraclius.

So we have at Camerton once more exactly what might have been expected, one of these late cemeteries with poorly furnished

[1] See Åberg, figs. 246, 249, 251, and 252.
[2] Åberg, fig. 252. [3] Åberg, fig. 294.
[4] Von Jenny und Volbach, *Germanischer Schmuck*, pl. 42. It is a constant feature of early manuscripts and of stone carving. A good example of the latter may be cited from the porch of Monkwearmouth Church, attributed to Benedict Biscop, c. A.D. 675 (R. H. Hodgkin, *A History of the Anglo-Saxons*. fig. 51). Compare the Farthingdown stoup (*supra*, fig. 15 b).

graves producing material that has little resemblance to any-
thing that has preceded it, at any rate in the districts outside
Kent. It is there that one can detect in a somewhat earlier con-
text the elements from which this cultural phase is built up.
Even there their date in the seventh century is assured. The
continental comparisons fully bear this out.

Enough has been said to indicate how closely in many respects
Anglo-Saxon art, more particularly in Kent, moved in con-
sonance with the changes that follow one another on the Con-
tinent, and yet throughout there can be observed a repetition
of that individual expression that is so strongly emphasized
through the ages whenever a newly introduced style or culture
has once established itself firmly in this country. For a time it
follows that of its parent stock or of its continental congeners
fairly closely, and in so doing tends to degenerate from lack of
fresh impulses. But these are bound to come; and as a rule it
has been in Fox's lowland zone that they have made them-
selves earliest felt. At no time is this more evident than in early
Anglo-Saxon days, for it is the lowland zone which corresponds
almost exactly with the area that fell to the invaders in the first
two centuries of their settlement.

Beyond it lay the Celtic fringe, greatly impoverished by the
raids of the Scots, Irish, Picts, and the initial bands of Anglo-
Saxon invaders themselves in the days succeeding the end of
Roman rule. Celtic literature and art, and the Celtic church,
had retreated to the fastnesses of the highland zone, and between
the Celt and the Saxon there was bitter war for many years.
During that period there existed ties of language, blood, and
culture between the various tribes of the new-comers, and, as we
have seen, they were sufficiently close to allow an interchange
of ideas in spite of tribal antagonisms.

One thing, however, is certain. Even in the conquered terri-
tory the Celtic element could not be entirely crushed or super-
seded. That the spirit was still alive is demonstrated by the
small traits that make themselves discerned even in the darkest
days, and when these were past, it leavens Anglo-Saxondom
still more strongly, pouring back from the Celtic world of the

north and west to invigorate the stiffness of Anglo-Saxon art with a liveliness and freedom that it would otherwise have lacked. The close of the seventh century witnessed the reaction of Celtic influence on the Anglian north. The Book of Lindisfarne, the carved stones of South Kyme, Lincolnshire,[1] show how forcibly it was working already in the eighth, and it would only be just to say that the brilliance of the southern Winchester School, despite all that it may have owed to foreign inspiration, would have been sadly dim without the quickening fire it derived from the undying Celtic flame.

Anglo-Saxon art in its infancy is dry, arid, and uncouth; in its maturity it has a vigour and a naïve freshness sometimes amounting to grace. Does this mean that Anglo-Saxon art had borrowed what it felt it lacked and infused itself therewith, or does it mean that the conqueror fell a captive to the conquered? With the reservation that there was an element it never conquered, the latter is, I think, more nearly true. Only Gildas could exterminate the Briton; the Roman never did nor indeed tried to, and it was beyond the power of the Anglo-Saxon. That his failure was his ultimate gain, is beyond all need of proof.

[1] *Antiq. Journ.* iii. 118.

APPENDIX

KENTISH CIRCULAR JEWELLED BROOCHES

WHEN we examine the most characteristic form among the Kentish jewellery, the circular brooches, and study the process of their evolution in England, we see that the early stage, as I have already stated in Chapter III, is the small composite brooch with radiating cloisons filled with wedge-shaped garnets, a type well known in Frankish cemeteries; but, as I have already pointed out, there ensues in Kent no logical series developing from this form as on the Continent. There is, however, another simple contemporary form like one from Andernach,[1] with four small garnets in free-standing settings on a chased background with a slightly raised rim, the chased design being of a simple geometric kind, e.g. Gilton, grave 41, or Sarre, grave 158, with four garnets and an amorphous design in the intervening panels. This latter is essentially the type that becomes so prevalent in Kent and is that for which alone of the circular jewelled brooches Mr. Kendrick gives the incomers any credit. It is here termed Class I and in Kent it shows four distinct stages:

(a) (Pl. XXXII, 1–3). Usually with three, rarely with four (as at Ash, Fig. 2) wedge-shaped garnets alternating with a very schematic couchant animal in a style akin to Salin's Style I. Only in one case, Sarre grave 4, does the animal retain the claws on its foot. The outer border of the brooch is invariably nielloed in small triangles, leaving a zigzag band between them. The rim is usually plain or beaded throughout; only in a few cases is it worked in what I have termed elsewhere the 'light-and-shade' style, in which plain alternate with beaded sections.[2] It is common to find the rim flat and raised considerably above the central field on which are placed the garnet settings. The animal ornament is evidently not in its first infancy, and my earlier dating of Sarre 4 must yield to the now accepted date of mid-sixth or later. Incidentally it allows the square-headed brooch from Howletts to be similarly dated (not c. 600, as Mr. Reginald Smith suggested),[3] inasmuch as the disk on its bow is identical with the circular brooch from the same cemetery assigned by him to mid-sixth. The brooches from the Jutish cemetery at the Chessel Down, Isle of Wight, are of this type.

[1] My *Archaeology of the Anglo-Saxon Settlements*, fig. 26, middle row, left-hand side.　　　[2] *Ant. Journ.* xiii. 245.　　　[3] *Proc. Soc. Ant. Lond.* xxx. 108.

(b) (Pl. XXXII, 4–8). Perhaps a seeking after symmetry prompted the filling of the zoomorphic panels with a pair of heads, e.g. Gilton 27 or 76, linked together by a Siamese-twin body. It is certainly an elaboration of type (a), for during its vogue additional jewels, either circular or of elongated wedge form, were inserted between the principal wedge garnets, with the result that the space available for zoomorphic ornament admits of no more than the two heads joined by a pair of lines beneath the secondary jewel. This device is eventually converted into a loop-like design (Pl. XXXII, 8), one of rare occurrence. The outer border again has triangular niello; the rim is invariably decorated in the light-and-shade style. The size of the brooch is consistently larger than is that of the preceding class. The brooch found at Little Wilbraham, Cambridgeshire, belongs to this class. It is copied on a pair of saucer-brooches from Barrington[1] (Cambridge Museum) embellished with red enamel centres, and on the brooch from Marton, Warwickshire (supra, p. 34).

(c) (Pl. XXXII, 9). The principal garnets are four in number and are always stepped. Secondary jewels are always present and are always circular. Additional settings are often placed in the border as on several examples of Class Ib. The zoomorphic ornament, if it deserves such a title, is probably evolved from the second stage of that on Class Ib; it resembles exactly the Egyptian ka hieroglyph ⎣⎦, and, like it, represents a pair of upraised arms. The hands are clearly distinguishable on one example from Faversham in the British Museum. The rim again is always of light-and-shade type, but the border, when not filled with jewels, has either niello triangles or annulets, the form on which Mr. Kendrick lays so much stress.[2]

[1] *Archaeologia*, lxiii. 192, pl. xxviii. 6. On a large saucer-brooch in the British Museum and on one like it, formerly in the Londesborough Collection, and now in the Pitt-Rivers Museum, Farnham, Dorset, the same device has been copied.

[2] Loc. cit., p. 434. I fail to understand why annular niello should, as Mr. Kendrick maintains, be regarded as the sign-manual of superior craftsmanship. I am assured by skilled metal-workers who have frequently had occasion to use this form that it presents no greater difficulties than the triangles. On Kentish jewellery it is an admirable sign of the times, for, as becomes clear, it falls into line with the fashion of annular filigree on the more sumptuous brooches which we now have to examine on the same lines as the foregoing types. It is quite well known in early sixth century Frankish work and can more reasonably be regarded as having been borrowed from such a source than as a survival of a technique once known to British crafts-

It may here be noted that of the two examples found at Ipswich[1] neither is quite true to Kentish models; the one with pseudo-stepped garnets bears a misinterpretation of the zoomorphic pattern of Class I*b*; the other with clean step-garnets employs a poorly drawn and a garbled Class I*c* design on alternate panels.

(*d*) (Pl. XXXII, 10–12). Four stepped garnets, in one instance with four inverted wedge garnets added below, and once with four wedge garnets only. The secondary jewels are always circular, and are flanked by knot-like motives, a schematic version of an animal (or of part of one, as on a brooch from Faversham[2]) with its head turned backwards and biting its own body (Fig. 10). Both triangular and annular niello are employed on the border, but on one example from Faversham (Fig. 12) this is inlaid with a band of pseudo-plait filigree.

Class II (Pl. XXXIII, 1–3). The series of more elaborate brooches on which the middle is surmounted by a thin gold plate decorated with filigree and with a free-standing cloison design around the central boss clearly belongs to the same school. Their framework is identical with that of the more advanced stages of their humbler sisters; they merely mark an advance both in craft by the jeweller and in the wealth of the community. If regarded in this light, they too fall naturally into their place in the general scheme. They possess features in common with the simpler class. The border is invariably in light-and-shade technique, and the arrangement of the cloison design is simply a variation of Class I*b* above, namely three or four garnets, here triangular or of various shapes alternating with roundels, suggesting that the use of roundels in place of additional wedge-shaped garnets is a secondary stage of the Class I*b* itself. On that assumption we reach a time-formula according to which we may place the initial stage of Class II at *c*.

Class II (*c*). It includes some of the most attractive examples, e.g. those from Faversham[3] on which the design of the roundel is neatly executed in a succession of semicircles enclosing a stepped cloison arranged either ⟨figure⟩ or ⟨figure⟩. The departure from simplicity and the striving for additional effect that fails of its purpose comes out very clearly in another Faversham brooch,[4] where the whole design is

men in Roman times. If such a thesis were tenable, is it not strange to find it employed not, as might be expected, on the masterpieces assigned by Mr. Kendrick to the British of the Dark Ages, but solely on those humbler pieces for which alone he will give the Jutes any credit?

[1] *Archaeologia*, lx. 334. figs. 2 and 3. [2] Åberg, fig. 196.
[3] *Antiquity*, vii, pl. 1. 1 and 10. [4] Ibid., pl. 1. 9.

marred by an impaled step inserted between the semicircles. The same result, perhaps conditioned to some extent by the form of the jewel on which it occurs, is to be seen on the ovoid pendant from Faversham.[1] A loosening of the curves of the semicircle produces triangles between the steps (Pl. XXXIII, 1). The filigree employed on this class seems always to be heart-shaped, in rare instances degenerating into a recumbent C-form. The border may have annular niello or a secondary circle of light-and-shade.

(d) The next stage is marked by a growing tendency to disjoint the pattern of the cloisons. The step is still common, but is employed alternately in inverted position, and at its best the motifs are linked together by a bar joining the angles of the lower steps.[2] The loosening of the design is plainly seen in another Faversham brooch.[3] The light-and-shade is constant; the niello in triangles or annulets, and in addition to the normal heart filigree and the recumbent C, S-spirals and annulets come into use, the last in consonance with their employment in niello. In this class have to be placed examples like those from Wingham, Sibertswold, Ash[4] (the last with its border inlaid with pseudo-plait), showing a combination of C, annular, and, more rarely, S-filigree. The complete disjointing of the decorative harmony of the design manifests itself in examples from Wingham, Dover (Priory Hill),[5] and Faversham (Ashmolean Museum), where the steps stand out by themselves, the remainder of the circle being divided up by triangles or plain, curved, or stepped transverse bars (Pl. XXXIII, 2 and 3).

Class III (Pl. XXXIII, 4–6). Obviously, even in Mr. Kendrick's interpretation of the material, the great brooches which he describes by the name of 'composite' cannot properly be considered apart from the foregoing class, since in the very nature of things the cloison work offers numerous points of comparison and resemblance. It is indeed remarkable, considering their scarcity, how the series, some half-dozen in number—and not even all of these come entirely into the picture—bear witness to the changes which Anglo-Saxon cloison work underwent in a relatively short space of time. Apparently they come into being as

[1] B.M. *Guide*, pl. 1. 7.

[2] e.g. Faversham, loc. cit., pl. 1. 2, and Fitzwilliam Museum (O. Dalton, *Catalogue of the McClean Bequest*, pl. III. 5).

[3] *Antiquity*, vii, pl. 1. 8.

[4] Boyes, *Material for a History of Sandwich*, 868 and fig. 6.

[5] Baldwin Brown, op. cit., IV, pl. 146. 3; Dover Museum Bulletin No. 3 (Jan. 1933).

a class almost simultaneously with the first representatives of Class II, and strangely enough one of the earliest specimens would seem to be that acknowledged masterpiece of early Anglo-Saxon jewellery, the magnificent brooch discovered on Kingston Down by Bryan Faussett in the eighteenth century. In the combination of semicircles and steps we have a repetition on a grander scale of the design on the two Faversham brooches of Class II*c*, but there is reason to suppose that in fact it comes a little later in time, a point that would be easier to determine if other zoomorphic motifs had been employed in the filigree panels. These are, however, a version of the animal with head turned backward and biting its own body, the motif that begins in rare examples of Class I*d*,[1] where the animal style is still in evidence and which, by the time variant (*d*) had been evolved, had been metamorphosed into a simple knot. It is this same schematic treatment of the motif that appears in the panels of the inner zone of the Kingston brooch.

The parallelisms with Class II are obvious. On an example like Pl. XXXIII, 4, from Faversham the inner zone is treated as those at the head of Class II*d* above, but as in that section, so here the changes which do not make for easiness set in. The brooch, known as Sarre II[2] (Pl. XXXIII, 5) is less tainted by them than are others of its kind, but even there symmetry is attained by a rather feeble substitute, namely, two divergent diagonal lines on either side of the steps in place of the satisfying curve of the Kingston brooch. Or take an example from Faversham,[3] in silver, not in gold, as are the majority of these great Kentish pieces, where the semicircles are still retained, but the craftsman has been content to fill them with a single stepped bar, an ugly and slovenly piece of work. Here, too, comes into being a cloison style that serves as a hall-mark of the greater part of these splendid brooches, namely, a series of stepped diagonal bars, of which the uppermost angle of one is linked to the lowermost of the next by a plain diagonal bar. It is seen to advantage on the unfinished piece from Faversham[4] in two of the roundels encircling the outer bosses, and, in a variant treatment that arrives at a 仒 motif, between the stepped bars round the central boss. It recurs on the Aylesford brooch,[5] in two panels of the outer ring, and on both the outer and inner rings of the well-known Sarre I brooch

[1] e.g. *Antiquity*, vii, pl. ii. 9.

[2] *Trans. Royal Arch. Institute* (Gloucester, 1845), frontispiece. Now in the Ashmolean Museum.

[3] Ashmolean Museum (Evans Collection), 1927, 204.

[4] *Antiquity*, vii. pl. v. [5] Ibid., 430, fig. 1.

in the British Museum.[1] As is made manifest by the Aylesford brooch, it goes in its initial stage hand in hand with the disjointing process which is the feature of this group, as of its counterpart in Class II.

(*e*) There remains a class that stands out in absolute distinction to the rest of the group. It is represented by three[2] examples, one from east Kent in the Fitzwilliam Museum, Cambridge, and two specimens found at Milton, near Abingdon, Berkshire, one in the British Museum,[3] the other in the Ashmolean Museum. Their characteristic feature is the arrangement of the cloisons in a kind of honeycomb pattern; the first two have the panels filled with an intricate animal enlacement, while the Fitzwilliam Museum specimen is content with two double zones of figure-of-eight filigree loops. This new animal style has some affinities to the simpler knot on brooches of Class I*d*, and like it must be regarded as a definite process of transformation of an animal style into an entrelac, a stage that cannot on any possible grounds be placed either before or even at a time contemporaneous with the beginnings of the appearance of Teutonic zoomorphic ornament in England. To argue that it may be is to claim for the art-history of England a development for which no immediate antecedents can be shown to exist in England itself, and, if these brooches are to be regarded as the work of British as opposed to Anglo-Saxon jewellers, such antecedents must be produced to support the contention. Furthermore, it presupposes a development that could hardly have been reached in Western Europe at the time when they are claimed to have been made in this country.

The style of Class III*e* is quite rare; it otherwise appears only on a very few objects, notably the great fish-buckle from Crundale in the British Museum,[4] on which it is fittingly applied to produce the effect of scales. This buckle has engraved upon its back-plate an animal which again, like that on the back of the brooch in the Fitzwilliam Museum, cannot by any possible stretch of imagination be regarded as early. Its slender, graceful lines clearly foreshadow the animal style of the earlier manuscripts like the book of Kells or the Book of Lindisfarne. If viewed in this light, it admits of the possibility of speaking of the Celtic spirit leavening the schematism of Teutonic art and at the same time of bringing it into a natural sequence as a link between pagan and Christian Saxondom.

The position of this fashion of cloisonné work is further established by

[1] B.M. *Guide*, fig. 60. [2] Dalton, op. cit. ii. 4.
[3] *Antiquity*, vii, pl. iv. 3. [4] *Ipek*, 9. Band, Taf. 28, fig. 12.

its employment on such pieces as the Gilton buckle[1] in association with the linked steps of Class III*d*, and on the Crundale buckle with its running knot-pattern along the border of the plate.

The series under review exhibits in addition a feature that marks the closing stages of cloison work as known from pagan times, namely, a return to less elaborate cutting of the stones. Thus the ⌂-form used in the honeycomb design is such,[2] but it is associated with one even simpler, the garnets being shaped in almost rectangular form to fill the bands round the bosses.[3] So it comes about that the brooch from Sitting-bourne in Dover Museum (Pl. XXXIII. 6) falls into place as the latest example of the varieties of Class III and at the same time serves to indi-cate the tendencies of the period, tendencies which give a clear lead to the dry workmanship that produced St. Cuthbert's cross. This, as its worn condition indicates, must have been made some considerable time before his death in A.D. 687.

The distribution of the first class of the circular jewelled brooches bears out the conclusions that may be drawn from their decoration (Figs. 24–6). It is recognized that the earliest Kentish cemeteries, as judged by their archaeological content, lie mainly east of Canterbury, Sarre, Bifrons, and Howletts being the most conspicuous, though some early features appear also at Faversham, at Milton-next-Sittingbourne, and at Chatham Lines. That is to say, they lie along the line of the Roman road from Thanet to the Medway, and half-way along that line comes Faversham. A glance at the map demonstrates clearly that Faversham is for all purposes, and in all probability actually was, the centre of the production of these jewelled brooches. There almost every type is more plentifully represented than at any other site.

At the same time the earliest types are otherwise almost confined to cemeteries along the line noted above.[4] There are no outliers recorded, except in one example of Class I at Stowting on the road from Canter-bury to Lymne. It is really only on the advent of the late variant of

[1] Baldwin Brown, iii, pl. LXXI. 4.

[2] Cp. on a sword from Joche, Marne, Salin, op. cit., fig. 277. *Rev. Arch.* 1880, pl. 20, fig. 2.

[3] As on the circular brooch in the grave-group from Wittislingen, Bavaria, von Jenny und Volbach, *Germanischer Schmuck*, pl. 42.

[4] It is only at Faversham, apart from one specimen from Howletts, that we find examples of this class decorated with the light-and-shade border, the innovation of which may fairly be on that account attributed to the Faver-sham workshops.

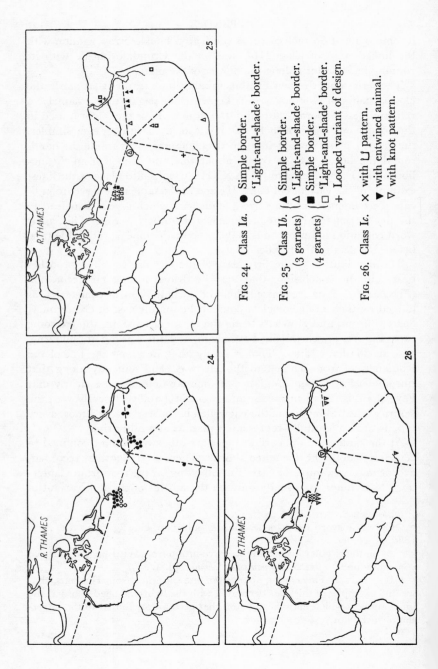

Fɪɢ. 24. Class I*a.* ● Simple border.
 ○ 'Light-and-shade' border.

Fɪɢ. 25. Class I*b.* ⎰ ▲ Simple border.
 (3 garnets) ⎱ △ 'Light-and-shade' border.
 ⎰ ■ Simple border.
 (4 garnets) ⎱ □ 'Light-and-shade' border.
 + Looped variant of design.

Fɪɢ. 26. Class I*c.* × with ⊔ pattern.
 ▼ with entwined animal.
 ▽ with knot pattern.

Class I*b* that a wider diffusion is observable, and even so it is very slight. In any case the earlier variant is again confined to the same line. In fact, out of six examples only one comes from Faversham, and the rest from Sarre, Gilton, and Ash. It is the later varieties that are best represented at Faversham, and it is only these, and that quite sparsely, which occur in the highland cemeteries south of Canterbury.

From Faversham hails the sole recorded example of a brooch with four garnets alternating with an animal style closely comparable with that employed on the Kingston brooch. From this design, as we have seen, was evolved the knot-like motif, pairs of which flank a circular or wedge-shaped setting in the intervals between four stepped garnets. Outside Faversham the variety occurs only at Ash, Maidstone, and Postling, while the type with four stepped garnets and the *ka* motif embracing a jewelled setting is, so far as I am aware, entirely confined to Faversham.

This evidence of the activity of the Faversham workshops is strongly corroborated by the distribution of the cloison-decorated brooches. All the specimens with star-pattern and heart-shaped filigree, save one from Sibertswold, come from Faversham, since two from a Kentish source in Canterbury Museum may well come from Faversham also, the source of many unprovenanced Kentish specimens. The later varieties spread at first along the old line; it is only the more advanced creations with recumbent C, annular, and S-filigree that show a wider dispersion.

In a word, all that a comparison of the two distribution maps, by which Mr. Kendrick illustrates his argument in favour of an outburst of British craftsmanship, serves to demonstrate is, that for some reason unknown to us the Bifrons and Howletts group of cemeteries must belong to settlements which, so far as it is possible to judge from the known cemeteries of the period, represent an early occupation in the vicinity of Canterbury, and that, unless portions of both cemeteries still remain unexplored, there was subsequently a movement to the higher ground farther south, the cemeteries of which appear to begin at an advanced epoch. It has always to be borne in mind in evaluating the material collected by Bryan Faussett that only one of the more extensive cemeteries explored by him, namely, Gilton, east of Canterbury, begins early and continues to the close of the period covered by the pagan cemeteries as a whole. Even Faversham, while falling within the category of early settlements, hardly vies with Bifrons or Sarre in that respect, though subsequently it develops until it becomes the focus of all Kentish art and craftsmanship, the centre, in fact, of Kentish

pagandom, and perhaps too of political and economic life. This position it appears to have retained for a time even when the revival of Christianity drew, as was only natural, the new faithful back to Canterbury, not necessarily to live within its walls, but for worship and burial within its sacred precincts. It is remarkable how little that is early has been found on or near the south coast of Kent. One can cite an odd piece of Jutish type from Lyminge. Otherwise the story begins with purely Kentish material from Stowting on the Canterbury–Lymne road, Folkestone, and Faussett's cemeteries on either side of the Canterbury–Dover road. The distribution southwards from Canterbury need not imply a diminution in importance of the original ports of entry in and near to Thanet, but a realization by the new-comers of the greater facilities afforded by the southern ports for communication with France, and a consequent trend of settlement in their direction.

I. GENERAL INDEX

Åberg, N., *passim.*
Aethelbert, 93.
Akerman, J. Y., 109.
Alans, 15.
Alemanni, 72, 93.
'Anglian' beast, 90.

Beads, amethyst, 77–78, 98–9, 100–1, 107.
— glass, 50, 98–9, 107–8.
— wire, 108.
Beakers, *see* Glass.
Bede, 37–9, 72, 93.
Belgium, cemeteries in, 57.
Belt-mounts, 5, 14, 33, 57, 64–5, 68–9, 73.
Bernicia, 93.
Bowls, bronze, 3 ff., 7 ff., 35, 74, 77, 99.
— hanging, 3 ff., 7 ff.
— Coptic, 35, 74, 77.
Bracteates, 50, 64, 66, 74.
Britons (post-Roman), 2.
Brøndsted, J., 71, 90.
Brooch:
 annular, 3–4, 98 ff., 100–1.
 applied, 39, 69, 102.
 bird, 47, 50.
 circular jewelled, 34, 43, 47, 51, 65, 68, 91–2, 107, 115 ff.
 — — distribution of, 121 ff.
 cloison, 46 ff., 65, 115 ff.
 cruciform, 33, 39, 51, 66, 69, 79 ff.
 — florid, 71, 80 ff.
 — — distribution of, 83 ff.
 disk, 3, 26.
 equal-armed, 25, 33–4, 39, 66.
 penannular, 3–4, 99–100.
 radiate, 47, 50, 61–2, 92.
 saucer, 13, 31, 34, 39, 69, 75, 88–90, 102, 116.
 safety-pin, 100.
 square-headed:
 large (Anglian, &c.), 34, 80 ff., 94;
 — distribution of, 84 ff.
 small (Anglian, &c.), 34.
 large (Kentish), 47 ff., 51, 56, 77, 115.
 small (Kentish), 51–2.

large (Rhenish), 49, 70.
— (Scandinavian), 49, 67, 85.
Haslingfield type, 84, 86–8.
Ipswich type, 85–7.
Kenninghall I type, 85–7.
— II type, 86–9.
'tutulus', 38.
Brown, G. Baldwin, xii, 7, 18, 42.
Bucket, 17–19.
Buckle, Gallo-Roman, 5–7, 18–19.
— Anglo-Saxon, 14, 64, 73–4, 77, 99, 102–3.
Buckle-plates, *see* Belt-mounts.
Bullae, *see* Pendants.
Burgunds, 72.

Casket, 14–15.
Celts, 113 ff.
Chlothair, 108, 112.
Clapham, A. W., 10 ff.
Clovis II, 57, 93, 106.
Coins, 2, 77, 105–8, 112.
Collingwood, R. G., 2 n.
Combs, *see* Toilet-implements.
Conway, Sir Martin, 19.
Coptic vessels, 35, 74, 77.
Cremation, 29 ff., 43, 91.
— distribution of cemeteries, 29 ff.
— duration of, 32 ff.
— proportion of, 38.
— implements with, 30 ff.
— Jutish, 43–4.
— ornaments with, 31 ff.
Cross, pendent, 121.
Crosses, Celtic, 10, 14.

Dagobert I, 106.
Daniel, 19.
Deira, 93.
Durrow, Book of, 75.

East Anglia:
 contacts with Kent, 69 ff.
 — north and midlands, 79 ff.
Eligius, 106.
Enamelled escutcheons, 3, 8 ff.

Faussett, Rev. Bryan, 33, 47, 97, 107, 123.
Flagons, Coptic, 77–8.
Frankish cemeteries, 34, 56–8.
Franks, Ripuarian, 54–8, 60.
— movements of, 4, 44, 55 ff.
Frisians, 54.

Gildas, 1, 114.
Gjessing, G., 54 n., 73.
Glass, 46, 50, 52, 76 ff., 105.
— lobed beakers, 46, 50 n., 76 ff.
Goblet, 17, 64–5, 75–6.

Hearth, 24.
Heirlooms, question of, 35.
Helmet, 14.
Hengist, 1, 7, 20.
Henning, 15.
Heorot, 21.
Heraclius, 108, 112.
Horn, drinking-, 75.
House, plan and construction, 20 ff.
— hearth, 24.
— implements found in, 26.
— loom in, 26.
— scoriae, 24.
— slaking-tank, 24.

Implements, found in houses, 26.
— miniature, with cremation, 30 ff.

Joliffe, J. E. A.; theory of Kentish land-
tenure, 54.
Justinian, 112.
Jutes, 43, 54.

Kendrick, T. D., 3, 41 ff., 123.
Kent:
 Anglo-Saxon pottery, 43, 77.
 Frankish pottery, 45–6.
 archaeological development, 41 ff.
 influences spread from, 69 ff., 80, 92, 95.
 jewellery, 46 ff., 115 ff.
 Jutish phase, 43.
 Frankish phase, 44 ff., 69.
 — — (reasons for change), 53 ff.
 Kentish phase, 53, 59 ff.
 land-tenure, 54 ff.
 origin of zoomorphic ornament in, 68.
Kühn, H., 60–1.

Latin inscription, 18.
Lethbridge, T. C., 35, 101–2.
Lindisfarne, Book of, 114.
Lombards, 35, 77, 93, 112.
Loom, 26.
— weights, 26.

Mauricius Tiberius, 108, 112.
Meyer, Fröken, E., 49 n.
Mid-Anglia, 83 ff., 94.
Midlands, external relations of, 90.
Missionaries, 10.

Necklace, 108–9.
Norway, contacts with, 66, 85.

Ornament:
 Anglo-Saxon, passim.
 Celtic, 9, 11–13.
 Christian, 8, 14–19.
 Classical (late), 14–19.
 Gallo-Roman (late), 5 ff., 14–15.
 Motifs employed in:
 animal knot, 117, 123.
 animal legs, 13.
 arcades, 17.
 beaked head, 5, 61, 69, 72–3, 81–2, 84–8; see griffin.
 beast, cowering or crouching, 4, 49, 63, 67–9, 72–3, 82 ff., 115.
 — rampant, 48–9, 51, 57, 68, 80 ff.
 dove, 4, 9, 19.
 entrelac (plait or 'skein'), 61, 64–5, 74–5, 100–101, 112, 117, 121.
 cloison, honeycomb, 65, 120–1.
 — steps, 117 ff.
 — — (linked), 65, 119.
 fish, 8.
 griffin, 62, 72, 74; see also beaked head.
 hare, 6.
 hippocamp, 5–7.
 hound, 4, 6.
 ivy, 14.
 Ka-motif, 116.
 leaflet, 6, 9–10, 12.
 lion, 5–7.
 maeander, 61.
 'marigold', 10 ff.
 masks, 6, 75, 81, 84.
 peacock, 19.
 pelta, 9, 12, 14.

Ornament: Motifs employed in: (cont.)
quatrefoil, 88.
serpent, 112.
'skein', see entrelac.
Solomon's seal, 11.
spiral, 9, 67, 82.
spotted bands, 74 ff.
star, 11.
swastika, 9, 12.
tendrilled scrolls (Ranken-ornament),
5–6, 60, 67.
trellis, 14, 18.
triple knot, 11, 111.
trumpet-scroll, 10.
vine, 14–17.
wolf, 4, 7.
Techniques employed in:
cabochon, 66, 99, 105–8.
chip-carving (Kerbschnitt), 5, 11, 61.
cloisonné, 117 ff.
damascening, 65.
enamel, 9.
filigree, 64, 66, 74, 105, 117 ff.
— types of, 105, 107–8, 117–18, 123.
light-and-shade, 115 ff.
niello (annulets), 116–18.
— (triangles), 114–18.
plating, 14, 18.
'tausia', 18–19.
Zoomorphic, 53, 61, 68, 81, 101–3,
112, 115–17.
— in Kent, 68–70.
— in Midlands and Wessex, 71.
— in north Germany, 67.
— in Scandinavia, 67–8, 71–2.

Paulinus, 98.
Peada, 95.
Penda, 95.
Pendant, 99–100, 105, 108–9, 111–12.
Picts, 20.
Pins (linked), 107–110.
Pottery, 30, 43, 77, 100.
— cooking-pots, 24, 28.
— cremation-urns, 30 ff., 43.
— Jutish (Anglo-Saxon), 43–44, 77.

Pottery, Frankish, 45–6.
— puddling-pit for, 28.

Relph, Dr. A. E., 4, 51.
Rhineland, 49 ff., 68, 77 ff.
— source of Kentish jewellery, &c., 49 ff.
— — of Kentish land-tenure, 54 ff.
— square-headed brooches in, 70.
— trade with, 44.

St. Cuthbert, 121.
St. Eloi, 106.
Salin, B., passim.
Sarcophagi, Christian, 15, 19.
Scots, 20.
Shears, see Implements.
Shetelig, H., 66, 81.
Slip-rings, silver, 110.
Smith, R. A., x, 7, 51, 81, 97–8.
Steam-bath, 28.
Stoup, see Goblet.

Thread-box, 99, 101–2.
Tiberius II, 112.
Toilet-implements, 30 ff.
Trade with Continent, 44, 52.
Tweezers, see Cremation and Toilet-
implements.

Valentinian I, 107.
Veeck, W., 59.
Visigoths, 57, 61, 93.

Warni, 54.
Weapons:
angon and pilum, 46.
axe (francisca), 31, 46, 73.
pommel, 74, 102.
scramasax, 100–2.
shield-boss, 71.
spear, 77.
spear-butt, 31.
West Saxons, 110.
Wessex, external relations of, 88–9, 95.

Zeiss, H., 61.

II. INDEX OF PLACES

1. BRITISH ISLES

Abingdon, 3, 31-2, 38, 46, 89.
Alfriston, 4, 6, 14, 17, 37.
Alton Priors, 110.
Ash, 47, 51, 115, 118, 123.
Asthall, 35, 74.
Aylesford, 65, 119.

Baginton, 9-11, 38, 89.
Barfriston, 105-6, 108 n.
Barlaston, 12.
Barrington, 12, 62, 84-5, 92, 105, 116.
Barton Seagrave, 71.
Basingstoke, 9.
Bedfordshire, 88-9.
Bewcastle, 13.
Bidford-on-Avon, 7, 11, 34, 38, 70, 89.
Bifrons, 3, 18-19, 42, 43 n., 44, 47, 49-
 51, 61, n., 84, 121, 123.
Billesdon, 85.
Bishopstone, 7.
Bourton-on-the-Water, 21, 23.
Bradford-on-Avon, 111.
Brassington, 108.
Breach Down, 103 n.
Brighthampton, 38.
Broadstairs, 46 n.
Brooke, 35, 83.
Broughton Poggs, 13.
Burwell, 7, 92, 101-2, 111.

Caister, 39.
Cambridge, 31, 86.
Cambridgeshire, 69.
Camerton, 36, 111 ff.
Canterbury, 74 n., 111, 121, 124.
Cassington, 2, 21, 26.
Castle Acre, 30, 33, 39.
Castle Bytham, 4.
Catterick, 86.
Chadlington, 36, 102.
Chartham Down, 74 n, 107-8, 112.
Chatham Lines, 121.
Cherbury Camp, 89.
Chessel Down, 8, 56 n., 77, 115.
Cotswolds, 110.
Cowlow, 108-9.

Croydon, 14, 46.
Crundale, 74, 120-1.
Cuddesdon, 77.

Dalmeny, 99 n.
Darlington, 86, 88.
Desborough, 108, 110.
Dorchester (Oxon.), 5, 19.
Dover, 9-11, 12, 118.
Driffield, 86, 94.
Durobrivae, 86.
Duston, 11-12, 84, 90.
Dyrham, 110.

Easden, 43-4.
Eye, 31.
Ermine Street, 86.

Fairford, 50 n., 69, 71, 89.
Farthingdown, 64, 112 n.
Faversham, 4-5, 8-9, 18, 64, 74, 116 ff.,
 123.
Ferring, see High Down, 31 n.
Finglesham, 50, 56.
Finningley, 8.
Folkestone, 124.
Forsbrook, 107.
Fridaythorpe, 94.
Frilford, 2, 30, 37.

Garton Slack, 100.
Gilton, 14, 61 n., 65, 74, 99, 115, 121,
 123.
Girton, 31, 33-5, 85 n.
Great Wigston, 86.

Harlton, 89.
Haslingfield, 33, 84-8, 90.
Hassocks, 31.
High Down, 4, 6-7, 31, 37, 46.
Holdenby, 71.
Holme Pierrepont, 85.
Holywell Row, 35, 82-3, 91.
Hornsea, 86.
Hound Point, 99 n.
Howletts, 4-6, 9, 18, 47, 50-1, 73, 77,
 115, 121, 123.

Icklingham, 91.
Ipswich, 85-6, 91, 117.
Isle of Wight, 56.

Kempston, 11, 33, 88.
Kenninghall, 85-6, 88, 91.
Kent, 43 ff., 115 ff.
Kettering, 30, 33.
Kilham, 92.
Kingston Down, 10, 42, 74, 102, 108, 119, 123.

Laceby, 85, 88.
Linton Heath, 89-90, 92.
Little Wilbraham, 31-2, 34, 79, 91, 116.
Londesborough, 10, 70.
Longbridge, 83.
Long Wittenham, 3, 17, 31, 37, 109.
Luton, 34, 88-9.
Lydney, 2.

Maidstone, 123.
Malton, 62.
Market Overton, 63-4, 71, 83, 85-6, 89.
Marton, 34, 116.
Mildenhall (Suffolk), 9, 11.
Milton (Berks.), 120.
Milton-next-Sittingbourne, 48, 121.
Mitcham, 7, 11.
Monkwearmouth, 112 n.

Needham Market, 10.
Norfolk, 30, 39.
Northamptonshire, 71.
North Leigh, 102.
Northumberland, 12.

Offchurch, 89.
Ormside, 14.
Orton, 21.

Painsthorpe, 100.
Postling, 123.

Quy, 90.

Radley, 21.
Ragley Park, 90.
Riby Park, 100.
Ringwauld, 73.
Rothley Temple, 71, 83.

Roundway Down, 108, 110.
Royston, 6.
Ruthwell, 14.

St. Neots (Hunts.), 21.
Saltburn-on-Sea, 32.
Sancton, 30.
Saxby, 89 n.
Scotland, 99 n.
Searby, 92, 100.
Shefford (Beds.), 71.
Shudy Camps, 101.
Sibertswold, 42, 99, 103, 105, 108, 118, 123.
Sittingbourne, 121.
Sleaford, 82, 84, 86.
Soham, 81.
Stanwick, 19.
Stapleford, 71, 83, 89.
Stowting, 121, 124.
Strood, 14-15.
Suffolk, 21, 39, 64, 69, 83.
Sutton Courtenay, 21 ff., 33, 38.

Taplow, 50 n., 64, 75-7.
Thames Valley, upper, 89.
Thanet, 124.
Thistleton, 86.
Thornbrough, 86, 88, 94.
Tostock, 108 n.
Tuddenham, 89.
Tummel Bridge, 9.

Uncleby, 98 ff., 100, 102-3, 105, 111.

Verulamium, 2.

Waldringfield, 30.
Wansdyke, 110.
Waterbeach, 21.
Welbourn, 84.
West Road (Suffolk), 21.
West Stow, 82 n., 91.
Whitehill Point, 86.
Wilton, 8-9.
Winchester, 12.
Wingham, 112, 118.
Wodensbeorh, 110.
Woodstone, 82, 92.
Wye Down, 112.

York, 11.

2. *FOREIGN*

Andernach (Germany), 115.
Armentières (France), 62 n.

Baldenheim (France), 14.
Ballana (Nubia), 78 n.
Beauvais (France), 17.
Babenhausen (Germany), 6.
Belgium, 57–8.
Bobbio (Italy), 10.
Buire-sur-l'Ancre (France), 17.

Castel Trosino (Italy), 112.
Châlons-sur-Sâone (France), 14.
Charente (Dept, France), 56.
Charenton-sur-Cher (France), 19.
Cologne (Germany), 55, 58.

Engers (Germany), 48–50.
Envermeu (France), 17.

Fétigny (Switzerland), 104.

Gammertingen (Germany), 14.
Giulianova (Italy), 14.
Gültingen (Germany), 14.

Heddesheim (Germany), 65.
Heilbronn (Germany), 61 n.
Herpes (France), 56 ff., 73.

Joche (France), 121 n.

Keszthely (Hungary), 62.

La Grazza (Spain), 77.
Loveen bij Wijster (Holland), 70.
Luxeuil (France), 10.
Lyngby (Denmark), 21.

Marchélepot (France), 17.
Marsal (France), 105–6.
Miannay (France), 17.
Monceau-le-Neuf (France), 62 n.
Mont-de-Hermès (France), 18 n.
Murr (Germany), 104.

Nocera Umbra (Italy), 112.
Nordendorf (Germany), 62 n., 65.
Norway, 49, 66, 85.
Nubia, 78.

Pfalheim (Germany), 65, 77–8.
Pry (Belgium), 58.

Rhineland, 68.

St. Vid (Dalmatia), 14.
Salling (Denmark), 21–2.
Saulgau-Grosstissen (Germany), 74.
Sedan (France), 5.
Séry-les-Mezières (France), 11.
Stockach (Germany), 104.

Thuringia, 60.

Vendel (Sweden), 76.
Verdun (France), 105–6.
Vermand (France), 4 ff., 11.
Vézeronce (France), 14.

Waiblingen (Germany), 62.
Westerwanna (Germany), 39.
Wieuweerd (Holland), 70, 112.
Wittislingen (Germany), 73, 112, 121.
Wurmlingen (Germany), 61 n.

PLATE II

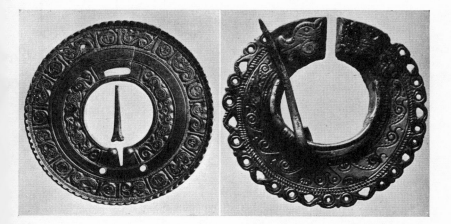

a *b*

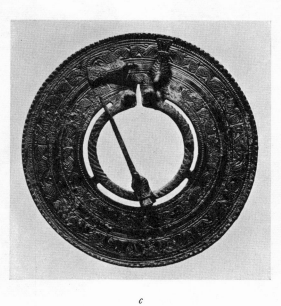

c

Decorated silver annular and penannular brooches
from Kent and Sussex: *a* and *c* ($\frac{1}{1}$), *b* ($\frac{9}{1}$)

PLATE III

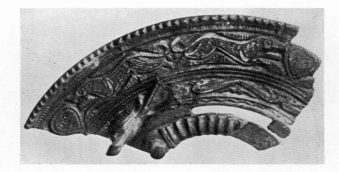

a

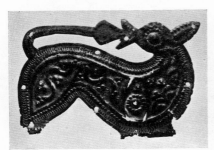
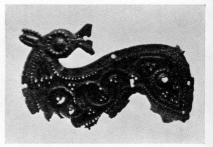

b

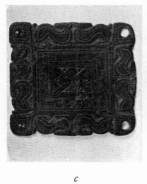
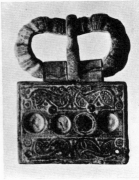

c

d

Objects from Anglo-Saxon graves decorated in late Gallo-Roman style
($\frac{1}{1}$, except *a* which is $\frac{2}{1}$)

PLATE IV

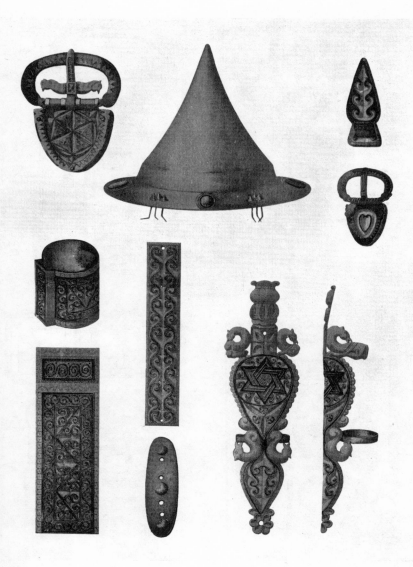

Objects from 'the Warrior's Grave' at Vermand, Dept. Aisne (after Pilloy)

PLATE V

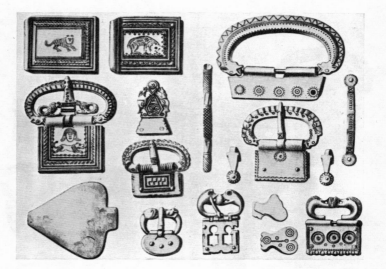

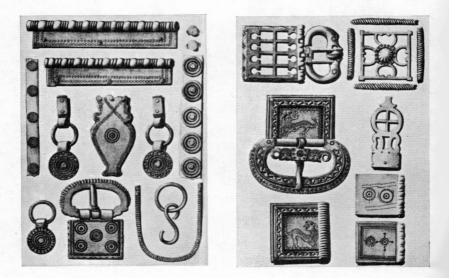

Buckles, belt-mounts, &c., from late Gallo-Roman graves at
Vermand, Dept. Aisne (after Pilloy)

PLATE VI

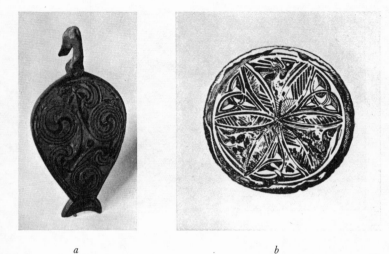

a *b*

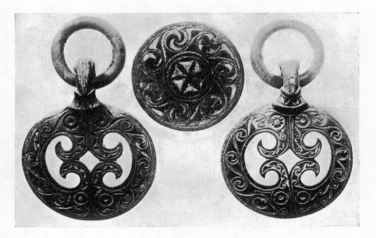

c

a. Enamelled escutcheon, Lincoln ($\frac{1}{1}$)
b. Bronze weight, Mildenhall, Suffolk ($\frac{1}{1}$)
c. Enamelled escutcheons, Baginton, Warwicks. ($\frac{1}{1}$)

PLATE VII

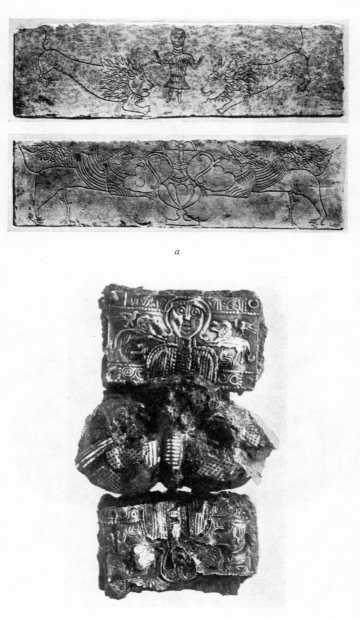

a. Sarcophagus from Charenton-sur-Cher (after le Blant)
b. Silver-plated iron buckle, Bifrons, Kent ($\frac{1}{1}$)

PLATE VIII

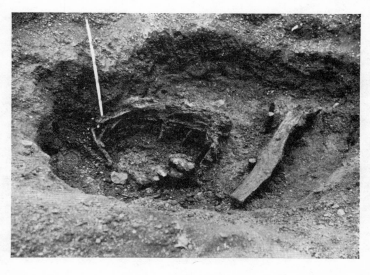

a

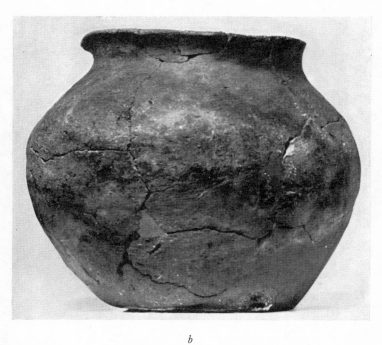

b

Sutton Courtenay, Berks., House XXI: (*a*) puddling-pit (?);
(*b*) cooking-pot (under $\frac{1}{3}$)

PLATE IX

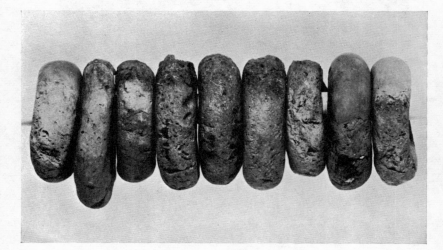

a

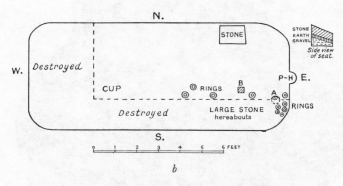

b

a. Clay loom-weights, Cassington, Oxon. (*c.* ½)
b. Plan of House XX, Sutton Courtenay, Berks.

PLATE X

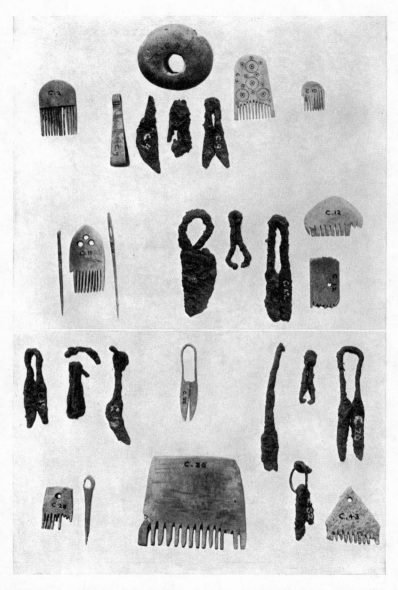

Miniature toilet-implements from cremation-urns, Abingdon, Berks ($\frac{1}{1}$)

PLATE XI

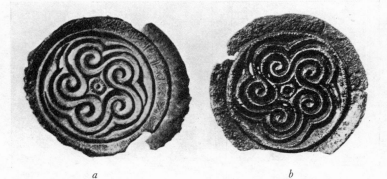

a *b*

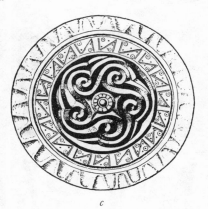

c

d

a, *c*, and *d*. Bronze brooch and urn, Westerwanna,
Hannover ($\frac{1}{1}$ and $\frac{1}{4}$) (after *Anglia*)
b. Bronze brooch, Caister, Norfolk ($\frac{1}{1}$)

PLATE XII

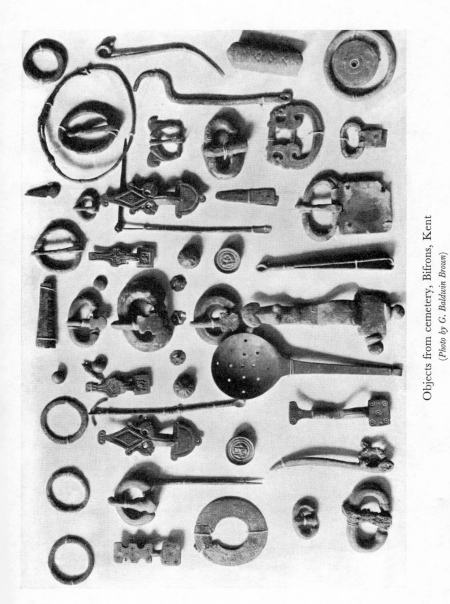

Objects from cemetery, Bifrons, Kent

(Photo by G. Baldwin Brown)

PLATE XIII

a

b

Pottery from Kent in Liverpool Museum: (*a*) Saxon, (*b*) Frankish or Kentish

PLATE XIV

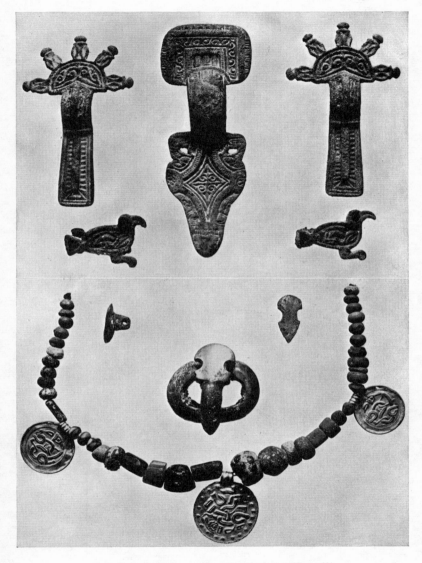

Jewellery from grave D 3, Finglesham, Kent ($\frac{3}{4}$)

PLATE XV

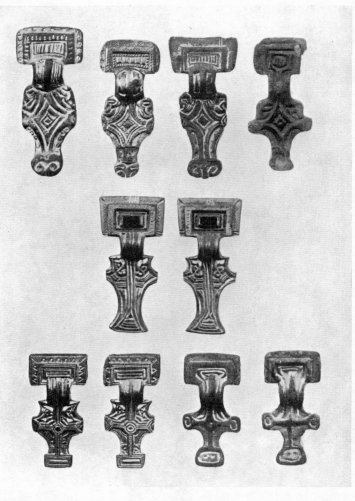

Small square-headed brooches (Kentish type) from Kent and
Upper Thames Valley; Ashmolean Museum ($\frac{4}{5}$)

PLATE XVI

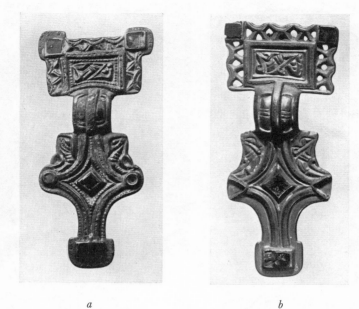

a　　　　　　　　*b*

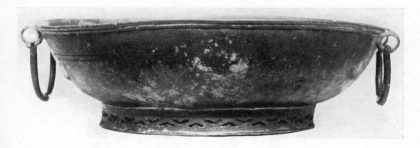

c

Square-headed brooches (Kentish type): (*a*) Finglesham, Kent; (*b*) Herpes,
Dept. Charente ($\frac{1}{1}$)

c. Bronze Coptic bowl, Chilton Hall, Sudbury, Suffolk; Ashmolean
Museum ($\frac{2}{5}$)

PLATE XVII

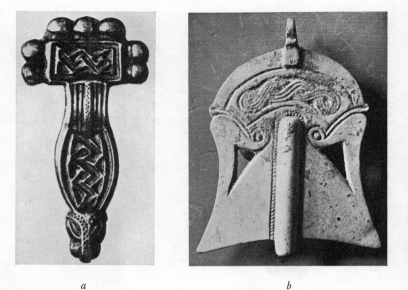

a *b*

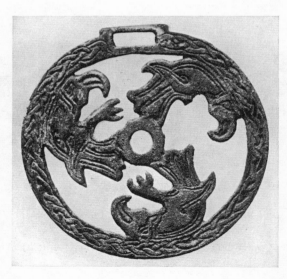

c

a. Square-headed brooch, Wurmlingen, Württemberg (after Salin)
b. Bronze brooch, Malton Farm (Barrington A), Cambs. ($\frac{1}{1}$)
c. Bronze pendent disk with griffins, Andernach, Germany ($\frac{2}{3}$)

PLATE XVIII

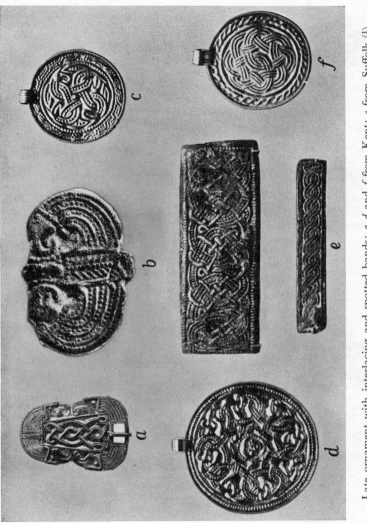

Late ornament with interlacing and spotted bands: a–d and f from Kent; e from Suffolk ($\frac{1}{1}$)

PLATE XIX

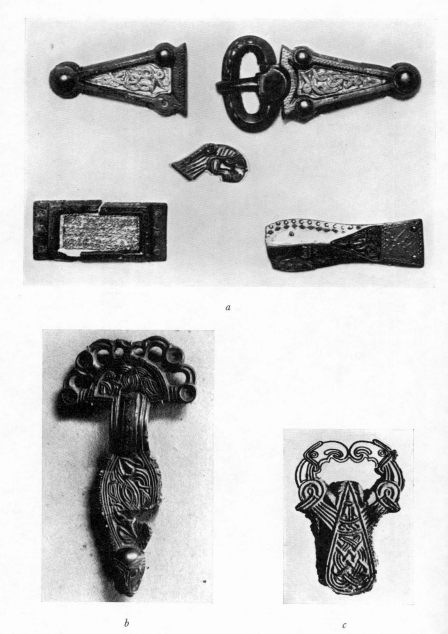

a

b *c*

Jewellery with interlaced zoomorphic ornament: (*a*) Gilton, Kent;
(*b*) Market Overton, Rutland; (*c*) Asthall, Oxon. (¼)

PLATE XX

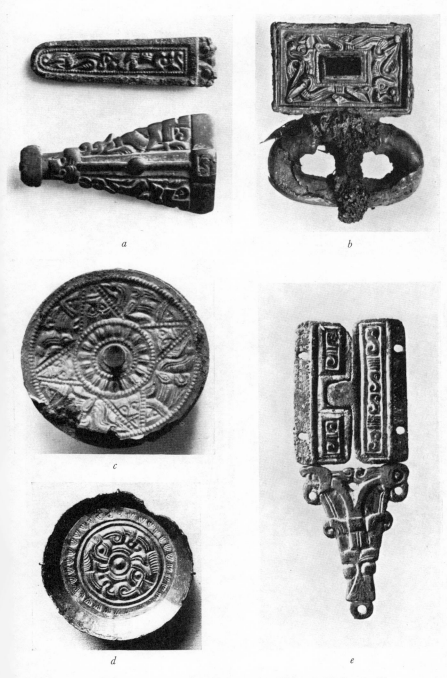

a

b

c

d

e

Zoomorphic ornament: Kent, East Anglia, and Midlands (¹⁄₁)

PLATE XXI

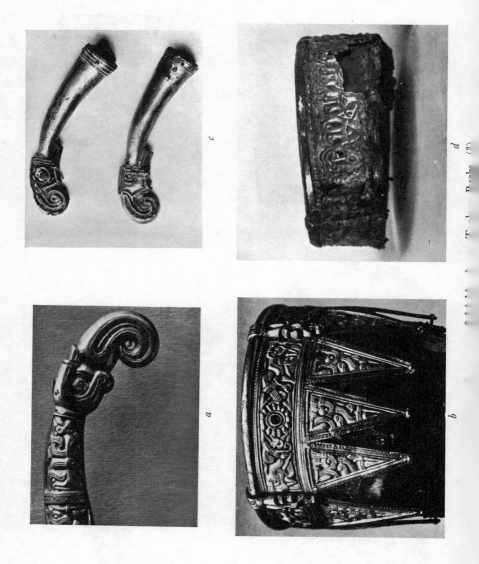

PLATE XXII

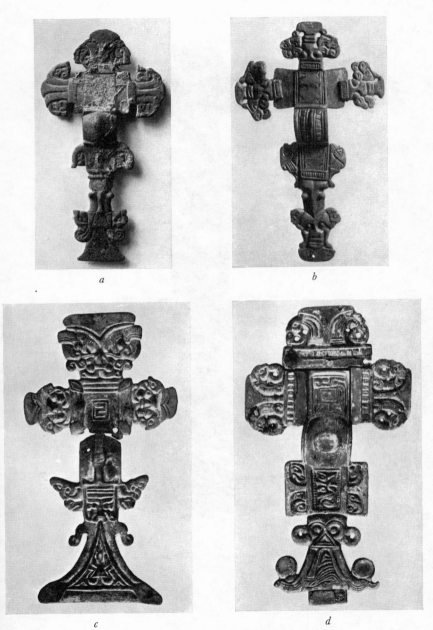

Florid cruciform brooches ($\frac{1}{2}$)
(a) Haslingfield, Cambs.; (b) Icklingham, Suffolk; (c) Newnham, Northants;
(d) Duston, Northants

PLATE XXIII

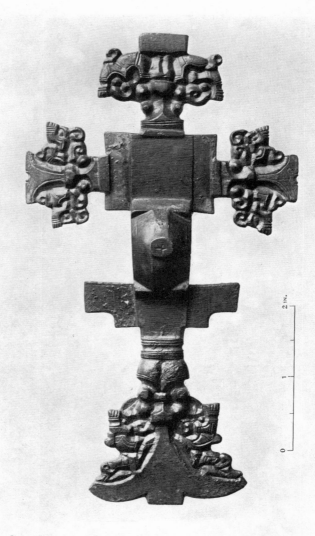

Cruciform brooch with rampant beast, Soham, Cambs. ($\frac{1}{1}$)

PLATE XXIV

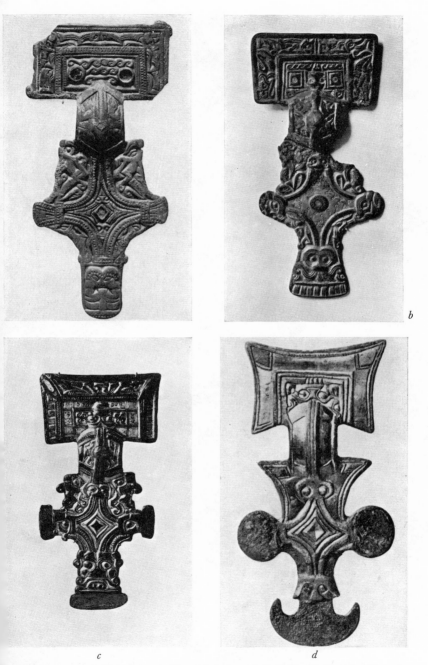

c *d*

arge square-headed brooches in Kentish style: (*a*) Suffolk; (*b*) Rothley Temple,
Leics.; (*c*) Lakenheath, Suffolk; (*d*) Market Overton, Rutland ($\frac{2}{3}$)

PLATE XXV

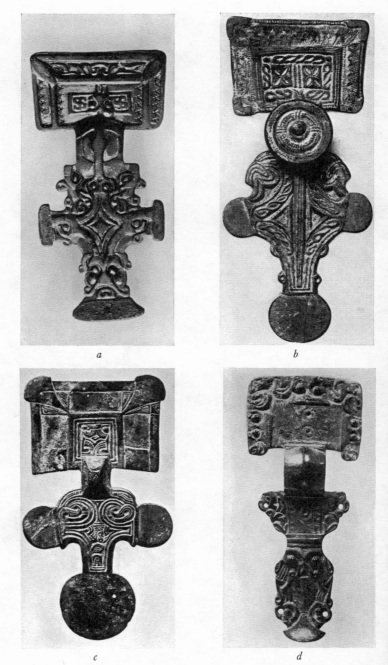

a

b

c

d

East Anglian square-headed brooches ($\frac{2}{3}$): (*a*) Haslingfield, Cambs.; (*b*) Ipswi[ch?] Suffolk; (*c*) Thornbrough, Yorks.; (*d*) Darlington, Durham

PLATE XXVI

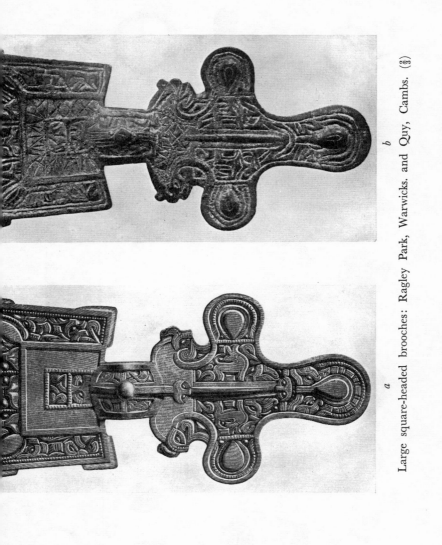

Large square-headed brooches: Ragley Park, Warwicks. and Quy, Cambs. (⅔)

a

b

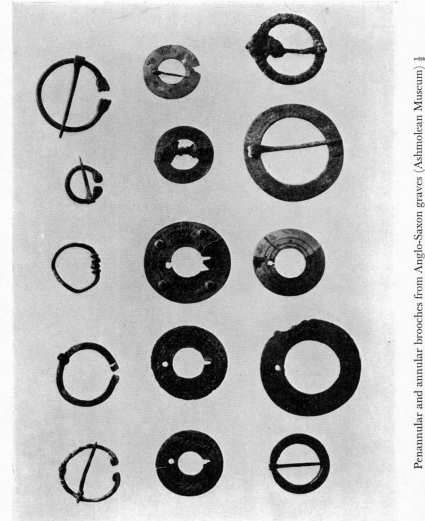

Penannular and annular brooches from Anglo-Saxon graves (Ashmolean Museum) $\frac{1}{2}$

PLATE XXVII

PLATE XXVIII

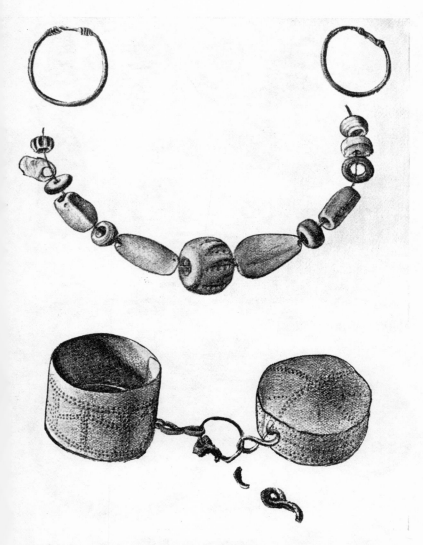

Objects from grave, Garton Slack, E. Riding, Yorks. (after Mortimer)

PLATE XXIX

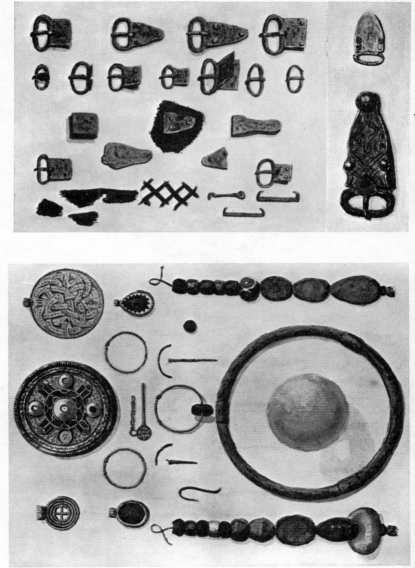

PLATE XXX

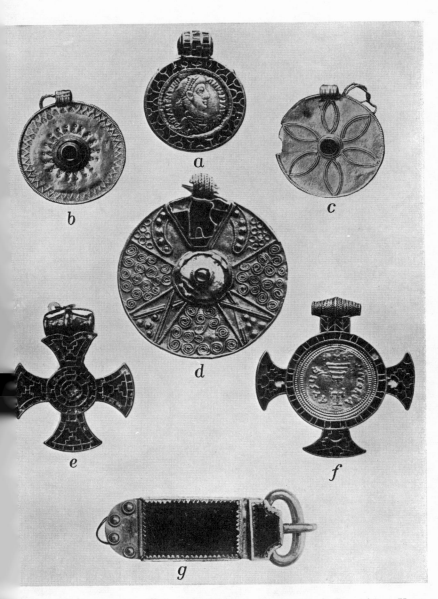

e (seventh-century) jewellery: (*a*) Fosbrook, Staffs.; (*b–c*) Faversham, Kent;
Womersley, Yorks.; (*e*) Stanton, Suffolk; (*f*) unknown; (*g*) Tostock, Suffolk

PLATE XXXI

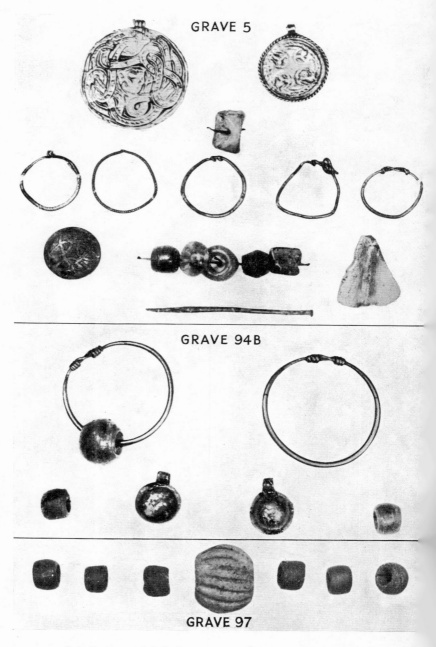

GRAVE 5

GRAVE 94B

GRAVE 97

Jewellery and beads from graves, Camerton, Somerset ($\frac{1}{1}$)

PLATE XXXII

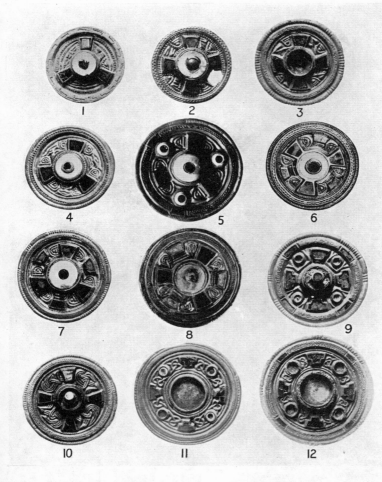

Kentish circular jewelled brooches (Class I) ($\frac{2}{3}$)

PLATE XXXIII

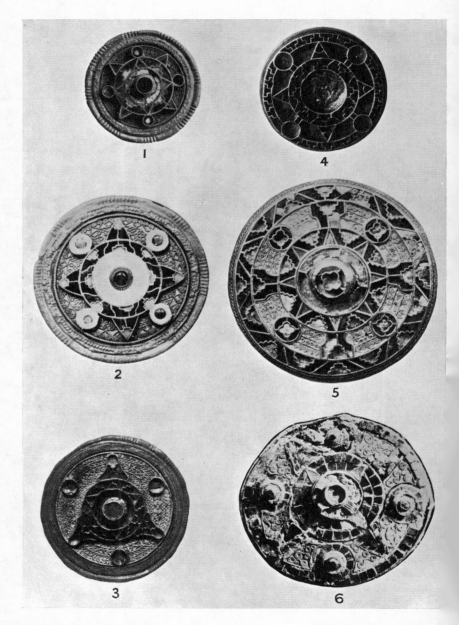

Kentish circular jewelled brooches: Class II, nos. 1–3; Class III, nos. 4–6 ($\frac{1}{1}$)